How To Master
Airbrush Painting
Techniques

How To Master
Airbrush Painting
Techniques

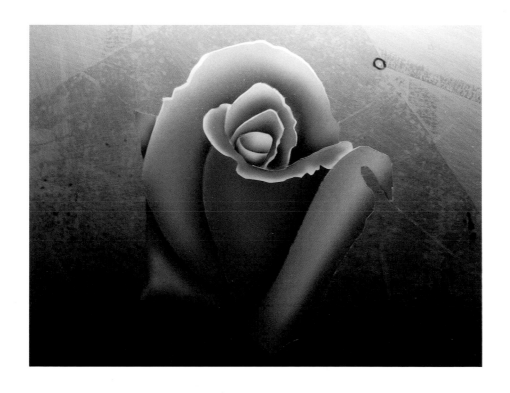

JoAnn Bortles

Dedication

To Jeanmarie Kamm Begey, my mother who dragged me off to art lessons and
opened my young eyes to all the wonders and possibilities. Thanks Mom.

First published in 2006 by Motorbooks, an imprint of MBI
Publishing Company, 400 First Avenue North, Suite 300,
Minneapolis, MN 55401 USA

MBI Publishing Company titles are also available at
discounts in bulk quantity for industrial or sales-promotional
use. For details write to Special Sales Manager at MBI
Publishing Company, 400 First Avenue North, Suite 300,
Minneapolis, MN 55401 USA

To find out more about our books, join us online at
www.motorbooks.com.

ISBN-13: 978-0-7603-2399-1
ISBN-10: 0-7603-2399-2

Editor: Peter Schletty
Designer: Chris Fayers

Printed in Singapore

On the cover, main: Painting a photorealistic portrait is one
of the most challenging projects an airbrush artist can
undertake. **Inset:** Painting soft highlights in a graphic. Before
spraying each highlight, the spray of the airbrush is tested on
the stencil material off to the side.

On the title page: Airbrushing a flower is one of the easiest
things to paint, yet the use of multiple masks results in
surprisingly detailed results.

On the back cover: In this mural, accurately painted surface
textures combine to create a dimensional image.

CONTENTS

Acknowledgments .6

Foreword .6

Introduction .7

CHAPTER 1: The Basic Equipment .10

CHAPTER 2: The Basic Tools and Supplies24

CHAPTER 3: Airbrush Theory and Preparation 40

CHAPTER 4: The Basic Movements: Learning to Use Your Airbrush48

CHAPTER 5: Using Frisket Film and Other Tricks58

CHAPTER 6: Metal Surface Texture Effects65

CHAPTER 7: Working with Stencil Layers80

CHAPTER 8: Airbrushing a Wolf .87

CHAPTER 9: Creating a Vector Drawing and Using a Plotter100

CHAPTER 10: Using Complex Stencils: Airbrushing on a Guitar112

CHAPTER 11: Using Liquid Frisket or Spray Mask132

CHAPTER 12: Airbrushing an Eagle .143

CHAPTER 13: Painting Skin Tone and the Human Face152

CHAPTER 14: Troubleshooting and Care of Your Airbrush183

Appendix: Airbrush Resources 189

Index .190

ACKNOWLEDGMENTS

Big thank you to Peter Schletty and Darwin Holmstrom for all their help.

Big thank you to Dan-Am SATA USA. Their spray equipment makes my life easier and they are wonderful people.

Jim Bortles, my husband, thanks for putting up with me.

And more thanks to Knut and Bent Jorganson, Tony Larimer, Gary Glass of Iwata Media, Steve Augers of Bear Air, Dave Monig of Coast Airbrush, Dru Blair, Allan Edwards, Click Baldwin of Carolina Harley-Davidson, Grandma's Music and Sound, Tim Drennin, Paul Camesi, Lindsey Beattie, Wayne Springs, Jimmy Springs, Kevin O' Malley, Sheri Tashjian Vega, Ginny Ross Jefferies, and MaryAnn Surette Beattie.

And to my dad for buying me that first airbrush.

FOREWORD

Working in the world of custom automotive painting, a field traditionally dominated by men, JoAnn breaches many barriers with her savvy, yet practical approach. She marries the task of creating beautiful automotive airbrushed graphics and artwork with real world experiences in an intelligent and straightforward manner to which many people can relate. Although she instructs with automotive custom painters in mind, JoAnn provides a lot of useful information beneficial to everyone interested in airbrushing.

Working without the benefit of a mentor, JoAnn was often forced to experiment with the medium for herself, and in doing so invented solutions to custom painting that, while often unconventional, yield outstanding results.

JoAnn takes life's lessons and applies them to custom painting, and vice versa. Her techniques allow anyone, male or female, young or old, to comprehend and succeed in the world of custom paint.

If there is one lesson to be learned from JoAnn's experience, it is that tenacity is a major component of success. In many circumstances, her staunch refusal to give up has allowed her to discover unique solutions to the many challenges associated with airbrush artwork.

Dru Blair
www.drublair.com

INTRODUCTION:
The Reality of Working
as a Non-Starving Artist

Imagine New York City, 1978, Times Square. It was very different than it is now. Not the glittery polished high rise theatre/hotel district it has become. It was dirty, nasty, and smelly, with discount electronic and porn stores on each block screaming out at you. Pre-Giuliani NYC. You could not walk down the street without being accosted by some scammer begging for money or "just a minute of your time." Now imagine a dingy, rundown boarding house one block down from that Times Square. That is where many of the paintings you'll see in this book were painted.

I was a young idealistic, yet jaded, dreamer going to Parson's School of Design. I worked a few blocks down the street tending bar. My dad had bought me a Paasche H single-action external spray airbrush. I had only one window in that room which overlooked the wall of the apartment building next door. Not very inspiring. But my mind was back in the world of a 1970s gearhead and my paintings

reflected that. Any spare moment I had, I went back there through my art. And much of it was done with that little airbrush and cans of compressed air.

One of my greatest thrills was going to the big Charette Art Store in Woburn, Massachusetts, with my dad. We'd roam the isles, seeking out the few treasures my dad could afford to buy me, such as wild ink colors like Dr. Ph. Martin's Lake Scarlet watercolor. Over the years, the airbrushes improved as well as my airbrush technique. But somewhere along the way, I got lost. The Pink Floyd song that talks about having a look in your eyes, like black holes in the sky, very aptly describes the pitfalls of trying to be a working artist.

Writing this book has been a very different experience than the three previous books. It has been a trip through the past. I had to dig out artwork I had not seen in over 20 years. I found paintings and drawings I had thought were long gone. I showed some of it to visitors to my studio and

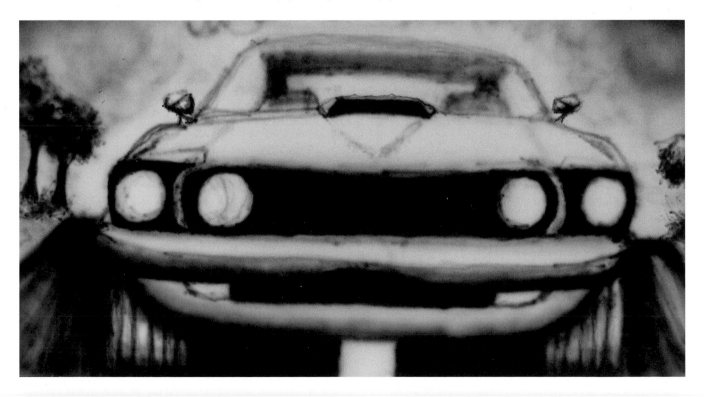

One of those early Times Square airbrushed paintings, 1978.

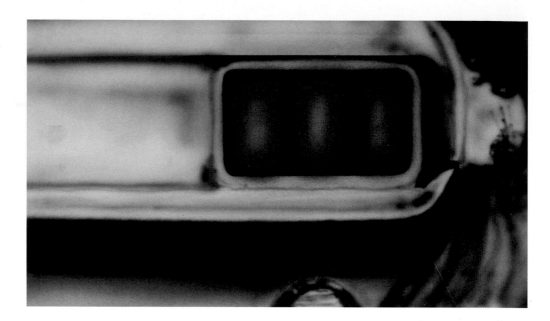

View from the rear of a 1970 Mustang heading down the road, 1978.

they were amazed by the rawness yet fire present in that artwork. Looking through all the older artwork, I was reminded of how I felt about art way back then, when I was young and full of hope. I painted and drew things that I lived for: my friends, my cars, my dreams. Back then I did not worry about painting things that were commercially viable. I painted for the love of it, not for the money.

Back when many of these early paintings were done I worked many various jobs: truck driver, airport services, welder, machine operator, bartender, even at a fast food joint. Note that artist is not listed. I did not become a full-time artist until much later in life, although I had tried several times. But art is not an easy gig. It takes real discipline, and for many artists, myself included, discipline is not one of our strong points. We are dreamers, and if we have a week of no clock punching, it is all too easy to get lost in the beauty that inspires us to paint. I would spend a morning, down at the Connecticut River, soaking up the wonder of its timeless atmosphere, and then sit down to paint, rather than spend the morning and afternoon painting and working.

Being a full-time artist is much more than painting. It is dealing with customers, paying bills, scheduling work, typing quotes, answering the phone and emails, running errands, scrambling when things go wrong, cleaning, grunt work. Most of the time the art business is the cold, harsh reality of real business, rather than that idealistic world we see in our paintings.

And so like many artists, I got farther and farther away from the factors that were present in my earlier artwork. I now had to paint what customers wanted. I had forgotten those passions that drove me to paint Mustang picture after Mustang picture years before. Yes, I was very into early Mustangs.

Driving fast and spending time with friends was what I lived for 30 years ago and my artwork reflected that. And along the road over those years, I have gotten farther and farther away from painting my passions, although, along the way, those passions did change. Yet my paintings now do not reflect my passions much of the time. And herein lies the problem.

Most airbrush books deal only with the technical end of airbrushing. They don't address the psychological problems we deal with. Being an artist is stressful enough. But being an airbrush artist is far worse, because in addition to handling the problem of artistic stress, there is a huge mechanical factor involved due to all the problems that crop up whenever any kind of machinery (airbrushes, compressors, computers, etc.) is used. So in this book, I try to include ideas to deal with the emotional problems of airbrushing as well as the tech end.

So for new artists, I want you to look at the crudeness and roughness of my early work and compare it to how refined and polished my artwork has become. It was a long, long journey from the shaky lines on those Mustang paintings to the sharp ones in the Stevie Ray Vaughan bike tank. I didn't pop out of the box painting straight smooth lines. It is so easy to get discouraged, as you are not only dealing with learning a new craft; you are also learning how to deal with all the equipment problems that crop up.

For experienced artists who may read this book, use it to rediscover the passion that you may have misplaced along the way. Go through your old artwork, even the stuff you did as a teen or child. For every airbrush artist that is successful, there are many more who have given up. Their love for the craft extinguished by bad experiences that smothered what used to drive them to paint. For example, as I write

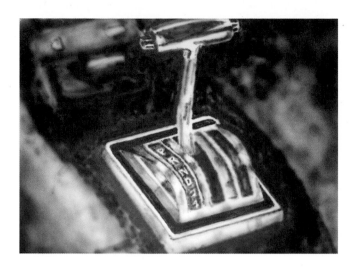

Painted in 1978, this is a gearshifter from a 1970 Mustang—my earliest attempt at metal-effect. Compare this to what you see in Chapter 6. My metal technique has come a long way indeed.

Painted in 1979. One of my favorite paintings, but no one else seems to get it or like it. It's a very fine pencil drawing, but I airbrushed the taillights lit up in red. It never mattered that no one liked it. I painted it for me and I still love it.

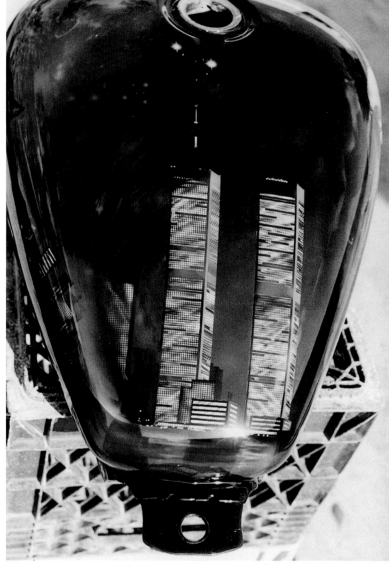

World Trade Center mural on Suzuki tank done in 1996. Paint was airbrushed through screen mesh to create the windows.

this, it is Sunday. I was enjoying a quiet morning of reflection and then the studio phone rang. It went to voice email, but it still took away the peaceful ambiance of where my mind had been. Reality barging in. This is the downfall that kills the passions we felt as young artists.

I think about that young 18-year-old girl, sitting on the floor in that nasty room in NYC, creating artwork fueled by passions she was completely unaware of. Only recently did I become reacquainted with that young artist I used to be. Maybe this time, I won't lose her. Maybe the trip I took in writing this book will not only help other artists, but will help me redirect my journey. The artist that reaches a point and says, "that's it, I'm here," is missing out on the best part.

They are stuck on the road. Art is a journey that begins at birth and ends at death. Do I want to know what lies ahead in my journey? No. And neither should you, because that is what fuels the passion and keeps it alive. Take the time to enjoy the journey. Unplug the phone for at least one day each week. Unplug from the world at large and live in your art. Go to those places that only your art can take you. And if your airbrush or other equipment breaks down along the way, take a deep breath and hope that you thought ahead to have a good spare packed in the trunk. It's a rollercoaster ride. Know that there will be lows along with the highs and plan accordingly. Don't get lost like I did.

CHAPTER 1
THE BASIC EQUIPMENT

Airbrushes work on a very simple principle. Compressed air is driven through a hose and into a tool that holds a pressure valve. The valve opens and closes, which draws paint material up through another valve, then into a nozzle where the paint mixes with the air and is propelled forward. Varying the elements of this equation determines just how the air/paint mixture is controlled.

The two main factors that affect controlling the mixture are the makeup of the airbrush and the thickness of the paint. For thicker paint, more air pressure is required for optimum atomization, or the conversion of fluid paint into a fine spray or mist. Higher air pressures (40–100 psi) will spray a finer paint pattern than lower air pressures (10–40 psi).

First off, let's go over the different types of airbrushes, from the simplest to the most complex. Airbrushes are divided up into two groups: external-mix and internal-mix.

EXTERNAL-MIX AIRBRUSHES

With this kind of airbrush, the paint and air are combined beyond the tip of the nozzle and outside of the airbrush. The paint is controlled by turning the round-knurled edge around the tip: turn forward to release more paint by opening the gap, and turn backward to close up the gap between the tip (the cone-shaped part) and the tapered needle valve, which is stationary. The tip basically fits over the tapered needle valve.

An external-mix airbrush, the Paasche HS#1 single-action.

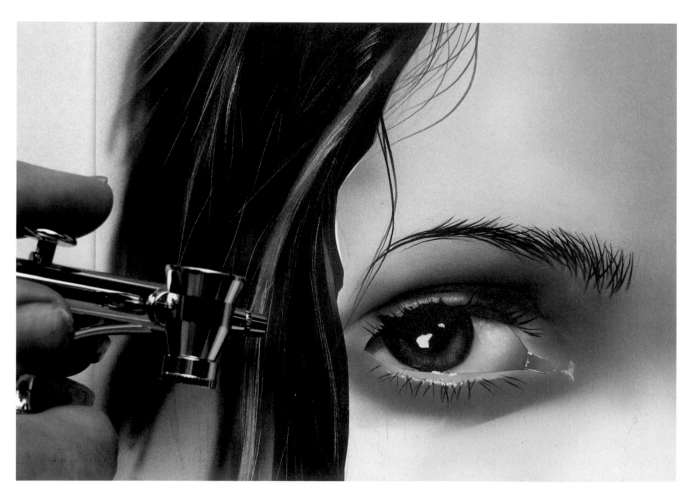

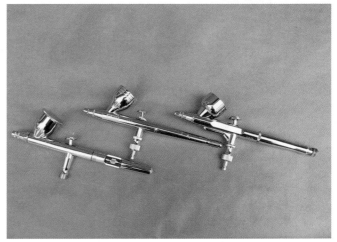

Above left: *The Richpen 013G, a single-action, internal-mix airbrush.* **Above right:** *A few different brands of dual-action airbrushes that I use and recommend, from left to right: Iwata Eclipse, SATAgraph 3, and Richpen 213C.*

This is a siphon-feed airbrush, which means it picks up the paint from a bottle mounted below the airbrush. The bottle's cap has a hose that fits inside a hole on the end of the needle valve. The air is controlled by pushing down on the trigger.

External-mix airbrushes are usually single-action models. Many beginners start with an airbrush like this because it is very inexpensive (less than $50). My first airbrush was an external-mix model.

SINGLE-ACTION INTERNAL-MIX AIRBRUSHES

Single-action means just that—there is only one element controlled by the trigger. The trigger is pushed down to release air. The external-mix airbrush keeps the paint outside of the airbrush body, but the internal-mix airbrush runs the paint inside the airbrush body. The tapered needle runs through the center of the airbrush body, through a hole in the trigger stem, and it seats into a tip that is precisely contoured to fit the end of the needle. This creates a valve that the paint flows through. The opening between the needle and tip is controlled at the rear of the airbrush by loosening a lock knob that the end of the needle passes through, adjusting the needle and then tightening the lock knob. Move the lock knob forward for a finer flow, or backward for a thicker flow.

Like the external-mix airbrush, the paint is still fed into the airbrush with a bottle, but now the hose fits into an inlet that projects from the airbrush body. The paint flows up into a paint chamber that is inside the airbrush, where it flows along the needle and through the tip. It mixes with the air in the tip and is atomized. The air is directed through passages in the airbrush body and into the airbrush's head. The head holds the tip in its center so that the airflow surrounds the tip.

Many new airbrushers start with a single-action airbrush because only one movement is needed to operate the airbrush. Less airbrush experience is needed to paint with a single-action brush. They also work well for repetitive use, such as for assembly line work. For situations that require less fine detail, such as taxidermy, handicrafts, and model painting, a single-action internal-mix airbrush can be ideal.

When you are considering what airbrush to buy, use common sense. You will want to think through many factors such as: How serious are you about airbrushing? Is this something you are merely curious about, or have you wanted to learn to airbrush for a while? Is this an artwork technique that you'll be sticking with? What kind of budget do you have to work with? Keep in mind, you'll be needing more equipment than just the airbrush. You'll need an air source (most likely an air compressor), hoses, the regulator, a fan or ventilation system to remove the paint fumes, and, of course, the paint. The costs do add up, so it is best to put some thought into the exact goals you have for airbrushing. Also, remember that it's very easy to upgrade your airbrush after you've become more experienced. You'll learn which airbrush works best for your purposes. The air system you choose will work with any airbrush, so don't be afraid to start with a less expensive airbrush and upgrade later. That way, you will have two airbrushes!

This is a cutaway view of a gravity-feed double-action airbrush, an Iwata HP-C. The red represents the paint. It flows from the color cup into a paint passage in the airbrush body, passes around the needle valve, and then flows into the tip. Note the chuck assembly behind the trigger; the chuck holds the needle valve. When the trigger is pulled back, the spring around the chuck gets compressed and maintains pressure on the needle so it can "spring" back when the trigger is released. The end of the airbrush or handle is actually a removable cover with a tailpiece that unscrews to allow access to the chuck assembly and needle valve. Air pressure comes up from beneath the airbrush and through a hose that connects an inlet on the bottom. The spring in the lower part of the airbrush keeps the pressure on the up and down movement of the trigger, which controls the air. The air passes into passages that allow the air to flow around the tip, where it meets up with the paint just beyond the end of the tip. Illustration courtesy of Iwata Media

DUAL-ACTION INTERNAL-MIX AIRBRUSHES

The trigger for a dual-action internal-mix airbrush has two functions. Not only does it control the air, the trigger also controls the paint flow. When the trigger is pushed down, the air valve opens and allows air into the air passages. Pulling the trigger back draws the paint material into the airbrush. The artist can separately control both the air and paint flows, based on the amount of pressure placed downward on the trigger and how far back the trigger is moved. These airbrushes allow the artist to continually adjust the amount of paint flowing through the airbrush with the slightest finger movements on the trigger.

Experienced artists can make countless adjustments in paint flow or spray patterns as they are working. The movements of the trigger are so slight, it would be hard for someone watching to even notice.

The first action is pushing the trigger down to release the air. The paint will not come out until the trigger is pulled back. The second action is pulling the trigger back to start the paint flow, while still holding the trigger down. The paint combines with the air, and as the trigger is pulled farther back, more paint can mix with the air and flow out.

This "push down and pull back" technique takes some getting used to. Its difficulty level is the reason many people don't recommend dual-action airbrushes for beginners. To learn the technique requires patience and practice, plus it can be very discouraging for new airbrushers because it is very hard to get good results immediately. Whereas with the single-action

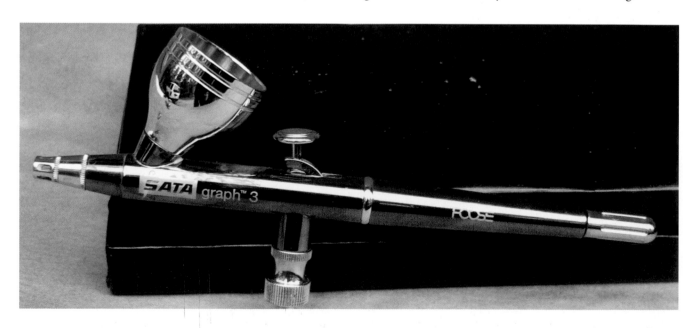

This is a gravity feed airbrush, sometimes called a top-feed. These are very popular for automotive airbrushing. The SATAgraph 3 is pictured here. This is the most popular style of dual-action airbrush.

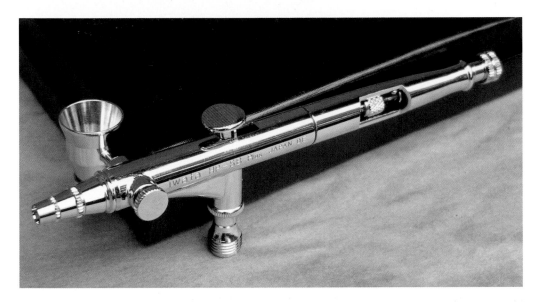

This side-feed airbrush is a big favorite of fine artists for super realistic airbrushing. The Iwata HP-B Plus is pictured.

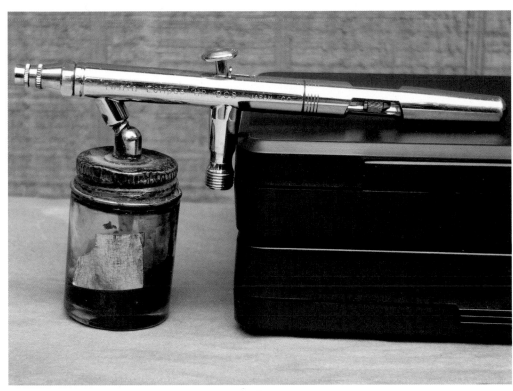

This is a siphon-feed airbrush, also known as a bottom- or bottle-feed. T-shirt airbrushers tend to prefer this airbrush because they use a wide variety of colors at once, and the bottle-feed makes it possible to quickly and easily change colors using one airbrush. Pictured is an Iwata Eclipse HP-BS.

airbrushes, immediate results are easier to get, as not as much trigger control is needed. Professional artists prefer to use dual-action airbrushes. With enough practice and use, movements that seemed complex will become second nature.

PAINT FEED STYLES

There are three different ways that paint gets fed into an airbrush: Top- or gravity-feed, side-feed, and siphon- or bottom-feed. Each kind has its advantages. Siphon-feed airbrushes use a capped bottle that is attached to an outlet on the underside of the airbrush body. The cap, which screws on the bottle, has a fitting that a hose slides over. The paint flows from the bottle up through the hose, through the fitting, and into the airbrush. The big advantage is that multiple bottles can be used, so the artist can easily change colors. Many different colors can be used with one airbrush, which is the reason a siphon-feed airbrush is a good, economical choice for new airbrushers. Most external mix and single action airbrushes are siphon feed. The nozzle sizes on siphon-feeds range from 0.1 to 0.5 mm. A

Many companies make an airbrush designed specifically for ultra-fine detail artwork. It can present a problem for thicker paints, such as some water-based automotive paints, unless the paint is drastically thinned down. SATA's SATAgraph 1 and 3 airbrushes are designed for these situations. SATA worked very closely with Auto Air Paints during the design and testing of these brushes. The result is a very unique passage from the color cup into the airbrush body that allows for a constant, even flow of paint. For use with Auto Air paints, the SATAgraph 1 or 3 with a 0.45-mm nozzle is recommended. The 3 also has an adapter that allows it to be used as a siphon airbrush. The adapter can be fitted right onto a bottle of Auto Air Color to pull paint directly from the bottle.

good, all-purpose size is a 0.35 because it can be used for a wide range of applications.

The side-feed airbrush has a cup attached to either side of the airbrush body. The cup can be rotated to any angle, which allows the artist to work at odd angles. The big advantage with this airbrush is that it uses a very small amount of paint. This is due to the fact that the color cup is smaller and located so close to the head of the airbrush. Very little paint is needed. It's a great choice for fine detail work like photorealism, where the work proceeds slowly and the colors are changed frequently. Nozzle sizes for this airbrush tend to run from 0.10 to 0.35 mm.

Gravity-feed airbrushes are the most widely used airbrushes. It is the best all-purpose airbrush because it can be used for fine detail and overall work. The gravity system of paint flow tends to give a better flow when using very fine

All the airbrushes I use for motorcycle painting are gravity-feed. Since automotive paints are thicker than many other artists' paints, the gravity-feed provides the consistent flow needed for the fine detail.

tips and needles, which is why most artists prefer to use gravity-feeds for ultra-fine detail work. The airbrushes do not tend to clog, but care must be taken to use the cover caps so that paint does not spill out of the color cup. The cap is pressed onto the color cup, and the brush is basically spillproof. Most dual-action airbrushes on the market are gravity-feed. Nozzle sizes range from 0.10 to 0.35 mm.

In this book, I'll be using a dual-action gravity-feed airbrush for all the exercises. For serious artists, I recommend starting out with a dual-action airbrush because this is what an artist will eventually be using. Dual-action airbrushes can be found for very low prices, so most people can afford them.

I've used inexpensive dual-action, siphon-feed airbrushes for many years and have done some amazingly detailed artwork with them. Most of them cost less than $75. Iwata's Revolution Series of airbrushes feature dual action, yet they are all priced well under $100. They also come in both gravity- and siphon-feed styles. Dual-action airbrush prices can range from $50 to over $300, so do research online or at the art supply store before you make a decision. Eventually, if you stick with airbrushing, you'll be using the higher priced airbrushes because they have the features that experienced artists require. I started out with a $30 Paasche HS and quickly moved up to a $50 Badger 150. I now use airbrushes that range in price from $200 to $400.

Go online and look over the selections on the airbrush pages. You'll see the many choices available for most price ranges.

Another style of airbrush is a pistol-grip airbrush like the Richpen GP-2. For artists or painters used to spray guns, this style of airbrush may be easier to use since they are already familiar with the trigger action.

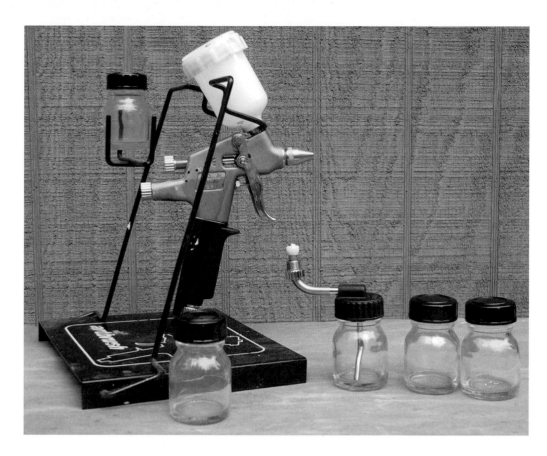

This is the SATA dekor artbrush. It has its own stand that also holds the gun when the siphon-feed bottle is attached.

AIRBRUSH MAINTENANCE

All kinds of things can go wrong with airbrushes, but dried and clogged paint is usually the biggest problem. Know your airbrush. Learn how to take it apart and thoroughly clean it with whatever cleaner is designed for the paint being used. For automotive paint, use lacquer thinner. For water-based paint, use water. Some paint companies sell specialized cleaners for their paints.

I remove the needle and use quality cotton swabs to clean out the color cup on my gravity-feed airbrushes. Little round-bristled brushes can also be used to clean out passages.

See Chapter 14 for detailed information on how to clean and maintain your airbrush.

SPRAY GUNS

While airbrushes will take care of most detailed airbrushing, there are occasions that will require larger applications of paint. Wall murals, and some artwork done on cars, need tools that will apply paint evenly over large surface areas. Also, in many situations, such as automotive paintwork, clear coat will need to be applied over the artwork with spray guns to protect it. Spray guns come in different sizes to accommodate various needs, but they require higher air pressures than airbrushes. It is important to consider the required air pressures when choosing your air compressor.

The SATA dekor 2000 artbrush is very similar to a single-action airbrush, but it has a pistol grip or spray gun trigger. For me, it works fantastically for shading in larger areas like painting flames.

Another feature of the dekor artbrush that I love, in addition to using a gravity-feed color cup, is that it also comes with siphon-feed capped bottles that fit onto a tube.

One thing I love about the SATA artwork system is its quick-disconnect hoses. You can quickly switch from the dekor artbrush to the SATAgraph airbrush.

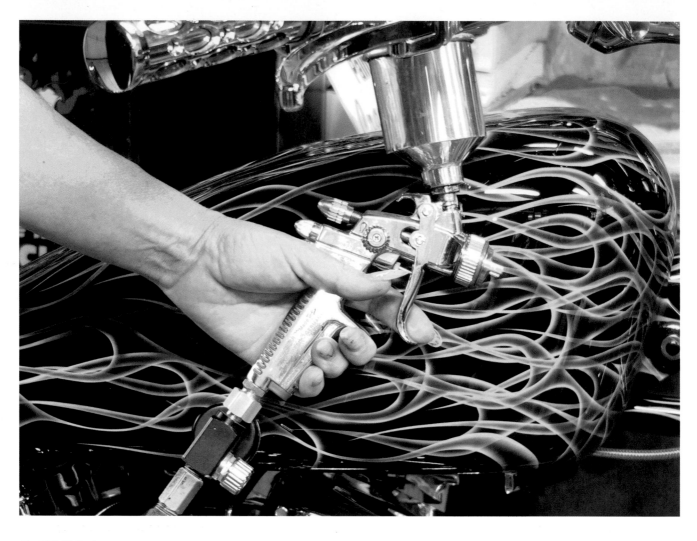

The SATA Minijet 4 spray gun.

The tube threads right into the same fitting as the color cup. This design allows the artist to easily change colors while working by switching bottles.

The dekor kit includes the bottles, fittings, and color cup. The kit retails for around $350. It is lightweight, easily maneuverable, and the perfect complement to any airbrush—a happy medium between a mini spray gun and an airbrush. The SATA dekor artbrush has a wide range of nozzle sizes from 0.2 to 1.0 mm. It is incredibly effective for airbrushing flawless fades.

For some larger surface areas, a mini spray gun might be needed, especially if painting wall murals, cars, or

Know your needs. Keep in mind that less expensive equipment will not hold up over time, but that quality tools cost more. If you are serious about airbrushing, look over your needs and design a budget based on the equipment that you need most. For example, a high-quality air compressor paired with several high-quality airbrushes and spray guns will last for years. If the budget is tight, try getting one good, quality spray minigun and a cheaper, larger spray gun, and pair it with one high-quality and costly airbrush. But if you are simply trying out airbrushing and not sure if you want to do it indefinitely, a less expensive airbrush and spray gun paired with a good-quality compressor should work just fine.

For the serious commercial artist, the last thing you want is equipment failure in the middle of project. If your equipment does fail, it will happen at the worst possible time such as on a Friday afternoon just before everything closes for the weekend. And the customer will be expecting to pick up the job on Monday morning. So, take that $200 or so that you were planning to blow on a weekend out on the town, and spend it on equipment instead.

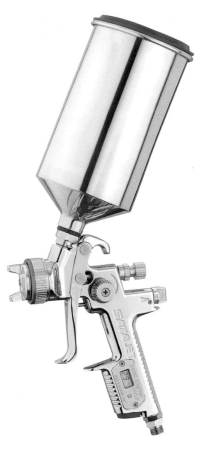

The SATAjet 2000 HVLP spray gun.

This is my homemade setup. I run five airbrushes and use a Binks regulator that is located within five feet of my airbrushes. A filter or water separator is mounted farther back with about three feet in the airline to keep out any moisture. I use a homemade air manifold made out of pipefittings. There are commercial manifolds on the market, but these tend to be pricey. A little common sense goes a long way. At some discount stores, you can find aluminum blocks with quick-disconnect fittings already installed. If you go to most quality auto parts or hardware stores, you can go through their air hose or pipefitting trays. Take along the fittings for your airbrush hoses and design your own setup.

motorcycles. It works great for spraying base coats on motorcycle sheet metal or bicycle frames, and backgrounds on wall murals or large paintings. I use a SATA Minijet 4. It is an HVLP spray gun, which means it is a high-volume, low-pressure gun. It will spray at low pressures, about 10 psi at the air cap, which minimizes overspray. This means that less paint goes into the air, and more material lands on the surface. The Minijet 4 can be fitted with nine different nozzle sizes from 0.3 to 1.1 mm. I use a 1.0, and I can adjust the circle pattern from a small spot to over a foot wide. They are also designed for water-based paint. The paint needle and nozzle are made of stainless steel, and the nickelplated gun body has been refined with a special coating. It is a very durable gun and with proper care will last a lifetime. It retails for about $300. There are many different brands and types of miniguns to choose from depending on your budget and your needs.

For covering the largest areas, an automotive spray gun is preferred. There are countless brands of guns. I use HVLP guns from SATA. I like the way HVLP guns really break up the paint. For water-based paints, HVLP is a must. For most airbrush artists, this is an area where the artist needs to know his or her needs. For auto painters and

OK, this is very important! Do not use automotive water-based paints, like Auto Air, in airbrushes and spray guns that have been used with solvent-based paints. Solvent-based paints and thinners will contaminate the paint passages so that they will not react well with the water-based paint. If you want to use a product like Auto Air, it is best to designate a gun and airbrush for Auto Air use only. I highly recommend Auto Air because it is a great product. However, to get the intended results, it must be used correctly. More information on automotive water-based paint is in Chapter 2.

This air manifold is available at Bearair.com. It comes with choices of 4, 8, or 16 air outlets and retails for $49 to $99. It's a good choice for those who are not mechanically inclined, or do not have access to good hardware stores.

wall mural artists who paint a large volume of work, a high-quality gun is needed. For occasional use, a less expensive gun will work fine.

AIR REGULATORS

Not all artists recommend air regulators for airbrushes. I do. Many air compressors come with a regulator. A quality air regulator will maintain constant pressure in your airline, and this regulator needs to be located within 10 feet of your airbrushes. Why is that necessary? If the regulator is too far away, or if a small or cheap regulator is used, pressure can build up in the line. Then when you press down on the airbrush trigger, all that air will rush out until the line pressure equalizes to the desired level. It's very annoying. The Binks regulator I use is heavy duty and meant for use in a body shop. It costs about $53 and less than 5 feet of hose length runs between it and my airbrushes. The setup allows very accurate and consistent air pressure, which translates into better control while airbrushing fine detail.

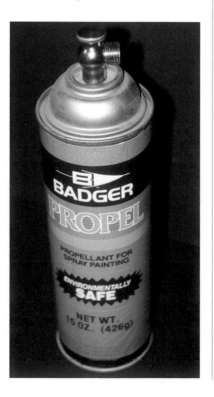

Badger's Propel with screw-on adapter valve attached to the can.

Canned air propellants and CO_2 tanks cannot be used with spray guns. Large volume spray guns will quickly empty a tank of its air pressure.

AIR SOURCES

The first thing to consider when deciding on an air source is the type of equipment you will be using. Will you stick with only airbrushes and maybe a mini spray gun? How much air brushing will you be doing? Do you live in an apartment? Will noise bother the neighbors? And again, how serious are you about airbrushing? How much can you afford to invest in equipment? An air compressor is easily the single most expensive piece of equipment you'll be buying. So take these air sources into consideration before making a decision.

To get the most effective result out of your airbrush, air pressure is everything. It sounds like it would be fairly obvious, but insufficient air pressure is one of the biggest causes of airbrush problems. Air line pressure must be consistent for an airbrush to work properly. The air pressure at which the paint is sprayed (psi = pounds per square inch) determines the fineness of the paint pattern (or how grainy it appears). As I've mentioned, thicker paints require higher air pressures. In order to evenly cover large surface areas, high air pressure is also needed. Let's start out with air sources for hobbyists and work our way up to the big stuff for commercial shops.

Canned Propellants

Small, compressed air canisters were my first air source when I started airbrushing. The canisters can be used for small or simple projects, and they work great for places where no electricity is available. They're also good for an artist who wants to try out airbrushing, but doesn't want to invest in a compressor.

While canisters are convenient, they are the most expensive air source for long-term use. They run down rather quickly, and once the can is empty, it cannot be refilled. The cans usually contain about 10 to 15 ounces and cost from $5 to $10.

You'll also need a small pressure valve that will attach to the airbrush hose, and the hose screws into the top of the can. A knob on the valve is opened, and the air flows out of the can and into the airbrush hose.

Compressed Air or CO_2 Tanks

For airbrushing on a small to medium basis, CO_2 tanks are a great choice. Like the canned air propellant, no electricity is needed, and they are quiet. There's no noise to bother that

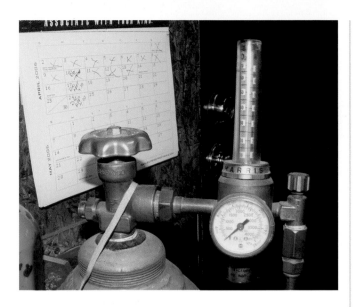

The top of a CO² tank with a welding regulator.

pesky neighbor in your apartment building or condo. For airbrushing on location, say at a festival or flea market, they are ideal. The tanks aren't expensive, and large tanks last for months when they are used with a single airbrush. The tanks come in different sizes, so if you live in a second floor apartment, a smaller tank can easily be carried up the stairs.

It's a simple matter to find the tank that will meet your airbrush needs. A 20-pound tank will work fine for most situations. The amount of pressure being used and the frequency of airbrushing will determine how long your tank will last. For fine art that uses low pressure, a tank might last a month or so. For airbrushing T-shirts all day, where you're constantly working, it may last only for that day. You can either buy or rent a tank. Renting will cost about $50 per year. Buying a tank can cost around $200, but then you own it. Filling the tank with CO_2 will run about $20 to $25. Since the gas contains no water vapor, a water trap is not needed. The tank will run out, but it is easy to get it refilled or drop it off in exchange for a full tank.

A CO_2 tank will require a welding regulator to control the air pressure. These regulators cost about $65 to $75. A full tank will contain up to 1,200 pounds of pressure. Regulators designed for electric air compressors will not endure that kind of air pressure and can, in fact, be dangerous. Welding regulators have very small orifices that only let a small amount of gas through. Yet, airbrushing uses far more gas than welding.

Once the regulator is securely threaded into the outlet on top of the tank, attach the airbrush hose to the outlet end of the regulator. Only open the valve on the tank a small amount so that the gas is pre-regulated before entering

the regulator. Then use the regulator to adjust the amount of pressure required for your airbrush. Check for leaks—you may need to wrap Teflon tape around the threads of the fittings. If you are using more than one airbrush at a time, ice will tend to build up on the regulator. A clamp light with a 100-watt bulb can be used to heat up the regulator and prevent ice buildup. Be sure that the light does not allow the regulator to get too hot, or it could cause damage and create a dangerous situation. Simply direct the light at the regulator, and up to eight people can airbrush at once using one CO_2 tank.

Always make sure the tank is secured so it cannot fall over. Larger sized tanks can be very heavy and cause damage if they fall over. Always remember to turn off the tank valve when you're done airbrushing because the tank will leak down quickly if the valve remains open for long periods of time.

COMPRESSORS

This is not the place to attempt saving money. I cannot say enough about buying a quality compressor. Unlike an airbrush, there are many moving parts that can wear out or break at the worst possible time. Evaluate your budget and needs so that you can make the best possible choice. I've had air compressors that last for years and others that barely lasted one year. Bargain compressors are usually no bargain. When the noise from a compressor is about to drive you or your neighbors insane, you'll wish you'd done more research and spent the extra $100 or so to purchase a very quiet air compressor.

Carefully look over the details of the compressor that you plan to buy, and make sure it has the features you need. Go online and do research. Companies are always advancing compressor technology, so what was out of reach pricewise last year, could suddenly be affordable this year. There are several styles of air compressors to consider.

Diaphragm Compressors

These compressors use a reciprocating diaphragm to pump air into the air system. They are the least expensive kind of compressor and can be bought at most hobby shops. They

No matter what type of compressor you get, read the manual. Make yourself familiar with the different parts, the recommended maintenance, and how to properly use it. Lots of moving parts mean many things can go wrong. I know it may sound overly cautious, but don't learn the hard and costly way. Read the manual before the compressor is turned on.

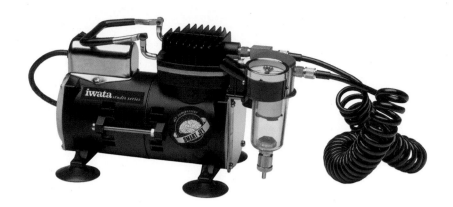

Iwata's Smart Jet model of piston air compressor. This style has no storage tank, yet it has an oil-less design, a water trap, and a pressure gauge. This is the least expensive style of piston compressor, with some brands and models starting at $200.

work great for small projects that require less than 45 psi. They are not suitable for projects that require large volumes of air or nonstop airbrushing.

Some models have a storage tank, and some do not. Models without a storage tank will run constantly. Air is replaced at a slow rate, and only one airbrush at a time should be used with a diaphragm compressor.

These compressors can be pretty annoying, because many are loud. Most compressor companies have switched over to piston-driven compressors. Even small, single-airbrush compressors that retail for less than $200 now feature a piston-driven design.

Piston-Driven Air Compressors for Airbrushing

With this kind of compressor, a piston inside an air-cooled cylinder is driven by an electric motor. The air leaves the cylinder and goes to a storage tank. After the pressure inside

the tank builds up to a certain psi, an air-pressure sensor switch will automatically switch the compressor off. The air is warm as it enters the tank, and as it cools off, condensation quickly builds up. A quality filtering system must be used in order to remove any oil or moisture that builds up. Water from this condensation runs to the bottom of the storage tank, and it is drained out by opening a valve in the bottom of the tank.

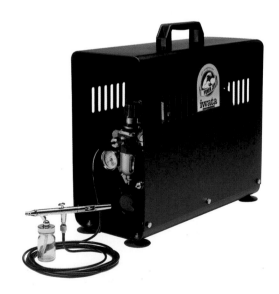

Iwata's PowerJet compressor features a storage tank and it is oil-less. It has dual pistons, puts out about 70 psi, and can run two airbrushes. It features an air pressure gauge and a water trap, and it retails for around $640. Compressors with storage tanks shut off automatically when the pressure in the tank builds up to a certain psi. Piston air compressors with storage tanks do not run constantly and are priced from $300 to $700, depending on the size of the storage tank.

WHAT TO LOOK FOR WHEN BUYING AN AIR COMPRESSOR:

- How much pressure does it produce? (one airbrush: 30 to 40 lbs; two or more: 70 to 114 lbs)
- What is the horsepower? A big tank needs a 5-horsepower or more motor. Smaller tanks require less.
- Is it oil-less?
- Is it silent? What are the decibels it produces (noise level)? Over 55 decibels is pretty loud.
- What kind of vibration level does it have? You want it to be low.
- Does it have a replaceable air filter? Does it even have an air filter?
- Does it have a moisture trap, a regulator, and a bleeder valve? (Tank models only.)

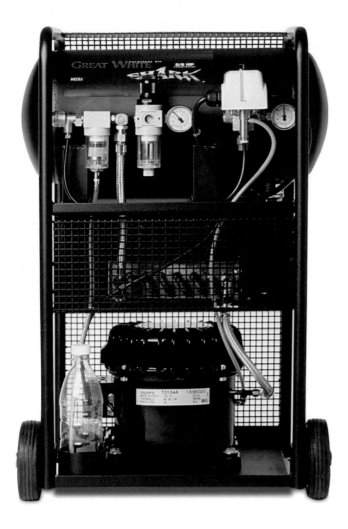

Iwata's Great White Shark compressor. This piston-driven compressor is from their line of silent compressors. It puts out about 114 psi and can run up to four airbrushes at once. It is a good air compressor for small retail airbrushing shops, such as T-shirt shops. It has a 4-gallon storage tank and comes with oil and water filters, and a pressure regulator already in place. If possible, when shopping for compressors, look for one that has these features so that you can take the guesswork out of setting up your air system.

Some of my compressors have lasted for more than 10 years, but overworked compressors will not last. A piston-driven compressor cannot run constantly or it will overheat and damage the internal components. Check your air line and hookups for leaks and if you hear air hissing out, even if it's a small amount, get out the Teflon tape to repair those connections.

Other ways to prevent overheating:
- Be sure that your compressor is a good match for your needs. Do not overwork a small compressor when a larger one is what you really need.
- Make sure your compressor has an automatic shutoff switch that turns off the motor when the tank pressure reaches a certain psi. On some compressors the automatic shutoff can be adjusted, but most of the time these are preset at the factory and should not be tampered with. Changing it can result in damage to the compressor or ruin things around it, including the artist.
- Some compressors have a high-temperature limit safety switch. This will immediately shut off an overheated motor if it has been overworked or operated on low voltage. The motor will not run again until it has cooled.
- Lastly, make sure the compressor is properly plugged in. If possible, plug the compressor directly into an outlet. If you have to use an extension cord, make sure it is heavy duty and designed for this kind of use. Not only will a proper plug give you better results, it is also a safety issue. When choosing your compressor, look at the plug. Some large piston-driven compressors need a 220 outlet, like the kind a dryer uses. Know if the compressor you're about to buy is 110 (regular household outlet) or 220.

As these compressors get more use over time, seals and rings on the piston wear down and result in more oil entering the air system. Oil contaminates paint and the painted surface, so don't try and save money by skimping on a quality filtering system. By now, many of the compressors by Iwata, Polar Bear, and some models of Silentaire, feature an oil-less design. So look for that feature when choosing an airbrush compressor.

There are two styles of piston-driven compressors; one style is designed specifically for airbrushing only, and the other style is designed for use in garages and bodyshops to operate air tools and spray guns. Iwata, Silentaire, and Bad-ger are just some of the brands out there that are designed for airbrushing.

Many of these larger piston compressors are "silent" compressors and are available at art stores and online. But they can be pretty pricey, with many costing $1,000 or more. These compressors are not designed to run air tools like grinders or buffers.

Airbrush and Custom Paint Shop Compressors

For most automotive airbrushing, you will need a piston-driven compressor with a motor that is 1 horsepower or more, as higher pressures will be required to operate spray

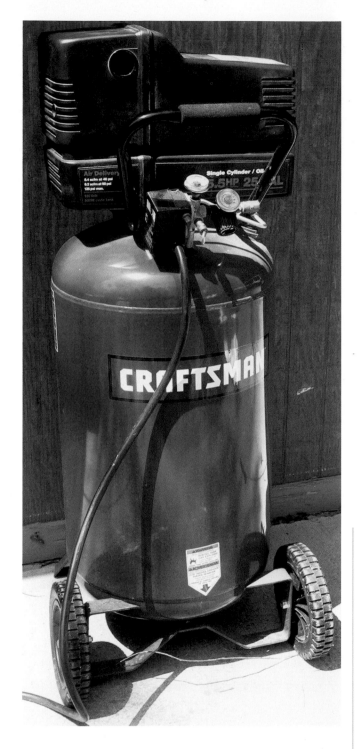

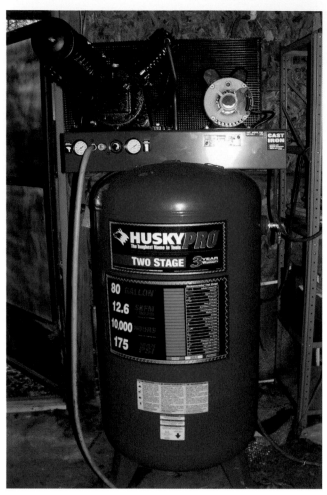

This is the two-stage, piston-driven air compressor that I use. Instead of one cylinder, it has two. Two cylinders allow for the compressor to provide air more quickly. The large storage tank means I can airbrush for over an hour before the motor turns on again. For my shop, this is a great choice because I can do just about anything with it, including run air tools like grinders and buffers. There is never a shortage of air. Most airbrushers will not need a compressor this big. They run about $800 to $1,000 at discount home improvement stores.

This Sears Craftsman single-stage compressor is designed for the small shop. It features a 5.5-horsepower motor. It will run spray guns, grinders, and, of course, airbrushes. A small compressor like this is a good choice for the automotive custom painter who does not run air tools like grinders and air wrenches every day. These single-stage compressors range from 2 to 5 horsepower. The prices range from $300 to $500. Many come with a pressure regulator, but I recommend also adding a water trap. Many of the newer models even feature an oil-free pump, which means not having to change the oil.

guns. These bigger compressors are like cars because they must be serviced; piston-driven air compressors need regular maintenance. If this maintenance is ignored, your most expensive piece of equipment will not last long. A good compressor should last for years.

What is the most forgotten maintenance for any air compressor? Draining the water from the storage tank. A compressor that is used for a whole day to run air tools and paint guns must be drained at the end of each workday. Compressors used mostly for airbrushing should be drained several times a week. One sign that a compressor needs to be drained is that it comes on more often than usual. Water is taking up space in the storage tank where air would normally be.

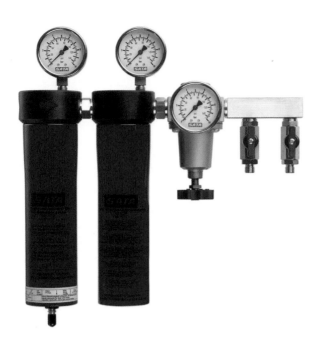

For the larger compressors that do not come with regulators and filters, you will need to install them no more than 50 feet away from the spray gun, or 10 feet for airbrush setups. SATA's 0/444 modular system of lined-up filters makes it easy. The first filter pre-cleans down to five microns. The second stage filter goes down to 0.01 microns. The setup even includes two outlets; there's one for your gun hose and one for an air-supplied respirator.

The heat from a running compressor will cause moisture to build up, and an overheated compressor will superheat the air. This super-hot air will not allow water drops to form, the moisture will not be trapped in the water separator, and it will pass into the airline where it will cool and build up. This water will eventually find its way to the end of the airline and spit out of the airbrush or spray gun at the worst possible moment.

Regular oil changes are also needed if the compressor pump runs oil to lubricate it. It is just like a car. The user's manual will explain how to change the oil (where the drain plug is, how much of what kind of oil, where to pour it, etc.). The air filter also needs to be blown out occasionally. If the filter is stiff with age or full of crud, it should be replaced. Many times a hard-to-diagnose problem, like the compressor making an unusual noise, or sounding like it's working too hard, can be traced to an air filter that needs to be replaced. So, buy a pack of two and keep a spare handy. These filters are very inexpensive.

Piston-driven compressors with motors that are over 1 horsepower are loud. Very loud. Compressors like the small, red, 5.5-horsepower compressor in the picture are actually louder than the big, red 7-horsepower one. If you live where the noise will bother your neighbors (or you), careful considerations must be made regarding your compressor selection. Since I've been around auto shops my whole life, I know it's such a relief when the compressor stops running, and you can talk again or hear or think. My big compressor is located in a barn, on the back of my property, that is about 200 feet away from my house. The air runs through an underground pipe to my shop and studio.

FILTERING EQUIPMENT
Hoses

Most airbrushes come with hoses. Braided nylon hoses are easier to handle and more durable than thin plastic airlines. For most projects, a 10-foot line is plenty.

For large projects, such as working on a car, you have two options. You can set up your airbrushes and regulator on a cart and run a shop airline to it. Or, for projects such as wall murals, you can add more hose using quick-disconnect fittings.

Lighting

Good lighting will save your sanity. I know this from experience. I use two clamp-on lights with one to the left of me and one to the right, both pointing at my work. One has a spiral fluorescent natural light bulb in it. The other has a 100-watt incandescent bulb. The overhead light in the room also has a spiral natural light in it. Between the three lamps providing two different kinds of light, I can really see the whole surface I am working on because there are no shadows.

One shop expense many artists don't think about is how much it will cost to run your compressor. Big compressors that have 1 or more horsepower will use more electricity while running compared to a smaller compressor. Most compressors will use about the same amount of power as running a clothes dryer. If you have any doubts about how much power your compressor will be consuming, turn on your dryer and then go outside to look at the electric meter. How fast is it spinning? Now turn off the dryer, turn on the compressor, and look at the meter. You'll be surprised to see how fast the dials turn or spin. Lighting, ventilation, and air pressure all use power. Go over your needs carefully before deciding on the airbrush system you wish to purchase.

CHAPTER 2
THE BASIC TOOLS AND SUPPLIES

As you develop your airbrush techniques, you'll find that other tools will come in handy. Some things you'll buy and seldom use. Some of them are tools I cannot live without. Others are things that other artists prefer. Each artist will discover his or her favorite tools as airbrush technique experience builds up. In this chapter, I go over many different tools and supplies.

BASIC TOOLS

Cutting rails allow the artist to make smooth, straight cuts quickly and safely. They also keep your hands off the surface so it doesn't get marked up and the artwork doesn't get disturbed.

Steel rules make it easy to measure areas of artwork in order to keep things even, or to draw straight lines. I use the 6-inch as much as the 15-inch.

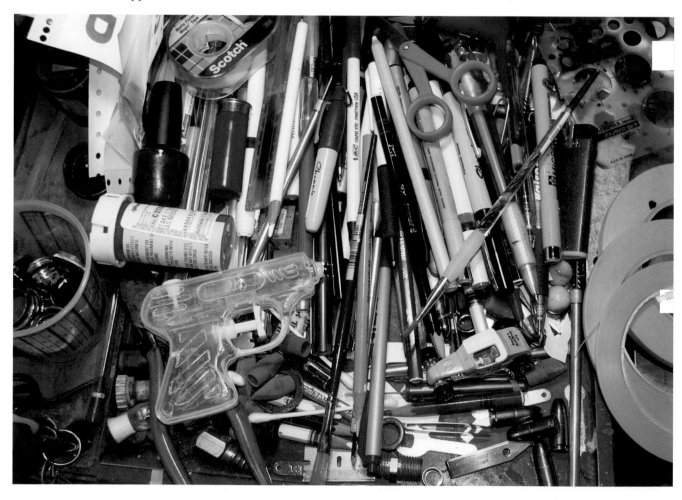

Above: *Just a few of the essential tools needed for successful airbrush art.* **Opposite:** *Easel and drawing board. Unless all you plan on painting are motorcycle parts, it's a good idea to have an easel. A heavy-duty wooden easel like this one from Windsor Newton can even hold a car hood or trunk lid. When working on illustration boards, canvases, or coated boards, you need an easel, and it is best to have a hard backing to hold the surface. I use a drawing board, seen here. This provides a rigid surface to back up whatever surface you are painting. I highly recommend buying a drawing board. I use it for many things. For example, when workspace is limited on my airbrush bench, I'll lean the drawing board up against the bench and let the lower end rest against my lap. Then I have an immediate extra surface to work on a drawing, cut a stencil, or whatever else.*

BIG TOOLS

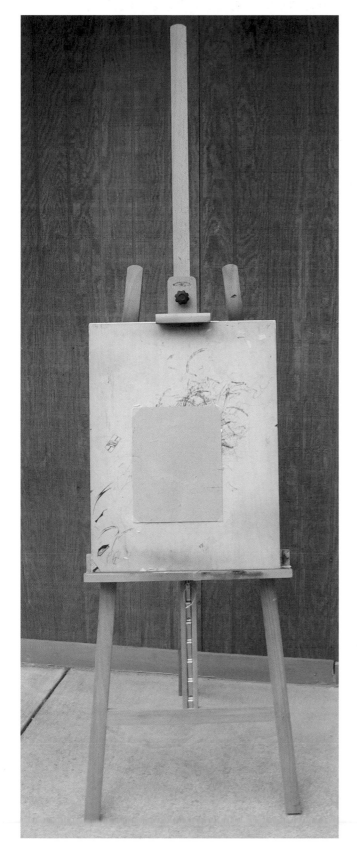

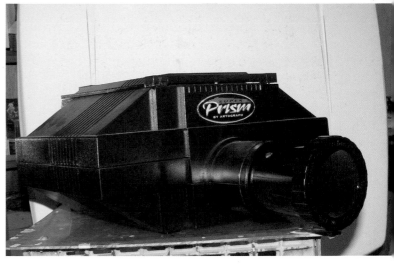

For large surfaces, a projector can be very helpful. The top panel flips up to reveal a glass surface. Simply place the drawing or photo you are working from face-down on the glass plate. Then place the projector the necessary distance from the surface that is being worked on. The farther away the projector, the larger the image will appear. The lens tube slides back and forth to focus on the image. Once the image is displayed on the desired surface, just draw it on the prepped surface with a pencil or Stabilo pencil. Then you'll be ready to airbrush. One factor to consider is that the brighter the light in the work area, the less visible the image projected will be. Just like any other tool, the more a projector is used, the more effective the artist will become with it. I use an Artograph Super Prism projector. They run about $200.

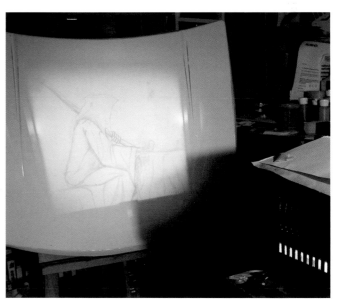

Here the image of a grim reaper is projected onto a hood. The room is nearly dark and the hood is white, while the reaper is a black outline. But it is not as visible as you would think. Projectors are great, but they do have their limitations.

A light box is also an essential piece of equipment used mostly for tracing. You can buy them online for around $55. Don't have a light box? You can make one using a plastic crate, a sheet of clear Plexiglas, and a light bulb fixture. Or just tape whatever you're tracing to a window (during the day, of course) and trace away. I use whatever happens to be easiest at the time. I usually use the plastic crate light box I made 15 years ago. That light box is what I'm seen using in most of the chapters. For very large tracing, I'll tape my drawings to a window to trace.

Use a compass for perfect circles every time on any surface, even curved ones like motorcycle tanks.

Uncle Bill's Sliver Gripper tweezers are available online at http://www.slivergripper.ca/. I use the tweezers to grab frisket paper when removing it and to handle tiny fineline tape ends. It's easier than trying to maneuver and place them with my fingers. I could not survive without them.

The little steel template is meant for drafting, but I use it for very detailed shielding, like quickly masking off a nostril when painting a portrait.

My favorite cutting and hand tools, clockwise starting at upper left: Whetstone for sharpening blades, compass, fine scissors for detailed cutting, Uncle Bill's Sliver Gripper tweezers, magnets, steel eraser template, big scissors, large and small steel rulers, cutting rail, #11 and #4 X-Acto stencil knives on top of self-healing cutting mat.

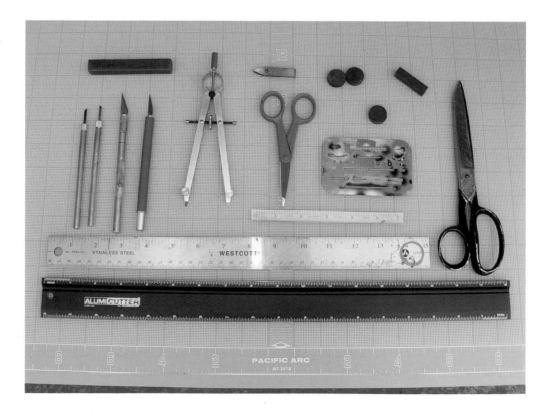

When it comes to cutting, I prefer the small #4 knives to any others. When cutting frisket paper, they are small enough to maneuver around curves. But #11 knives work better for cutting paper stencils. I use a smooth, white cutting stone to keep the blades sharp. The new Gripster knife has a rubberized surface for easier maneuvering. Keep plenty of spare X-Acto blades around. Airbrush master Dru Blair recommends that #11 X-Acto blades be changed every minute, and he's not kidding.

I also keep small magnets handy to hold down paper stencils on metal surfaces like motorcycle or auto sheet metal.

Lastly, I worked for years and never used a cutting mat. But after using it only once, I was hooked. The hard-yet-soft rubbery surface allows for extremely smooth and even cutting, especially when cutting sharp curves. This one has a self-healing surface so that the knife marks do not mar the surface.

BRUSHES

It's OK to use traditional brushes when creating airbrushed paintings. I find myself using a variety of brushes as I'm airbrushing, everything from Mack Pinstriping brushes to squirrel-hair lettering brushes to fine art brushes. There are no hard rules here. Most artists combine the airbrush with regular brushwork.

Many times, artists will trim their brushes to suit whatever specific item they are painting, on occasion even trimming them down to a single hair. Sometimes it's just faster and easier to use a very fine brush to paint in small details like single hairs or groups of hairs, like eyelashes.

Brushes come in a range of sizes from 0 up to 14. Keeping a good set of brushes in various sizes and styles will come in handy. Keep in mind that good brushes are not found at the dollar store. Expect to pay $5 and up for a quality brush.

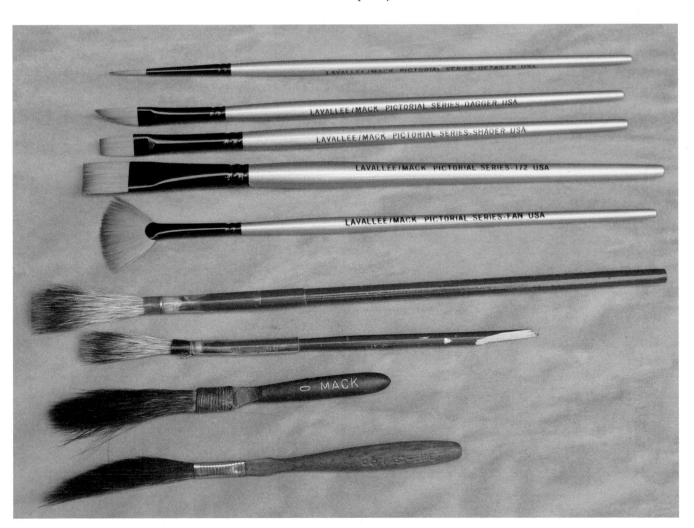

The brushes I use, from top to bottom: Mike Lavallee signature five-brush set, including a #2 fine detail brush; a fan brush; the slash-shaped dagger brush; two squirrel-hair lettering brushes; and two trusty Mack striping brushes. Some of these brushes are over 20 years old.

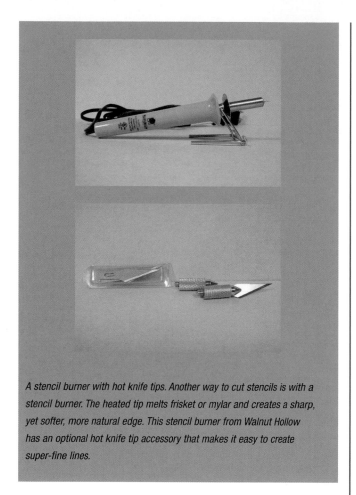

A stencil burner with hot knife tips. Another way to cut stencils is with a stencil burner. The heated tip melts frisket or mylar and creates a sharp, yet softer, more natural edge. This stencil burner from Walnut Hollow has an optional hot knife tip accessory that makes it easy to create super-fine lines.

For very fine details, a sable brush is the best choice. It keeps a nice point, bends with the slightest pressure to paint wider strokes, yet goes right back to its tapered shape to draw in fine lines. The set of Mike Lavallee-designed brushes pictured above are a synthetic blend that reacts like a natural sable brush, yet they are more durable. They were designed specifically for airbrush artists, retail for about $43, and can be found at www.letterheadsignsupply.com.

With proper care, a brush will last for many years, but they must be kept clean. If you use them with enamels, clean and oil them with mineral oil, smoothing them flat and straight. If you are using them with water-based paints, just wash them with mild soap and water, then smooth them flat with your fingers.

MASKING SUPPLIES
Adhesive-Backed Films

There are many different kinds of mask or stencil materials to choose from. I keep all kinds on hand because some work better for certain tasks. This is yet another area where experience will help you to figure out which techniques work best for you.

Gerber mask is the only vinyl mask I use. Vinyl mask is mainly used with a cutting plotter, although I have used it for freehand stencil cutting. (More about plotters in Chapters 9 and 10.) Gerber mask is incredible stuff and very forgiving. Unlike regular frisket paper, it will not leave residue on uncleared automotive base coat paint. It is used heavily throughout this book.

Many artists who paint on cars and bikes like using transfer tape. Transfer tape is mainly used for transferring computer-cut vinyl onto a surface, yet many airbrush artists have discovered that it also makes a good stencil material. Sticky Mickey transfer tape was developed by artist Mickey Harris for use as stencil material (www.mickeyharrisart.com to purchase). It is easy to draw on and cuts pretty cleanly. Its only drawback is that it is not transparent. Coast Airbrush (coastairbrush.com) also makes an excellent transfer tape mask called Automask.

Need to quickly mask off a portion of a painting? Try a clear transfer tape like TransferRite Ultra Transfer Tape. I find I'm using it more and more. It leaves no adhesive behind and is handy for freehand cutting of detailed areas.

For overall stencils on most mural artwork, I prefer Grafix-brand frisket paper. I use it to mask off the basic outline for most of my mural work. It is a transparent film that has an adhesive on the reverse.

Masking tapes come in many sizes but the handiest are 2-inch, ¾-inch, ½-inch, and ⅛-inch. The wider the tape, the less flexible it is, so wide tape does not create smooth curves.

For smooth, even curves around sharp corners, plastic fineline tapes work effectively. 3M Fineline tape comes in sizes from 1-inch down to 1/16-inch. I prefer the green tape over the blue because it creates a more even line. I use ordinary Scotch tape to tape together large drawings that are printed out on the computer.

Here's a quick outline of the process I normally use for the main subject in my mural artwork: Simply place a drawing or photo on a light box or window, lay the frisket paper over it, and trace the outlines of the character or subject of your stencil. Cut the stencil out, remove the backing, and carefully stick the frisket stencil to the surface. It is not solvent proof, so take care when using with automotive paints. For use over uncleared automotive paint, it may leave adhesive behind, so I use the frisket paper for the overall stencil only when working over catalyzed, urethane clear. Next, I use the TransferRite tape for masking off individual areas as I paint. More on this process will be covered in the various chapters.

Some artists recommend using Mylar drafting film. It is a thin, transparent material that cuts pretty easily with a stencil knife or stencil burner. It can be used with any kind of paint because it is solvent resistant. Mylar is also fairly

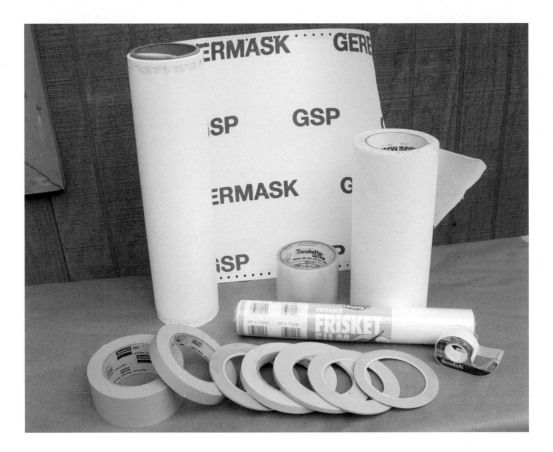

Masking films like Gerber mask (a vinyl film), TransferRite and Sticky Mickey transfer tapes, and Grafix frisket paper are what I use for any masking that requires an adhesive-backed stencil. Masking and fineline tapes in all kinds of sizes are also used. I even find I use a lot of regular Scotch tape.

strong because it doesn't tear easily, and it's flexible, which makes it good for using on curved surfaces.

There are several types of Mylar film: glossy on both sides, matte finish on both sides, or matte on one side and glossy on the other. This last one is the Mylar I recommend because it is versatile. The matte side can be drawn on, yet the glossy side cuts more easily. The artist draws on the matte side, flips it over to the glossy side, and cuts the design.

Next, 3M Spray Mount Artist's Adhesive is sprayed on the glossy side and allowed to dry a little in order to tack up and become usable. Then the stencil is laid into position on the painting. Spray Mount bonds to practically any lightweight material instantly, yet allows work to be lifted and repositioned. So, if the stencil needs to be moved, it's not a problem. However, if it's used on metal surfaces, it

Watch your paint edges! Masking tape is thick, and using it can result in thick paint edges building up. If the edges build up, you won't notice it until the tape is removed. Take care to watch as you paint, especially if you are working on paper surfaces or canvas. Unless you're using automotive paints and will be using urethane clear as a filler to build up the paint levels, these edges will be quite visible.

may leave a slight residue. Use a postpainting wax and grease remover, like House of Kolor's KC-20, to remove it.

Reusable Plastic Shield and Templates

Solvent-proof, hand-held shields and drafting templates are one of the quickest and easiest ways to get super-sharp detail as you work through a mural. They last for years and years. If you buy them as you need them, you'll accumulate quite a collection that will mask off nearly any shape you run into. For example, say you're painting an eye. To shade or highlight the upper and lower lids without getting overspray into the eye itself, simply find a shape that fits the line of the lid, hold up the shield to mask off the eye, and spray. The result will be a crisp line against the eye and a smooth transition into the face.

Liquid Masking

Liquid frisket is a product I find very useful. Chapter 11 features more about using Spray Mask. There are a number of liquid friskets on the market. Products like the Masquepen, Shivas Liquid Masque, and Grumbacher Miskit Liquid Frisket 559 are just a few that are designed for using with paper surfaces. When working on these surfaces, make sure to use a liquid frisket that is designed for use on paper. Others, like Metalflake Company's Spray

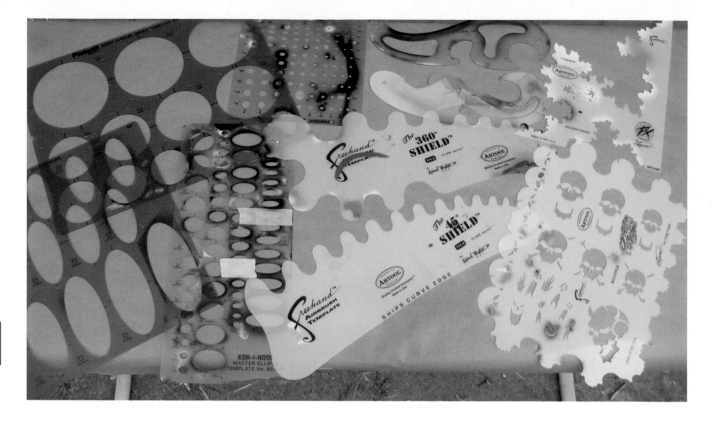

I like using flexible drafting templates, such as circles, ellipses, ovals, French curves, specialized airbrushing stencils, and Craig Fraser's line of skull stencils. You can find these stencils and templates at most online art and office supply stores.

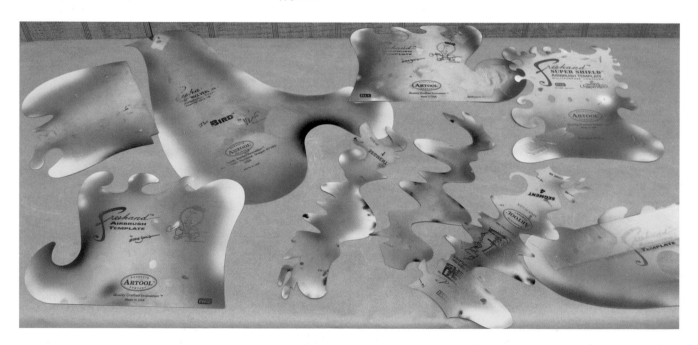

Artool Freehand Shields are one of the handiest tools I use. Pictured here is the Essential Seven shield set as well as the S.P. Radu Vera Master Series, which includes the "Bird" and "Pharaoh." The Matchmaker set has four stencils that fit together so you can use them to get both sides of a curve. There is a positive and negative side to all the curves. There are endless ways to use these, from getting hard edges when airbrushing rock and bone surfaces, to creating edges on murals, to quickly masking off fine details like eyes on a face. These shields are a small investment that will pay off big. Please note, these are my shields and they are covered with paint. New ones are clear and easy to see through. They are solvent proof, and most kinds of paint are easily wiped off with whatever cleaner is being used.

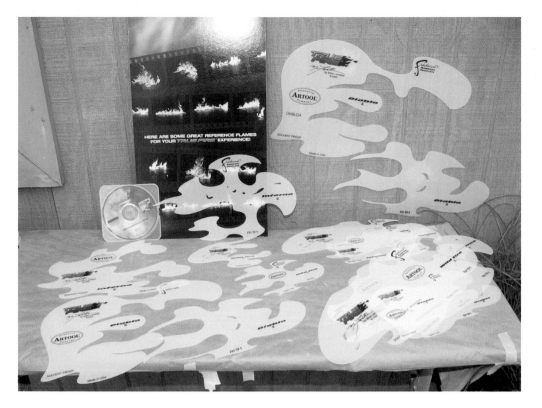

Realistic fire is one of the most popular things being airbrushed these days. Mike Lavallee pioneered this technique and designed these Artool freehand shields specifically for airbrushing fire. They are very, very effective.

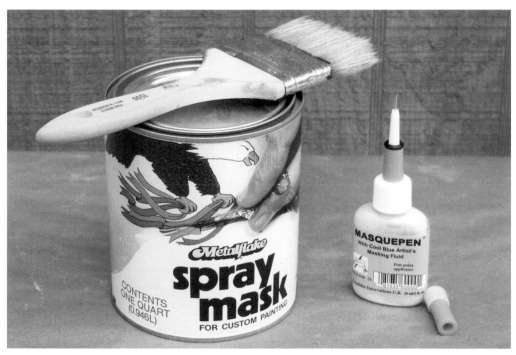

Metalflake Company's Spray Mask and Masquepen Artist's Masking Fluid. The Masquepen is pretty easy to use because it features a fine nib for the masking fluid to flow out. The nib makes it easy to apply the fluid wherever it's needed. Lines or forms can be drawn on with masking fluid to create white highlights.

Mask, are designed for use on hard, nonpaper-based surfaces like metal or masonite. It is not meant for use on paper surfaces like illustration board.

Liquid friskets are very easy to use. They are applied with an injectable nib or a fine brush, or in the case of Spray Mask, a wide paintbrush is used. Once it is dry, it can be trimmed with a stencil knife, and then you can simply airbrush it away. It peels up rather easily after you're done with it. When using liquid frisket, it is important to clean up your application tools immediately after applying the frisket. Whether you're injecting it through a nib or using a brush, rinse the tools thoroughly with water until

Tracing paper is one of the handiest things I keep in my studio. I do most of my drawings on it because its translucence makes it perfect for using on a light box. You can easily use different photo elements to create one drawing when using tracing paper. Trace the face from one photo, an arm from another, and so on. For instance, if a photo you're using for reference has something missing, say a woman's arm is behind a post, simply trace the woman, and then find another photo with an arm you can trace to complete the photo. Or, get a friend to pose her arm for you, take a picture, use your computer to resize the picture to the size you need the arm to be, and draw in the arm. Many times I'll work my ideas out on tracing paper, flip it over, and trace along the lines of the design. Now all I have to do is to flip it over again, put it on whatever surface I'm painting on, line it up, and trace along the lines. This process will transfer the design to the paint surface. If I'm working on a motorcycle tank and need to reverse the design, I simply take a few measurements from the side with the design and transfer them to the other side. Using a lead pencil, trace along the design lines of the original drawing. Then flip your traced drawing over, line it up on the marks that were just made, and trace along the lines. Tracing along the lines will transfer your design onto the surface. Just make sure to erase any pencil lines after the artwork is completed.

all of the frisket material is rinsed out. If this step is not taken, the tool used to apply the material will be ruined.

COMPUTERS

It's hard to believe that years ago, people created art without the use of computers. While some airbrush art is painted with no computer-generated help, much of it is.

For commercial applications, I learned many years ago that the simple copy machine at the library could seriously help me reduce my work and improve my paintings. Is it cheating to use a computer or a stencil cutter/plotter? When I'm trying to get my work done in order to pay my bills, the last thing I ask myself is "Am I creating pure art?" Airbrush artists like Mike Learn have transformed

AIRBRUSH HOLDERS

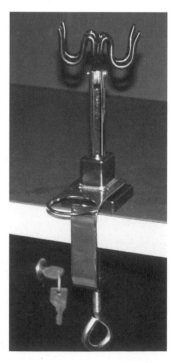

For the entire time I have airbrushed, I've used only one type of holder. It came with the Badger 150 airbrushes I used early in my career, and it's a small, hanging-style holder. It works well for me because it hangs below the bench and is out of the way when I am working. The drawback is that it is very easy to knock the airbrush off the hook, which happens to me all the time. For most airbrush artists, a holder like this one from Bearair.com is a better choice. It clamps to any bench and holds two airbrushes. At $18, I may even get one!

computer-aided airbrushing into its own art form. Learn to use your computer to manipulate your drawings and photos. Take a course in CorelDraw or Adobe Illustrator. These days many airbrush artists are also becoming computer graphic artists. Yes, you can airbrush very successfully without even owning a computer. But if you are computer literate, use your computer skills and advance them.

BASIC SUPPLIES

For fine detail work, it is handy to have pencils. Colored pencils and lead (also known as graphite) pencils range in hardness from soft (B to 9B) to hard (H to 9H). Colored pencils, as well as Stabilo pencils (which are softer, waxy pencils) can be used for fine detail in your paintings. Stabilos will draw on slick or shiny surfaces that harder pencils cannot. Stabilos can also be used with automotive paints and covered with clear coat.

Quality erasers are a necessity. I like the simple, pink pencil toppers because they have a sharp end for detailed erasing. The infamous Pink Pearl eraser is also a favorite of mine. Pink Pearls are soft, and they work great without damaging the surface. They can also be used to erase overspray that creeps in between pieces of tape. I just finished touching up a logo on a bike tank, and some overspray had

seeped between bits of masking tape. Under the rework there was plenty of clear, so the overspray rubbed right off without affecting the original artwork. The Faber eraser stick is a harder, more aggressive eraser. You need to be very careful when using it on paper, but its rigidity is great for finely detailed erasing.

Fineline permanent markers are used directly in artwork to get super-fine detail. Permanent markers can be clear coated over without loss of detail. Make sure the markers you buy are permanent or, in the case of auto paint, the clear coat may mute their inks.

I use lead pencils mainly for transferring images. Mechanical pencils are great for getting the very fine lines needed on stencils and such. Many of the chapters will feature these tools and will show how I use them, but don't be afraid to work outside the box and find new ways to get wild, different effects.

Also there are paper products very similar to old-fashioned carbon paper. One product is Saral Transfer Paper. It comes in five colors: red, yellow, blue, white, and graphite. Use it just like carbon paper to transfer images. Simply place it between your drawing and the surface you are working on, and then trace the drawing. The image will be transferred to the surface.

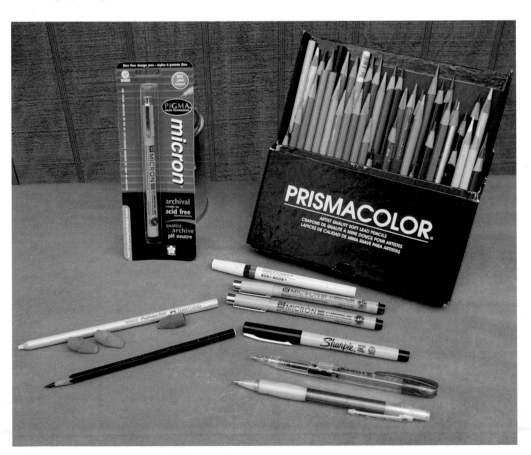

Clockwise from the lower left : Stabilo pencil, pointed erasers, Faber-Castell Perfection eraser stick, Pigma Micron permanent marker, Prismacolor Pencils, Koh-I-Nor Rapidograph pen, more Pigma markers (in sizes .01 and .005), Sharpie Fine Line permanent marker, Pentel Techniclick 0.5 mechanical pencil, and Bic 0.9 mechanical pencil.

SURFACES

Most of the examples in this book involve painting on metal surfaces. But many airbrush artists work on illustration board and canvas. Airbrushes can be used to paint on fabrics, leather, detail on models, or be used in other crafts. Nearly any surface you can think of can be airbrushed.

Hard-Surfaced Paper Boards

Illustration board is another popular surface for airbrushing. It is only finished on one surface. There are two types, cold press and hot press. Cold press has a slight texture, which tends to do a better job holding pencil materials. Hot press is smoother and does not hold pencil materials as well. For example, a pencil or marker will smudge more easily on a hot press board, yet they produce sharper and finer lines. The smooth texture makes it a better choice for detailed stencil mask work. Hot press board scans better, which means sharper detail can be reproduced from its smooth surface.

An illustration board is intended as a surface for creating artwork that will be scanned or reproduced onto other mediums. Crescent #9208 Cold Press Premium Hi-Line illustration boards are a favorite of many airbrush artists.

Bristol Board

Bristol provides two working surfaces, front and back. One side is usually a slightly textured vellum (cold press) surface, and the other is a smoother (hot press) surface. Bristol board is usually lighter in weight than illustration board, and it is intended for long-term use and preservation. Quality bristol boards are archival and made with cotton fibers. Bristol board also comes in pads, which is a very economical way to purchase it.

How do you decide which kind of paper board suits you? Buy a few sheets of each type and play around to find out which kind works better for your artwork.

Canvas

Even though canvas is traditionally a rough surface, many airbrush artists use that rough surface to their advantage for creating unique-textured artwork. Artists requiring a smoother canvas surface simply apply more coats of gesso to their freshly stretched canvases. Gesso is a smooth, yet thick, primer applied to canvas in order to create a smooth, flat surface on which to paint. The gesso is brushed onto the entire surface of the canvas using a large paintbrush.

PAINTS

There are two types of paint, opaque and transparent. Opaque paint is thicker because it contains more pigment.

It can be more of a challenge to spray; it can easily clog the airbrush when spraying fine lines and detail. Experience will tell you how much the paint needs to be thinned down. In the individual chapters, I'll explain how much I thinned down the paint I happen to be using. But generally, these paints are thinned down anywhere between 100 and 200 percent, depending on how finely it is being sprayed.

Opaque colors will cover better. Yet, despite being "solid" colors, some opaque colors are less solid than others. For example, while white will easily cover black, a color like yellow is more transparent. In order to cover another color with yellow, white paint must be sprayed first, then the yellow is layered over it. Be careful when mixing different opaque colors together to get a third color because they can quickly turn a color to "mud."

Transparent paints are not as thick and flow more consistently through the airbrush. Auto painters call these colors "candy" because their appearance is similar to the coating on a candy apple. Candy colors are very much like stained or colored glass in that you can see right through the color to the surface. This effect allows for some cool effects. Layer red over blue, and you'll get purple. Airbrush blue over yellow and get green. Unlike opaque paints, which will reach a certain level of lightness or darkness after a few coats, transparent paints will change with each layer applied. For example, the more transparent paint that is airbrushed, the darker the color will get. So it is very important to work from light to dark when using these colors.

Inks

Ink is the first paint I used for airbrushing. Look for brands like Dr. Ph. Martin's or Luma. These are great for airbrushing because they are thin and do not need to be mixed with anything. Inks are transparent, not opaque. They work great for layering on color tones and for soft shading.

Watercolors

This is the most popular and commonly used paint for fine art airbrushing. It is a thin paint that airbrushes very evenly. It flows consistently through the airbrush, which makes it great for beginners. The range of ready-mixed colors is endless. There are two types of watercolors, those that come ready to airbrush and those that come in tubes and must be mixed with distilled water (one-part paint mixed with one-part water, or dilute as much as needed). Like any paint, play around with it and learn how it reacts.

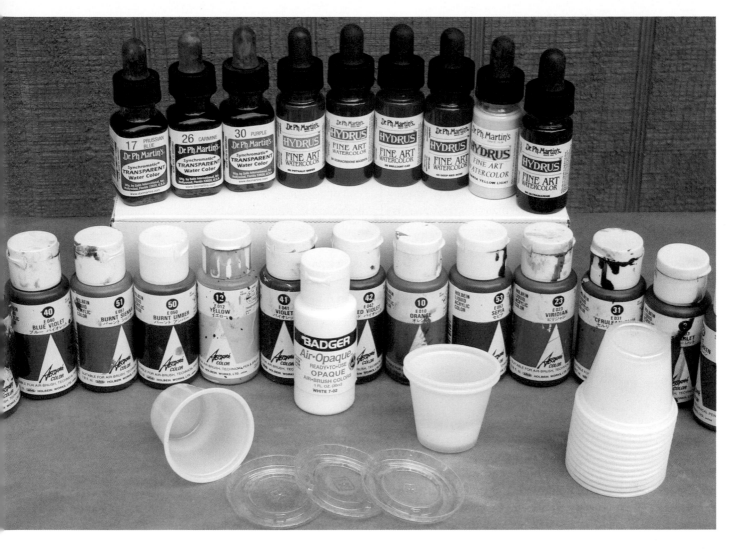

Different kinds of paint for fine art airbrushing. Top row: Dr. Ph. Martin's Transparent Watercolors (like an ink, with very little pigment and highly concentrated), Dr. Ph. Martin's Hydrus Watercolors (more of a traditional watercolor with a little more pigment). Bottom row: Holbein Aeroflash Colors. Many of these are also transparent colors, but they contain much more pigment than the paints in the top row and need to be thinned with water. When used with Badger Air Opaque White as a mixing base, they become opaque or solid colors. The little plastic cups and lids are great for mixing these colors. They are actually food condiment tubs and can be found at restaurant supply stores. Please note that these should not be used for solvent-based, automotive paints.

Gouche

Gouche is a water-based paint that is very opaque due to the amount of white pigment in it. It comes in tubes and has a creamy consistency. It can be mixed with a small amount of water for interesting textured effects, or thinned way down, or mixed 50/50 and used as a regular watercolor. Experiment and try various mixes of this unique paint. One thing to remember: Make sure to thoroughly clean your airbrush after using gouche because it will dry completely solid.

Acrylics

Acrylics are fast-drying, long-lasting paints and they are very popular among professional artists and illustrators.

When airbrushing, stick with a one-paint system. For example, if starting with water-based paint, stay with that throughout the painting. If using solvent-based, stay with that. There are some exceptions to this rule, but only time and experience will help you figure them out because each kind of paint and paint brand reacts differently. This is yet another reason why you should test your materials and experiment with them. There are times you can mix media, such as acrylics and oil paints. But when starting out, play it safe. Explore new ground, and test the rules after you've learned about your materials.

35

Mix your paints! Make sure that the paint is mixed before you use it. Different kinds of paint react differently. Pigment is usually mixed with some kind of binder to create a paint color. Some pigments will stay mixed. In thicker paints, the pigments may separate from the binder in the bottle or can after it's mixed. So, before you pour it out, look at the bottle. Is there a visible separation of pigment and clear liquid (binder)? Be familiar with these properties of your paints. Make sure to shake the bottle or stir the paint in the can to properly mix the color and binder. After you mix your paint color with water or solvent (commonly referred to as the reducer or vehicle, as it is what will dry the paint after it is sprayed), check to see how fast the paint separates from the reducer. It may need a mix or stir every few minutes or so. Pigment is heavier than binder or reducer, so it will sink to the bottom of your color cup. In gravity-feed airbrushes, this can be a pesky problem. Know your paint and know how it will react. Then you will know what to expect and can act accordingly.

There are two kinds of low-viscosity colors that can be thinned with water. Like any paint, start with one-part paint and one-part water, and then go from there to suit your needs. There are denser, high-viscosity acrylics that require a special solvent along with the water. This paint can be used on any surface. It adheres very well, and adhesive-backed friskets or masks will not pull up acrylic paint when they are applied over it and removed.

Acrylics dry very quickly into a plastic film that is not water soluble. You may need a special solvent to clean your airbrush. If you're working for an extended period of time, you may also need a special retarder to slow the drying of your paints because they will start to dry in whatever container you've mixed them up in. Each brand of acrylic sells a retarder for this problem.

Arylics are also toxic, so if you're spraying heavily or if there's no good flow of air through your workspace, you should make sure to use a mask. There's more about safety in Chapter 3.

If you're painting on textiles, use a brand of acrylic paint that is designed specifically for that. The paints are also designed to be heat-set into the fabric with a heat gun. As these can be pretty thick paints, an airbrush needle/tip combo of 0.5 should be used, and it will take more air pressure to properly atomize it. Try 45–75 psi and keep checking your paint to make sure it is still properly mixed—heavier paints separate more quickly.

Golden Artist Colors are a favorite of many, many airbrush artists and are highly recommended for beginners because they are very easy to work with.

Oil Paints

I love oil paint. It's normally used on canvas but can be used on ceramics, primed wood boards, plastic surfaces, glassware, as well as metal. The colors are amazing. They have a tendency to literally glow. But for airbrushing, they can be a challenge because they dry so slowly. This slow drying time makes using stencils and masks very difficult if you're in a rush. Oil paint comes in tubes and is reduced with one-part paint to one-part turpentine or mineral spirits. Oil paint is for the most part opaque. Yet, when thinned down enough, certain colors can become transparent. Many airbrush artists who specialize in fine art prefer using oil due to the luminescent properties of these colors.

AUTOMOTIVE PAINTS
Solvent-Based Paints

Airbrushing with automotive paint is completely different than airbrushing with watercolors or acrylics or any kind of "traditional" fine art paint. Most auto paint is solvent based. This means that it is made with highly toxic and flammable chemicals. For the most part, these paints were not designed for custom painting or airbrushing. Yet there are more and more companies that have their own line of paints made specifically for custom work.

I've written two books that are all about using automotive paint for custom work and airbrushing. But for now, in this book, the thing to remember about using auto paint is safety. The work area must be well ventilated. You cannot

All throughout this chapter, you'll notice that I continually suggest cleaning your airbrush immediately after working. Some paints will really damage an airbrush if you allow them to sit and harden. Some paints dry much faster than others, and can dry to the consistency of a brick in no time flat. Others paints dry to a sticky, gummy mess that no solvent or cleaner can easily remove. Some thin, solvent-based paints will soften the seals in an airbrush and leak into air passages. If the air passages become clogged, the airbrush will be ruined. So, make it a rule to always clean your brush immediately after working. Do not let the paint sit in the airbrush. If you take a break, clean the brushes first. You may get sidetracked and not get back to work as soon as you had thought.

House of Kolor is a line of solvent-based auto paint that is designed for custom painting. It offers a wide variety of colors, from pearls and metallics to transparent (candy) and opaque (solid) colors. House of Kolor has a very complete paint system, from bare metal primers and sealers to custom designed colors (opaque and transparent) and urethane clears.

Airbrushing with water-based paints like Auto Air has truly advanced over the last few years. The technology improves every year. Airbrush masters like Blake McCully and Mickey Harris use nothing but Auto Air to airbrush their creations. With the incredible color selections and specialized products for use with water-based paint, there is no reason not to use it.

MIXING CUPS AND BOTTLES FOR AUTO PAINTS

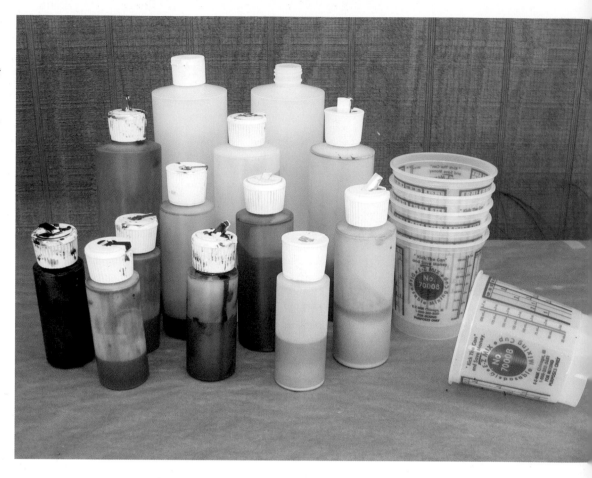

Paint storage bottles from Coastairbrush.com come in 1-, 2-, 4-, 6-, and 16-ounce sizes. I prefer the Yorker spout cap, which has a spout that flips up and makes it easy to squirt a small amount of paint into the airbrush color cup or bottle. I only use the bottles for colors like white, black, red, blue, skin tone, and other colors I use frequently. For custom-mixed colors that will only be used for one painting, I like these disposable mixing cups from E-Z Mix. They are economical, come in different sizes, and they have a variety of various measurements that make it easy to mix up paint. Solvent-based paints must be used with containers that are designed for their use.

breathe the fumes because they are very damaging to the body. The paint and reducers cannot touch the skin either; they can cause rashes and other damage. If they do get on you, then a non-toxic cleaner like 3M's Paint Buster should be used to remove them immediately. Never use reducers or thinners directly on your skin—never ever.

When used correctly, these paints work great for airbrushing. Most of the examples in the book are done with solvent-based auto paint because that is what I am comfortable using.

Water-Based Auto Paint

Many companies are improving their water-based paint products. This is due to the fact that government regulations are becoming more and more restricted. Eventually in the near future, solvent-based paints will gradually be phased out. There are laws in place that will ban urethane base coats in the United States starting in 2009. The automotive custom painter, and airbrush artists who learn the techniques of airbrushing with water based paint, will be far ahead of those who do not. Products like PPG's Envi-

robase and Auto Air Colors are being successfully used by many airbrush artists.

In fact, there are many reasons to use it, the chief one being that it is not toxic. Since the average person will not be able to purchase solvent-based paint in the near future, paint companies are working to improve the technology of their water-based paint products.

One of the challenges with using this paint is that it dries more slowly than solvent-based paint. Yet, Auto Air's Flash Reducer paints perform like never before with improved flow and leveling, decreased drying times, and control when airbrushing detailed artwork. For more information and the latest news on Auto Air Color product, go to their website www.autoaircolors.com.

FINDING TOOLS AND SUPPLIES

These days many artists, including me, buy their materials and tools online. You can shop around for the best price and service. For airbrush supplies, I usually go to bearair.com or coastairbrush.com. For things I don't find there, like Stabilo pencils or #4 X-Acto knives, I'll find

HANDY HINTS FOR USING AUTO AIR COLOR PAINT

Try to have a work area temperature of 70 degrees Fahrenheit or more in a dry, dust-free environment. When painting in humid or colder conditions, allow for extended drying time. Use of warm, moving air, a heat gun, or infrared lamp is recommended to speed up the drying time, and it will ensure all the excess water is evaporated. Make sure the air source is free of contaminates, especially oil and water.

Use the recommended airbrush nozzle/needle combo sizes:

0.5 mm: 40–50+ psi

0.3 mm: Transparent colors thinned with Auto Air Reducer, approximately 300 percent or more (3 parts reducer: 1 part color)

0.2 mm: Transparent colors thinned with Auto Air Reducer, approximately 500 percent or more (5 parts reducer: 1 part color)

To improve atomization when using an airbrush, Auto Air Reducer may be used to thin paints. Often colors are reduced up to 400 percent (4 parts Auto Air Reducer: 1 part Auto Air Color) when using an airbrush. Mix ratios may vary per color and Color Series. Exact ratios are not required.

Proper preparation is crucial in ensuring a successful paint job. Prepare surfaces using normal custom-painting methods. Clean surfaces thoroughly, before and after sanding, and use a solvent-based degreaser/panel wipe.

Scuff over primed surfaces, using 600-grit wet and dry paper or a rough-grade scuff pad. When applying graphics over a urethane finish that serves as base color for Auto Air Colors, scuff with 800-grit wet and dry paper to avoid large scratches. Sanding and/or scuffing should completely remove any gloss points from the surface. Pay close attention to crevices, edges, folds, and other areas that are difficult to sand with broad strokes.

Clear coat artwork done with Auto Air, as with any automotive paint. Before clearing, use a low solvent-based degreaser to remove any dust, particulates, smudges, or fingerprints that may be on the painted surface. Do NOT clean with water.

Auto Air Colors are compatible with all urethane clears. Some colors may dry to a textured, porous surface. Applying multiple tack coats creates an even film upon which wet coats may be applied. Use a slower activator/hardener to allow for more reflow and self-leveling. Allow time for the clear to soak into paint. There are no time-window limitations to follow when applying the clear. Once the Auto Air Colors have been cured with heat, the clear may be applied.

Cleanup properly. Use Auto Air Cleaner or Restorer as directed on the label for best removal and maintenance of spray equipment when using Auto Air Colors.

Exercise safety. Although Auto Air Colors contain 0.0 volatile organic compounds (VOC), the user or any persons who may be exposed to the airborne particulates are required to wear a respirator approved by the National Institute for Occupational Safety and Health (NIOSH) and the Mine Safety and Health Association (MSHA). Protect from contact with skin or eyes. Use standard safety and handling procedures to minimize potential hazards. Basically, although this paint contains no solvents, it's still not a good idea to breathe it. Ensure there is good airflow and proper ventilation in your workspace.

Find Auto Air Colors at most auto paint or art stores, or online at bearair.com.

them on dickblick.com and misterart.com. If you have difficulty finding a product, just go online and use a search engine such as Google.

If you have a good art store in your area, one of the most fun things to do is cruise the aisles for the things on your goodie list. It's also a neat way to discover new tools and materials. You might see something you never would have used, but standing there in person, holding it, you may see a way it can help with your painting. Big art stores bring out the kind of joy you used to feel as a kid in a toy store. If you're lucky enough to live near a big art store, take advantage. I do not live anywhere near a cool artist supply store, so when I'm traveling to a big city, I make sure to go online and find out if they have a major art store, like Pearl Paint (www.pearlpaint.com) or Jerry's Artarama (www.jerrysartarama.com). Warning: This behavior can be very damaging to your checking account or even worse—your credit card balance!

CHAPTER 3
AIRBRUSH THEORY AND PREPARATION

Many of the examples in this book are actual jobs for customers, so you'll get the full treatment of what actually happened as I worked. You'll hear the good as well as the bad. OK, so I'm about to start sounding like one of my teachers from art school. Back then, I didn't want to hear about theory. It sounded boring, but looking back I wish I had listened more. It might have saved me from an artist's worst enemy, him or herself. Most of the time, artitsts get themselves into their pitfalls while working. So, here are a few rules to get the best results out of your airbrushing experience.

1. Test your materials! Become familiar with how the tools, materials, and techniques react with each other before trying them on an important project. A very common problem that depresses most new airbrush artists is that they get frustrated with their airbrushes or with the materials. Give yourself time for testing and practice before starting any new project.

Even after 27 years of airbrushing, I still mix colors and practice techniques on test panels before I start on a paint job. As much as I'd like to put every kind of airbrushing on every kind of surface in this book, there just isn't enough space. I will focus on the techniques rather than the individual kinds of airbrushing. The techniques in this book can be applied to any kind of airbrushing with any kind of paint, and used on any kind of surface from textiles to metal to fine art airbrushing.

2. If you are totally new to airbrushing, don't expect too much from yourself at first. The single biggest mistake I see newbies make is that they get totally frustrated when things go wrong and they don't get the results they want. I've read many posts on the online airbrush boards about someone who has been airbrushing for a week or a month and they're getting completely angry at the airbrush, their artwork, the artists who try to give them advice, or the artists who don't tell them what they want to hear.

It is so easy to get discouraged with this art because you will invest more money in it than any other art. Not many paintbrushes or pens start at $50 and average about $200, but most airbrushes do. Yet, many people who have very little experience drawing or painting try to airbrush. So, take it easy at first. Do not sit down and expect your work to look the way you had envisioned. If you admire the work of an artist like Mike Learn or Fitto or Vince Goodeve, do not get angry if, no matter what you do, your artwork looks nothing like their art. Artwork is a journey. Each artist needs to go on their own journey and develop their own style. To fight this process will result in lots of frustration directed everywhere.

Have fun with your art. If you're not enjoying the process of the journey, you're missing out on the best part and the part that leads to creating the kind of artwork that you'll be proud to sign your name to. Is there a specific amount of time this journey takes before you see the results you desire? Of course not. But when it does start to come together, it will feel much better than any drug.

3. Try not to get frustrated with the tools. Unlike painting with a brush or drawing with a pen, airbrushing requires an assortment of mechanical tools, airbrushes, compressors, and such. Mechanical things *break down*, which leads to even more frustration for the beginner. Unlike the seasoned airbrusher who is used to compressors dying in the middle of a big job, the beginner is not expecting obstacles. Chances are it's brand-new equipment that is giving you problems. It's not supposed to break, and only years of airbrushing hell will help you know what is wrong with the compressor when it makes that noise and the air stops flowing. Or if paint comes out of the airbrush when the needle valve is closed. This frustration, combined with disappointment about your airbrush work, can completely discourage many artists who are new to airbrushing—some even to the point of giving up.

When tools or equipment break down, step back and work the problem. Do the obvious and look through the manual that came with the item. Use common sense to attempt diagnosing what is causing the problem. Look through the troubleshooting sections of any airbrush books you have. Go to an airbrush site like www.airbrush.com and use the search feature to find out if anyone has posted on the board concerning that particular problem. Relax and search for the answer. Don't freak out. Don't let the artistic temperament get the best of you.

4. Paint what you want to paint. When artists first airbrush, they paint subject matter that they like. A car freak will paint cars. A gardener will paint flowers. When you paint things you are interested in, you'll get a better result than if you paint things that you don't want to paint. As you develop your airbrush skills, you'll find there are some things you enjoy painting more than others.

For example, I do not like to paint dragons. For me, they are tedious to paint because there's a lot of fine detail. I am a nut about having each line extra sharp and perfect, so painting dragons drives me crazy. Unless I am in dire straights, I don't paint them. But I love painting skulls, wolves, and eagles. I developed a fun technique of painting the feathers and fur that makes it quick and easy. I love playing with the texture of bone, using darks and lights to airbrush the light playing across the surface of a skull. Clouds are my favorite thing to paint and it shows in my work because my clouds are very distinct. I also love painting faces and working the dynamic elements of eyes, noses, and mouths to combine and create a beautiful face.

The infamous cloud background referred to in Rule #5.

Find your niche. You'll learn that when you airbrush things you enjoy, you'll have much better results than painting things that you feel forced to paint.

5. When stuck on a painting, don't get upset. Go back to your reference material. Say you're trying to airbrush real fire, but you are trying to do it in the style of an artist that you admire. Then no matter what you do, it looks awful. Find photos of actual fire and study them. Put them right next to what you're painting and look over at them often while working. Look at the color and form. Many years ago, I needed references to make a cloud background I was painting look real. I had taken many interesting cloud photos outside my house. When I was working on the painting, I did not refer to another artist's representation of clouds. I used only the photos and the end result was extraordinary. I had picked a fantastic picture with very incredible clouds. Use other artists' styles to inspire and to learn how they solved similar problems, but always try to work from life. I have actual animal skulls, feathers, furs, and many other items in my studio that help me to make my paintings look real.

6. Professional artists who have never airbrushed will have an easier time of it than people who are not doing art full-time. People who have gone to art school are familiar with solving the problems that all artists face. They've already learned how to use form and light to create dimensional illusion. They're familiar with principles like achieving proper perspective in a painting by manipulating shapes to create a sense of depth in a two-dimensional format.

7. Things will not go according to schedule. Many times something will happen that will totally upset a careful plan. Maybe it's an airbrush acting up, or a color that's gone bad and it's nearly impossible to replace because it was a custom mix or an obsolete pigment that you were saving. Sometimes an idea will look great on paper, but not translate as well when it's actually airbrushed. Or a file has mysteriously disappeared and no matter where you look, it cannot be found. These things are going to happen, and when they do, the artistic temperament may not handle it very well. It is so easy to get discouraged. The thing to remember is that these things happen to nearly every artist. All of those artists survived and did not give up, even if they felt like it.

8. Lastly, do not airbrush for paying customers until you know for sure you are ready. A big cause of unnecessary airbrush frustration is trying to do work for someone who wants custom airbrushing. This is a surefire way to make even a good airbrusher hate airbrushing. In addition to working with unfamiliar techniques and using equipment you are still learning to fine-tune, now you're adding the stress of a deadline for someone who is expecting to be pleased by your work. You cannot imagine the feeling of horror this brings until you experience it. Kinda like stepping off a cliff when you're not sure the parachute is going to open. There's nothing wrong with earning a living airbrushing, but make sure you are truly ready before you take that step.

New airbrush artists freaking out over paint jobs that go wrong is another prolific problem I read about on the online airbrush boards. They read something like, "HELP ME! I took a job painting a tiger face. How do I do it? I tried but it looks awful and the guy is stopping by to see it tomorrow. I'm freaking out. What do I do?" Well, first off, you shouldn't have taken the job. You weren't ready. There's no way to be prepared for every art situation that comes up. But the experienced artist knows what it takes to get the job done effectively, how to do the research, where to look for ideas, and how long the job should take. They have a pretty good idea of what to expect during the process. And they know that most of the time things don't always go as planned. So when problems arise, they have an idea of how

to deal with them. The bottom line: Add plenty of extra time to every job, especially when you first start doing work for customers. Do not let the customer push you into doing it in less time than you actually need. It is far too easy to literally "paint" yourself into a corner, and it will feel like pure hell. Always give yourself a big "safety net."

SETTING UP YOUR STUDIO

Most airbrushers set up a small studio in a spare room, basement, or garage. For the most part, this is a good idea unless solvent-based automotive paints are being used. Solvent-based paints are highly flammable and very toxic. The fumes are extremely damaging. If you do choose to airbrush with solvent-based paints in your home, please take precaution because you may place your home and your family at risk. For more information on what equipment will be best for your needs, refer to Chapter 1.

AIRBRUSHING ON LOCATION

There will be times when you'll airbrush away from your home or shop. Unless compressed air is available there, such as at a body shop, you'll need to bring your own source. Small piston-driven compressors, like the Iwata Sprint Jets and Smart Jets, are very portable. The Smart Jet Pro is even built into a carrying case.

CO_2 tanks work well for places that have no electricity, like flea markets and swap meets.

Find a sturdy folding table and buy two. One should be used as a work surface and the other table can be set up for organizing materials, or use a small cart. Then pick up a couple of folding chairs such as those used for sporting events. You probably have some around anyway, especially if your child plays on a sports team. A bucket or box will hold your tools and materials, and an airbrush holder will easily clamp to a plastic bucket or you can cut a slot in the bucket to hold your airbrush.

VENTILATION

Even if you are not spraying solvent-based paints, you need good ventilation. You should not be breathing in paint particles from any kind of paint. Unlike paint that is being brushed on, paint through an airbrush is atomized and not all of this will land on the painting surface. That means you could be breathing these particles into your lungs. I airbrush in front of a window with a variable speed 8.5-inch fan bolted into a Plexiglas window. This pulls the paint fumes away from me. Another fan off to the side pushes the airflow over my work toward the window fan.

Some artists who do not have a window set up a wooden box that is open on one side and attach flexible ductwork (like the vent hose for a clothes dryer) to the back of the box. A small fan, like a bathroom vent fan, is installed at the other end of the hose. This draws the fumes and particles away from the painting area.

Whether you have a small or large shop, use common sense to rig up a system to maintain the airflow through your workspace. There will be times when the air will get hazy with paint, so keep a good respirator handy and wear it at those times. Wearing a paint mask or respirator does not make you a wimp, it means you're smart.

RULES FOR USING SOLVENT-BASED PAINTS

Solvent-based paints are usually paints designed for use in automotive applications. These paints are made with materials that contain very hazardous fumes. The reducers and thinners used with them are as, if not more, flammable than gasoline. Combine these with all the paper products that an artist's studio contains, and you have what can be a very dangerous situation. These paints should only be stored in an unattached workshop or garage.

I use a room in my house as a studio, but I have a very good ventilation system and only keep small quantities of whatever paint I'm using for the project in my studio. All other paint is stored in a climate-controlled shed that is not attached to my home or shop. More paint cans around the studio mean more fumes.

When I clean my guns or airbrushes, I always wear vinyl gloves. If I can possibly help it, lacquer thinner never touches my hands. The room I use is at the end of my home, so the fumes do not travel throughout my house.

A ventilation system is operating whenever paint is in the room. My airbrush bench is in front of a window with a fan that pulls the fumes away from me. A small fan off to the side blows the fumes away from my face, towards the fan in the window. If I'm doing anything but light airbrushing, I'll wear a respirator.

One more thing about solvent paints: Once the pigment or base color is mixed with the reducer, the paint starts to break down. Some colors or brands of paint break down faster than others. White will break down faster than black. Try to not have more colors mixed than being used on any particular job. Always have white, black, and other colors that are used often mixed up and ready to spray. I keep these colors in solvent-proof bottles. After a while, you'll know which colors break down quickly. To help keep your paint fresh, keep the containers closed.

I prefer working in front of a window. In addition to the benefit of getting that paint fume air out of my studio, I love the natural light that comes in the window during the day. If possible, a northern exposure window is the optimum choice, but an eastern exposure will do. You don't want to work with the sun hitting you in the face. I've had work areas in shops, surrounded by concrete and equipment. It definitely had a negative effect on my work. I find that the best work I do is work that was done sitting in front of a window that looked out into a world of trees and nature.

Folks ask me how I can do such tedious work for hours on end. Over the years, I've learned what works for me and what gets me the best results in my artwork. Calm, quiet, peaceful surroundings with no distractions work for me. Other artists thrive in shops that give them contact with people. Find what works for you and figure out the kind of atmosphere that makes you feel happy and relaxed.

Other safety considerations with airbrushing are paint storage, ventilation, and cleanup. I keep very little solvent-based paint and thinners in my studio. I have only the colors and materials for the artwork I am doing that day in the studio.

WORKING ENVIRONMENT

Some artists airbrush standing up. Others prefer to sit. One thing to keep in mind is that you'll be spending many hours airbrushing, so make whatever position, standing or sitting, as comfortable as possible. I still use the same bench I've been using for 25 years. It's the prefect height for me. If your workbench is too low, attach a few 2x4 pieces under the legs.

You'll want to sit up as straight as possible. Don't let your back hunch or slump because you'll be in serious pain the next day or even in a few hours. If you're using an easel, check the adjustment before you buy it. Most art stores have artist chairs. Pull one over to the easels and try them out. Make sure the easel is easy to adjust and goes to the different heights you'll need. Refer to Chapter 2 for information on easels.

I sit in a swivel chair that I can rock back in. My bench has a foot rest, but much of time I sit cross-legged in my chair. My easel also has a crossbar that I use as a foot rest. Experiment with bench and seating positions. Find a way to make it as comfy as possible. Keep a supply of various-sized pieces of wood and a few firm boxes handy. That way, you can just grab them and quickly readjust the height you are working at.

Keep everything handy and within easy reach. Paint bottles can get out of control. There will be colors that tend to be used in most of the painting you do. Black, white, red, yellow, etc. Try to not have more colors mixed than being used on any particular job. But always have white, black, and other

colors often used, mixed up and ready to spray. After a job is finished, try to go through the work area and put any paperwork related to that job in a file. Then clean up the area.

Hours can be wasted trying to find stuff. Take the time to have a system. It's great to be working on an eagle and be able to quickly pull up a drawing to reference or leftover feather stencils to help with the new mural. Each paint job I do gets a file.

Make your working environment as comfortable as possible. My buddy, pinstriping wizard Ryan Young, likes to advise that your artwork will be much better if you have quality music playing while you work. This is true. I have always worked with a TV on, playing movies. I don't watch them…it's more like listening to them. I find it can really add to my mood, such as playing a barbarian movie while painting a barbarian-themed mural. The point is to relax and get the most from this experience. Many years ago, a rock band practiced at my house after they lost their studio. I did some pretty incredible work during those times. Friends used to come by and hang on the couch in my studio. We would talk and laugh as I worked. So rock out, dance around your easel, have friends over when you're working. Have fun. Try not to make this feel like work.

RESEARCH AND REFERENCE MATERIALS

If you look at the photo of my studio, you'll see lots of books and papers stuffed into that bookcase. And there's even more in my shed. Old bike and car magazines, girlie magazines, catalogs, *National Geographic* magazines, etc. Books by artists like Frank Frazetta, Boris Valejo, Hajime Sorayama, Olivia DeBerardinis, and others are just part of my library.

Build a good photo reference library. A $25 investment in a book on eagles is money well spent because that book will give you ideas and great photos to work from for years. I can find a photo of nearly anything I need to airbrush, and what's not there is most likely on my computer. I have many photos of artwork I see loaded on my computer.

To get ideas, I go through much of this stuff. Sometimes an idea just pops into my head. Then I find the photos that help me develop that idea. Other times I have to go through my reference material to get ideas. Maybe I'll see a graphic, and I'll like only parts of it. I'll save that and change it around. Save as many photos and ideas as possible, but make sure to have a system in place to organize them all. I even have a box filled with photos which are filed in envelopes with headings such as "wolves," "women," "backgrounds," etc.

This is very high-tech stuff here, so pay attention. When I'm not working with an easel, I work on motorcycle parts at my bench. I use boxes and bits of wood wrapped with tape to raise up my work if I find myself bending over the bench. I have two taped-off boxes that I use to raise up and position bike tanks and fenders. There is also a gallon can filled with water that I can lean parts against.

It is fine to use other artists' work to inspire, to learn from, or to see how they handled a particular problem. It is not OK to copy it for use commercially. Take a design and make it your own. Use the artwork and photos of other artists for reference. For example, you see an incredible photo of a sunset in a book. Take elements of that sunset, maybe the colors, and use them for your own design. Change the way the clouds are laid out. Do not create an exact copy. Enough elements must be changed so that the design is different enough as not to be even close to an exact copy. Remember art is a journey. To copy the work of others means you cheat yourself out of that journey. It is also illegal to produce an exact copy of someone else's work.

The best work you will ever do will be from photos and designs that you came up with. Keep a sketch pad handy to put down ideas while you are thinking of them. Keep files easily accessible. I have file folders for ideas about wolves, flowers, women, cool tribal designs, lettering, etc. When I see an idea or photo, I take it and put it in that file. On my computer there are hundreds of ideas neatly organized. When I need a reference or idea, it's easy to go through my files. Say I'm working on a safari painting. I get out my books on lions, panthers, and Africa. I'll find the paper file with animal references, then I'll pull up my computer files with animal ideas and photos. Now I can sit down and start to draw up my ideas.

PHOTOGRAPHS

Earlier in this chapter, I talked about an incredible cloud mural I painted. It would not have been possible without the picture I took and used as a reference. Many of my best reference photos were ones that I took myself. Keep a small digital camera in your car, especially when traveling. As you become more in tune with your art, your eye will pick out things you may not have noticed before—sunlight shining on a river, a field of graceful purple flowers, some small interesting detail on a custom car or bike—there are so many things that are wonderful subject matter for your airbrushed paintings.

Need a reference for chrome? Go take a picture of what you need. A few years back, I was working on a mural of a grim reaper and a biker angel playing cards. The customer had provided a photo of a model posed as the angel. I looked through my wing file and after looking at several images of wings, I drew up a nice set on the angel. But I needed a good reference for the reaper. I wanted the folds of his robe to be just right, plus I needed his posture and form to be accurate. I set up my digital camera on a box. (I did not have a tripod

Here is a print photo taken with a zoom lens outside my house.

This photo was taken on vacation in Tahiti. It was the chance of a lifetime to get great reference photos for future use.

at the time, they cost a whopping $20, so there was no excuse.) I set up the scene where the reaper would sit at the table and put on an oversized silk robe. The camera was set on the self-timer mode with a 10-second delay. That gave me enough time to hit the button on the camera, rush over to my setup, and sit down in the reaper pose. The camera snapped the picture, and I had a great reference for the reaper's robe, allowing me to correctly airbrush the folds in the fabric. I also needed a reference photo of a hand holding a card, so I took a photo of my hand holding one.

One of the great things about digital cameras is that you can immediately see the photo and make sure it is good, then retake it if you need to redo it. Digital cameras also make it easy to e-mail your customers with ideas and photos of the artwork to get their input and approval. For business needs, digital images can be assembled into a website to display your work. For any airbrush artist, especially commercial artists, a computer, a printer, and a digital camera will make a big difference in the way you work and how you show your work.

Left: *Here's another great Tahiti photo that would be easy to airbrush.* **Below:** *I must have taken dozens of cloud photos over the years. As a result, they have been a big help in designing and painting cloud backgrounds like this.*

Right: *A reference photo of the artist posing for a mural figure.* **Far right:** *The finished mural of the reaper.*

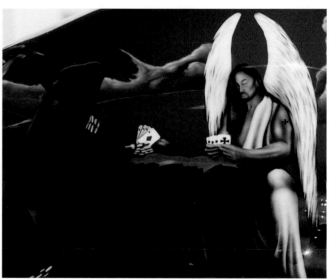

Years of working on clouds by using photos has allowed me to have fun when airbrushing clouds, as seen in this little detail. I airbrushed the edge of the clouds freehand and loosely filled in where the light hit the edges.

CHAPTER 4
THE BASIC MOVEMENTS: LEARNING TO USE YOUR AIRBRUSH

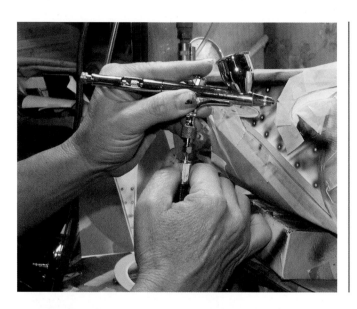

HOLDING THE AIRBRUSH

Looking at my artwork, you would never guess how unsteady my hands actually are. This next series of photos shows how I keep my airbrush steady and smooth. Over the years, I have found many ways to support my hands so that the airbrush stays steadfast, yet I don't contaminate the paint surface with oils from my hands. Before you do anything, play a little with your airbrush. All these exercises are done using Dr. Ph. Martin's ink. It is thin and easy to airbrush. You want to use an opaque color that flows easily through the airbrush and you want it thin, but not too thin. Black India ink works very well.

Put some ink in the cup or bottle, and move it across the surface of the paper. Get a feel for it, how the trigger reacts, and how the movements feel. Relax and play. Airbrush your name over and over. Spray some graffiti. Doodle around

Top Left: *I don't even realize I'm doing this. In the step-by-step chapters, each time I'm airbrushing, I'm steadying my hands. You just don't see it in the picture. Here I need to get the airbrush close to the surface. I need to spray a soft, even line of black along the edge of a graphic. One hand holds the airbrush. The other hand holds the airbrush hose at the fitting and guides the airbrush back and forth. This hand is steadied by resting a finger on the wooden block holding up the part.*
Above left: *In this photo, I'm airbrushing from a little farther away. My hand is steadied by my fingernail, of all things. My hand is far enough away from the surface that I can easily move the airbrush back and forth across the length of the graphic.* **Above right.** *Here I rest my hand on the part itself, but on the masked section, not the paint surface.*

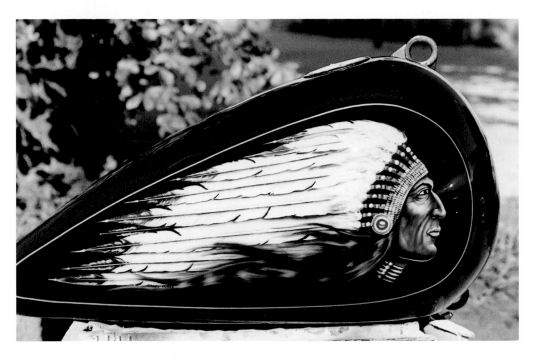

I painted this native chief many years after I first picked up an airbrush. The biggest mistake most newbies make is expecting results like this soon after first picking up an airbrush. Realize that this stuff takes time to master.

Right now, you're learning to enjoy your airbrush and keeping it casual. Once you feel more relaxed and are over the initial nervousness, start to follow the exercises.

SINGLE-ACTION VERSUS DUAL-ACTION AIRBRUSHES

Each brand and model of airbrush will spray differently. Each artist will handle the airbrush differently. Don't force yourself to spray a certain way. Be patient and get to know your airbrush, how it feels, and how it reacts to the way you spray. The following exercises are for either single- or dual-action airbrushes. Try to center your efforts on learning the right technique in order to not develop counterproductive habits. Here I'm using a dual-action gravity-feed airbrush.

To adjust a single-action airbrush, look at the instructions that came with it. Various brands of single-action airbrushes have different methods of adjustment. On this airbrush, a knurled adjustment wheel is turned. If it's turned counterclockwise, the needle is drawn backward and the gap between the needle and tip opens. Turn it clockwise to open. Refer to Chapter 1 for more information.

THE DREADED DOTS

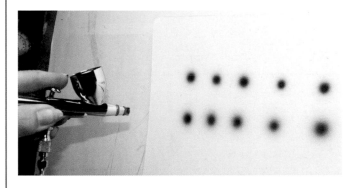

This is the most basic move you'll make, yet as simple as it may seem, it is very important. This is how you will be applying highlights and shadows in artwork. The basic principle here is that the closer you are to the surface, the tighter your paint pattern will be. The farther away the airbrush is from the surface, the more the spray pattern will spread out. Start off by spraying a few rows of faded dots, while holding the airbrush about two and a half inches from the surface. Just hold the airbrush in front of the surface, and carefully pull back and push down on the trigger. Do this very slowly and gently. What you're doing is learning at what point in the trigger movement the paint starts coming out of the brush. Play around with the distance and see the results.

49

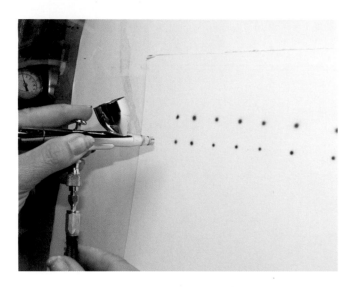

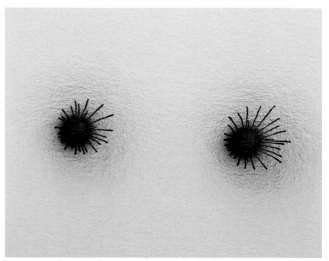

Left: *Now spray a few rows of tight, sharp dots by holding the airbrush about an inch from the surface. This will be harder. But relax and keep trying. Spray row after row until you can make a sharp, clean dot as well as one that is a soft fade.* **Right:** *This is what happens when too much air pressure and too much paint come out of the airbrush. The paint hits the surface, and the air runs the paint off to the sides. It will take time and patience to learn the right combination of air pressure and paint thickness to be able to spray a sharp or perfectly faded dot.*

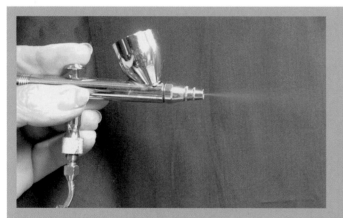

Left: *Look at the flow of paint out of the airbrush and the position of the trigger. The trigger is barely pulled back, but there is a thin line of paint flowing from the airbrush.* **Right:** *Now the trigger is pulled back farther and more paint flows from the tip. Note how the shape of the flow is tapered? That means the closer the airbrush is held to the surface, the smaller the area that will receive paint. The farther away it is held, the more dispersed the pattern will be because it is wider.*

LINES

No one is grading you on these, so don't work yourself up if they don't look perfect. Don't get tense. Have fun learning how your airbrush works. Airbrush a few lines, and don't worry if they are straight or not. What you are doing here is learning to keep a consistent pressure on the trigger. Your first lines will probably look a little wavy until your hands figure out how to keep everything even and steady. First hold the airbrush about 3–4 inches from the surface and draw soft, even lines across the surface, back and forth until the line is the same size and darkness all the way across. Concentrate on keeping the airbrush an equal distance from the surface for the length of the line.

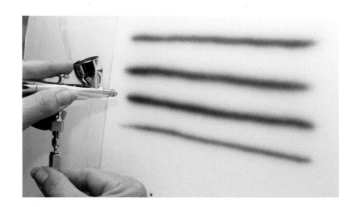

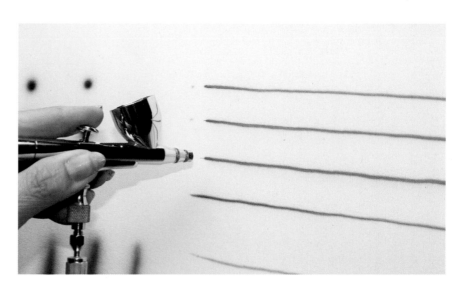

Now for thin, sharp lines. Hold the airbrush 1–2 inches from the surface and pull it across. Don't worry if your line is wavy because right now you're learning about trigger control. It's more important that the line be of even thickness. Just pull back and forth until the lines are even all the way across. Now here is where you find out if, like me, you spray better in one direction than another. Is it easier to spray moving to the left than the right? If not, then try spraying the lines up and down. If you can easily spray lines in any direction, congratulations, you have an advantage over me. If not, then in some cases try to reposition your work surface to suit the direction you prefer. Chapter 8 has a very good example of how to work around this.

DAGGER STROKES

These will be the hardest strokes to master; yet, they will be used the most. It is used to paint fur, hair, leaves, and feathers, to shade things, to freehand airbrush letters, and more. When you drew your name with the airbrush, you were using a rough form of dagger stroke. Think of them as a rat tail. They are fat at one end, and thin at the other.

Now that you've gotten more familiar with using the airbrush and have seen it in action, take a few moments to understand the paint spray dynamics. The paint comes out of the airbrush in the shape of a cone. The

pointed end is at the tip of the airbrush. When spraying the dots, you saw how the shape of the spray is round and how the farther away from the tip the spray travels, the more it spreads out, becoming a softer and less concentrated circle.

You'll need to keep the paint the same density at the start of the dagger stroke as it is at the end. You can change the amount of paint by moving the trigger forward or backward, but a combination of altering the amount of paint as well as the distance of the airbrush from the surface will give you the best results.

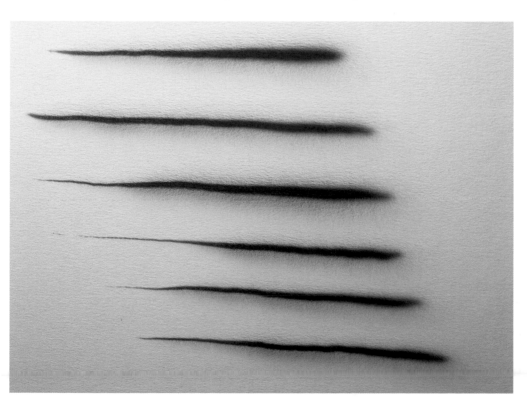

OK, here we go. With the airbrush held very close to the surface, push down the trigger to first get only air. Now pull back slowly until a flow of paint is started. Then move the airbrush across the surface, pulling the trigger back a little more, until you see the stroke get wider. Keep your movement fast. If you go slowly, the paint will hit the surface too thickly and spread into blobs. Practice these over and over until you see a nice even taper of paint across the length of the stroke.

This is the result of moving too slowly when painting a dagger stroke. The paint blobs out at the ends. It takes time to get the rhythm of the stroke, become used to the timing, and produce a smooth stroke. The main trick is to move fast across the surface.

THINGS TO KNOW ABOUT DAGGER STROKES

Adjust your paint flow to match the distance from the surface. Less paint is needed as you get closer to the surface.

Know that the closer the airbrush is to the surface, the finer and smaller the line will become.

At the end of each stroke, the paint flow will need to be reduced, so allow the trigger to come forward. Don't try to reduce or fade the stroke by pulling the airbrush up and feathering the end of the line. End the stroke the way you start it, by gently pulling the trigger back to start the stroke and let it come forward to end the stroke.

Airbrush the alphabet by writing letters using dagger strokes. This is a great exercise, and if it's done several times, you'll find that your technique will vastly improve. Think of it as calligraphy using an airbrush.

Now to add a little to it. Do the same thing, only as you're pulling back the trigger at the same time, pull the airbrush away from the surface as it travels across it. Wow, what a difference! It's kind of like "dive bombing" the surface. Try to go from thin to fat and fat to thin. Start curving the stroke, creating wavy daggers. Be sure to follow through the entire stroke. Don't stop. Start moving the airbrush a split-second before you start the paint flow, and continue moving after the paint is turned off. Just keep practicing! Now try airbrushing your name again. For T-shirt artists, most of the work done utilizes the dagger stroke.

LEARNING TO AIRBRUSH FADES AND GRADATIONS
The Cube

Above left: *With a ruler, draw a cube that shows two sides and the top. Cut it out. Take the outside piece and tape it to your paper. First, using masking tape, tape off the left side and cover the top and the right side. Since we want a soft fade, maybe mix a little water in with the ink to thin it down, but not too much. Hold the airbrush away from the surface. Think about how the light will hit those surfaces. On this cube, the light is coming from the upper left. First, airbrush color on the rear part of the surface, and bring the fade forward so at the start of the fade, the trigger is pulled back away and the airbrush is held about four inches from the surface. As the airbrush moves forward toward the front of the cube, the trigger is moved forward, shutting down the flow of paint.* **Above right:** *Now the right side of the cube is unmasked, and the left side is covered up. The process is repeated.* **Left:** *Finally, the top is airbrushed while the sides are covered by tape and paper. As the top receives more light, the tones are lighter and not as dark. Here is our finished cube.*

The Sphere

Airbrushing spherical shapes is one of the hardest things to master, right up there with the dagger stroke. But once you know how, you'll be able to airbrush tone to create any round shape, like a handle, baseball bat, people, tires, or any curved surface. Use a compass to cut out a circle. This will be your stencil. Tape it to your paper.

It is important to think about the light. Even better, find a ball and place it by your work area to see how the light plays across the surface. In this exercise, you'll also get to learn how much to thin down your paint. Remember, the thicker the paint, the more air pressure is needed. In order to get the very gradual, soft fades that paint needs to be thin, it must be sprayed softly. It is great to have the air pressure regulator nearby, where it can be adjusted. Fine-tune your air to match your paint and the needs of your subject matter. First, with the thinned-down ink, softly spray around the circumference of the sphere. Keep the airbrush moving around the circle.

I'm using about 20 psi (air pressure) with these exercises. There is no hard, fast rule for air pressure. Some artists will use 60 psi for their artwork while another will use 30 psi for the same thing. Artists using the higher air pressure are usually moving their airbrushes faster than artists who uses the lower air pressure. The faster you move the airbrush, the higher an air pressure you will need. This is why it is important to learn and develop your own style, and adjust the air and the paint to suit that style.

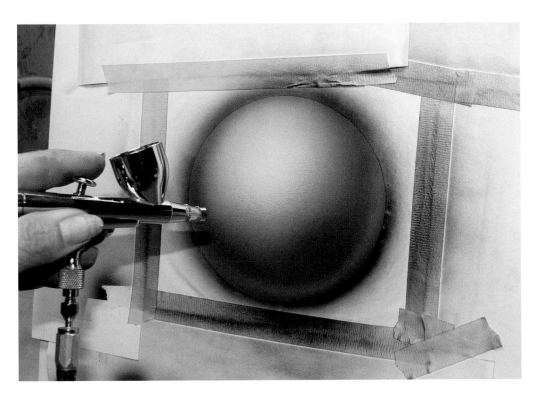

Pick where the light will hit the ball. I picked the upper left. Now feather the color from the edges to the light area. Follow the shape of the ball with the airbrush. Note that the bottom of the sphere has a lighter area along the edge. This will give the area above it a rounder effect, "allowing" it to bulge out. The darkest part of the sphere is just above that light area. It can make all the difference to have the actual item being airbrushed because you can carefully examine it and paint what you see.

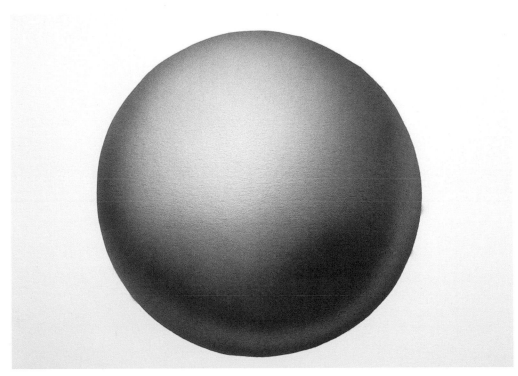

The shadowed areas are gone over again, which is the reason very thin color is used. Go over the areas, building up the color slowly. Now add the highlight. With a Pink Pearl eraser, emphasize the highlight by gently erasing a light spot in the center of the upper-left light area.

The biggest problem new airbrushers will deal with is nervousness. Being nervous will result in short, shaky strokes, spotty fades, and uneven shading. Most mistakes will result from not being relaxed as you work. Turn on the tunes or the TV. Take the time to enjoy learning how to use the airbrush. No one is timing or judging you.

ASSORTED HINTS FOR AIRBRUSHING

Listen to your airbrush. It will talk to you. The variations in the noise it makes will tell you many things, such as paint getting stuck in the tip, a paint obstruction built up on the crown cap, or if it is getting too much or too little air pressure. You will get used to the way your airbrush sounds when it is working properly.

All through this book you will see terms such as lightly, softly, and gently. Airbrushing is a series of nuances. The changes are very gradual. The softer and more gradual you can make your tones as you airbrush, the better it will look. The basic trick to remember is that you can always add more tone, more colors, more shadow, and more highlight. But it is more difficult to take it away.

PAINT MIXING

One of the best tricks for successful airbrushing is having two or three mixtures of each color to use. In most of the chapters, you'll see I have several mixtures of varying thickness for each color.

Now most of the techniques in this book are done on painted metal surfaces, using solvent-based automotive paint. But they can be used with any paint process. The main thing to learn is the technique for handling the airbrush. Once you know that, you can paint on just about any surface.

EXAMPLE OF A JOURNEY

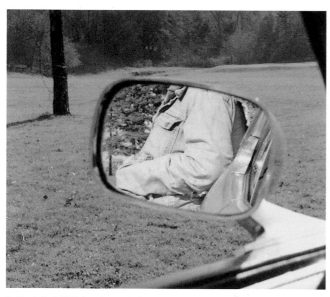

In the fall of 1978, I took a series a photos of my 1970 Mustang. These photos became the source of many of the paintings I did in the next two years. For example, this photo here.

I did a pen and ink in 1979 using the photo as inspiration. The photo gave me the correct measurement and perspective needed to accurately render the mirror and the view from it. I added my friend Sherri's 1967 Firebird in the mirror, as that was what I frequently saw in it throughout my years in high school.

TAPE HINT

Women with long fingernails have an advantage here. By using the end of my fingernail to press and secure the tape to the surface, I run the tape around a sharp curve. The tape holds fast to the surface and doesn't pull away.

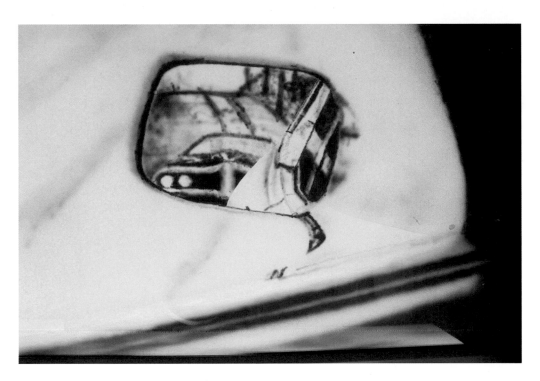

Left: *Later on, it became an airbrush painting. The airbrush's ability to sharpen or blur the focus gave the painting a surreal but real effect. I used stencil for only the hard edges of the mirror and the view of the Mustang in the mirror.*

Below: *Look for ideas everywhere. This stained-glass window has a nice design and the colors are incredible. Great subject matter for an airbrush exercise.*

CHAPTER 5
USING FRISKET FILM AND OTHER TRICKS

This was originally painted back in 1979. It has suffered a little wear and tear over the years, but it still is a good example of what can be done by starting with this very basic technique and then building off it by freehand airbrushing.

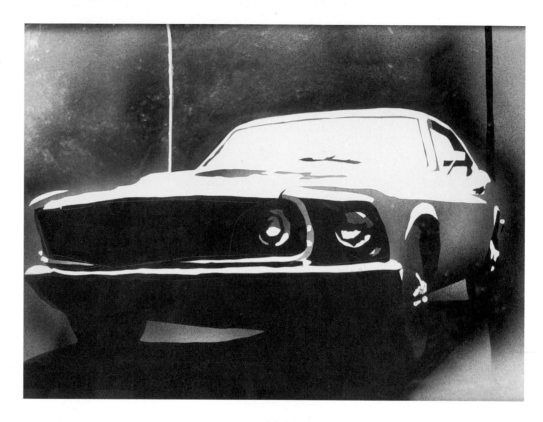

MATERIAL AND EQUIPMENT
- SATAgraph 3 dual-action gravity-feed airbrush
- #11 X-Acto knife
- Light box or window
- Cutting mat
- Illustration board
- Grafix frisket film

Frisket film, even matte finish film, can be slippery stuff to write on. I have found that fine-point ink pens and fine-point permanent markers work great. Make sure to use a permanent ink marker, or else it will easily smudge.

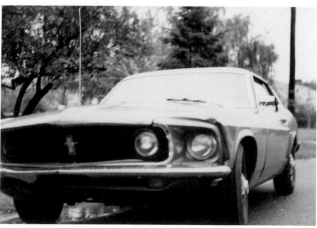

This is a quick and easy little trick. It is a simple way to start out and get great results right away. It also shows just what can be done with minimal airbrushing experience. Find a good photo, decide how large you want the painting to be, and use a computer or copier to enlarge it to the size you want. For this, I'm using a photo of my very first car, a 1969 Mustang. (No, I do not have it anymore.)

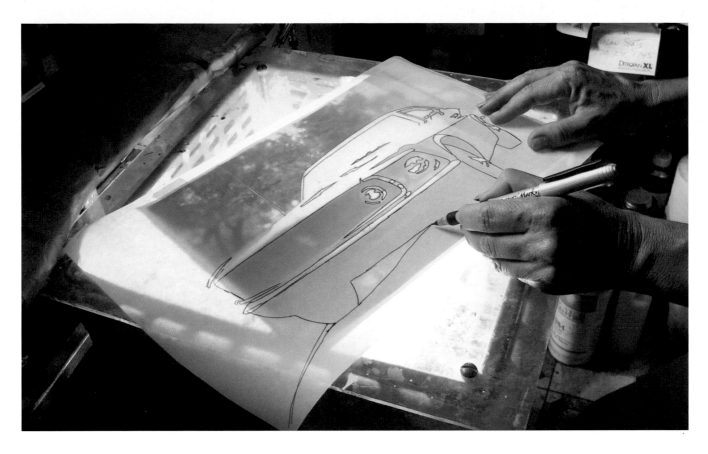

Cut a piece of frisket film the same size as the photo and place it over the photo. Tape it in two places to hold the film in place on the photo. Then put it on a light box or tape it to a window and spend a few moments looking at it. Note the light places and trace them with an ink pen. Here I have traced the light reflections of the windshield, top half of the fender, the wheelwell trim line of both wheelwells, the side window, the top half of the mirror, the top surface of the bumper, the antenna, part of the grille trim, the hubcaps, and the light areas of the headlights.

*Don't cut it yet, just carefully lift the film from its backing and place it on the illustration board. The trick to laying it out on the board is to start at one end and let the film touch down. Then roll it across and onto the surface. Pull a squeegee or plastic spreader across the surface to work out any air bubbles. **Do not throw the backing away!** It will come in handy later. Just put it over to the side.*

Now, with the #11 X-Acto knife, cut along all the lines of the design. Once color is sprayed on the frisket, most of the drawn lines won't be visible. First, I'll paint the black. As each area is cut out, the removed piece is placed on the backing because it may be needed later. You don't have to use them, but many times they will be needed again.

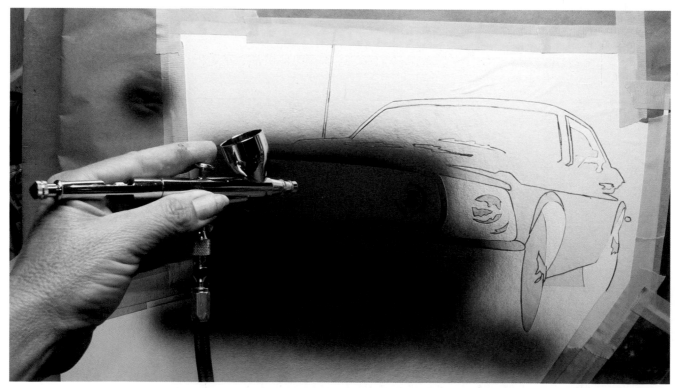

I'm using Dr. Ph. Martin's inks. First I'll use the black ink. On a spare surface, test the color and spray of your airbrush. Make sure it's a soft, smooth spray coming out of the airbrush. If you're getting a grainy spray, either turn up the air pressure or mix a little water in with the ink by putting some ink in a little mixing cup and adding a few drops of water. Practice spraying an even distribution of color on a spare surface. You don't want bands of color across the surface. Now spray the areas of the painting. Go light, and don't saturate the surface. Apply several light coats. I want a flat, even surface, so the airbrush is held back away from the surface. I'm using about 30 pounds of air pressure.

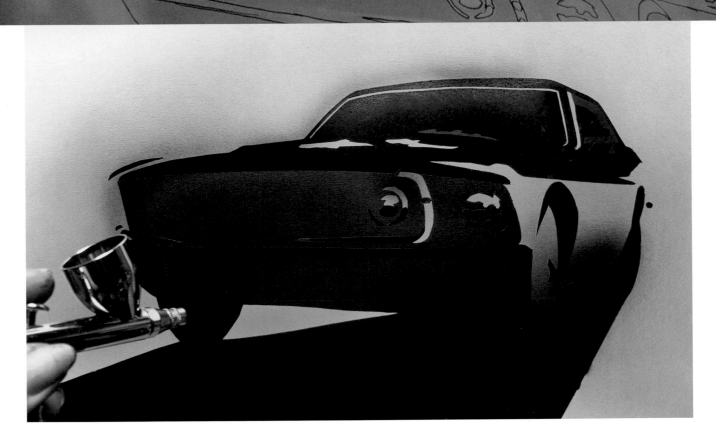

After the black area is dry, I'll pick out the areas I want to be green and remove all the film except for the pieces covering where the white will be. Use care as you remove the pieces and set them on the backing. Go light and easy with the coats. Try to stay away from the black areas. If the green tones do mute down the black, the removed pieces can be used to redefine the black areas. Just allow the painting to dry, put those stencil pieces back down and re-spray some black.

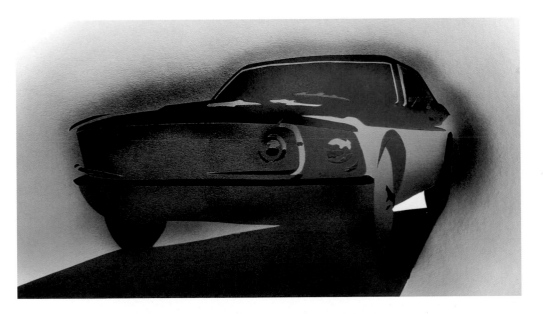

To spray the black fade around the car, I could mask off the green completely. Instead, I'll aim the airbrush toward the edges of the painting as I spray the black and then the green. This way, the overspray goes away from the painted surface. Note how the green I sprayed has softened the black near the headlight and wheelwell. I'll re-spray those areas using the removed stencil pieces as a mask. Note that a piece of stencil was just removed from under the car. The bottom of the car needed to be defined, so now a little green and some black will be sprayed there, leaving the sharp edges already there.

When using any kind of water-based paint such as inks, watercolors, or Auto Air, give the material time to dry in between coats. If too much paint is sprayed on at once, the paint will build up on the frisket and drip down. Paper surfaces absorb much of the water, but it will sit on top of the film and will dry much slower on the frisket film than on the paper surface of the illustration board.

*OK, here is the finished painting.
Quick and simple.*

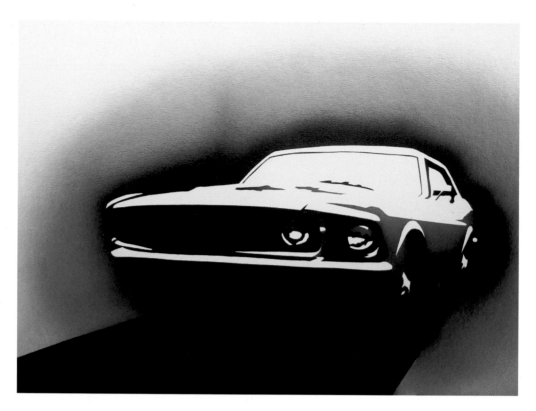

*Still too complicated? Try an
even simpler version like this. In
this single-color version of the
same photo, only a few white
parts are revealed.*

Left: *Don't get discouraged if your first airbrush attempts look nothing like the photo. Back in 1978, I tried airbrushing my first metal effect using this photo of a wheel.* **Right:** *Here are the shaky results. But I didn't let it stop my airbrushing.*

Don't be afraid to experiment when you're starting out. Twenty-eight years ago, I made a few versions of the same painting. Here is one attempt.

And here is the next one. A little better. The tones are more even as I find ways to steady my hand and find more effective ways of using masks.

WORKING FROM DRAWINGS

In 1979, I did this drawing.

I did at least three different airbrushed versions, using the same stencil technique as with the car painting.

CHAPTER 6
METAL SURFACE TEXTURE EFFECTS

One of the most fun, as well as most effective, airbrush techniques is creating metal effects. In this chapter, I'll explain how to use dark and light tones to achieve form. I'm trying something new on this motorcycle oil tank and taking you along for the ride—it turns out to be a rather bumpy ride. I'll be using two different styles of metal effect.

With the first style, I'll be using silver foil leaf as a base. The silver leaf was gilded on, and then three layers of clear urethane were applied, left to dry, and then wet-sanded. It is this base I'll be working over. The hope is that the silver leaf will give the metal effect even more of a metal look by having the foil reflecting up through the airbrushed tones.

MATERIAL AND EQUIPMENT

- White basecoat
- Black basecoat
- ⅟₁₆- and ⅛-inch green fineline tape
- ½- and ¾-inch masking tape
- Gerber mask
- SATAgraph 3 dual-action gravity-feed airbrush
- Richpen 213C dual-action gravity-feed airbrush
- Iwata HP-C Plus dual-action gravity-feed airbrush
- Uncle Bill's Sliver Grippers
- Mechanical pencil
- 6-inch steel ruler
- #4 X-Acto knife
- Roland GX-24 Camm 1 plotter
- Compass
- Steel eraser template
- Coast Airbrush storage bottles

This airbrushed metal effect is done over silver leaf. I'm trying to give it a real 1940s World War II look by using the rivets and giving it an aged feel.

The thing to remember about surface texture effects is how the light hits the surface and plays across it to cast shadows. A camera will come in handy for this project. Need to airbrush a tree? Simply go out in the yard and take a picture of the trunk and the leaves. Texture is rough, and rough means an uneven surface. Some parts will be in shadow, some parts in light. Actually, most airbrushing is all about texture and capturing it. The texture of skin, rock, fabric, feathers, fur. It's all about lights and darks. If you break it down into those two elements, it gets much easier. Not sure if you're getting the right mix of lights and darks? Stand back from your artwork, squint, and look at it. This simple exercise of putting the subject matter out of clear focus will break down your painting into those two elements. Then you'll see where you need to adjust them.

Here's what I started out with. The light area on the oil tank is the silver leaf with the sanded clear coat over it.

I'm going to airbrush a metal circle in front of the graphic. I'll draw a circle with a compass. Note the pad of green masking tape under the point of the compass. In order for this sharp point not to dig into the painted surface, I cut pieces of tape and stack them up to create a pad for the point to rest on.

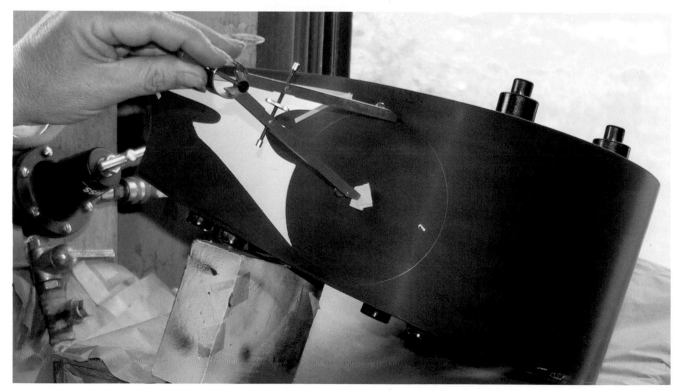

66

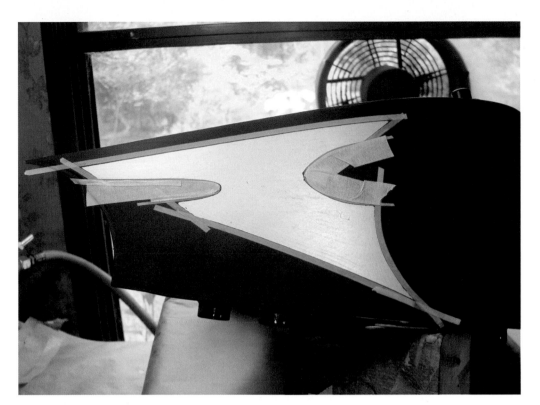

Now the silver foil graphic is taped off using a combination of green fineline and masking tape. Getting the fineline to hold in the tight curves can be a challenge. I find that gently stretching the tape as it goes around the curve, and then firmly pressing it down in place is effective. When trying to tape off tight corners, chances are it will take two or three tries to get it in place correctly.

Next, the bottom edges of the graphic are taped off. What I'm trying to do is give the illusion of three dimensions by showing the sides. Quarter-inch fineline tape is run along the bottom edge. The tape will neatly space off that side. For the tighter corners, I use two smaller sizes of fineline run side by side in order for the thickness of the side edges to match each other.

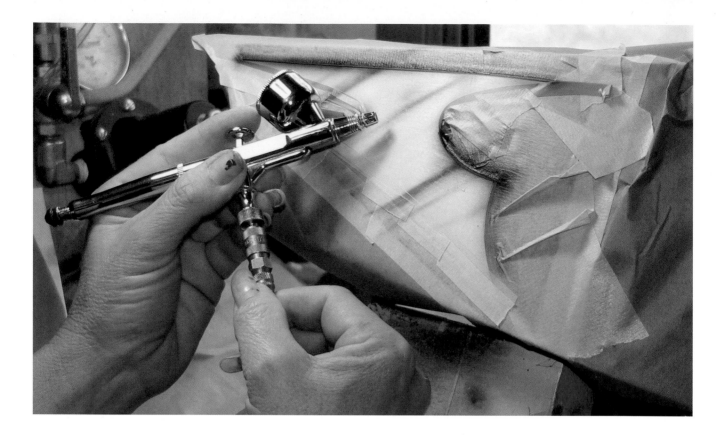

Now for the easy part: painting the light and dark tones. I make up two mixtures of white and two mixtures of black. There is one thick mix for overall shading and one mix that is thinner. The thinner mix will be used for most of the shading because the softer tones will be more effective. Start out with the black. Think of the way the light will hit the metal. At the upper edges, it will catch the edge and cast a shadow, while at the bottom it will catch the light. The black is airbrushed along the surfaces that face toward the top of the oil tank. If too much paint was airbrushed on, it would completely cover up the foil. So, light streaks of black are sprayed across the surface at an angle.

Next, white is softly sprayed along the edges that face toward the bottom of the oil tank. It is also sprayed in between the lines of black, concentrating the white at the bottom and tapering it off toward the top. Note the way I'm holding the airbrush. I find that holding the brush in the direction I'm painting makes for a finer line. Keep the shading very soft, and avoid hard or dark lines.

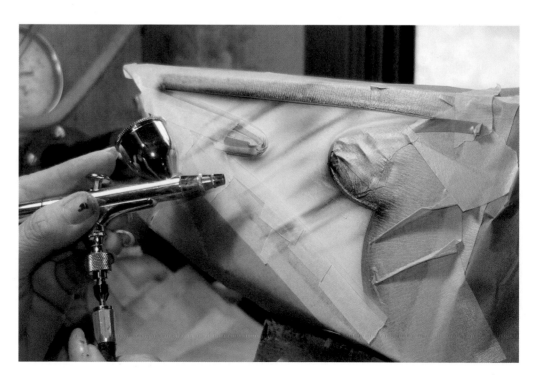

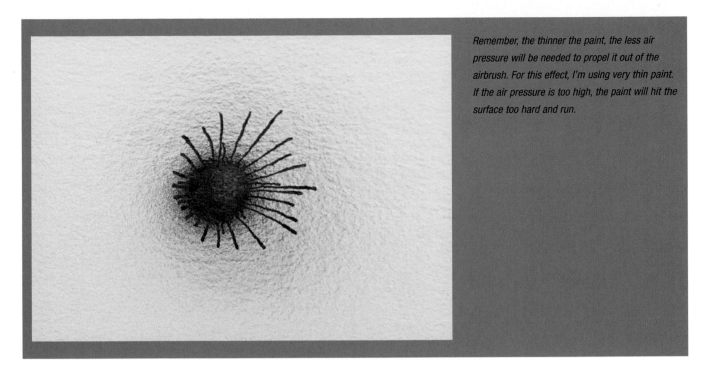

Remember, the thinner the paint, the less air pressure will be needed to propel it out of the airbrush. For this effect, I'm using very thin paint. If the air pressure is too high, the paint will hit the surface too hard and run.

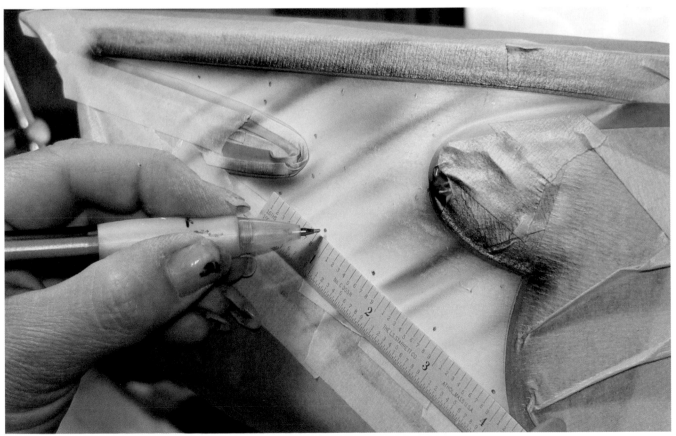

I need a row of rivets along the edges of the top facing surface. Adding rivets will really give it a heavy metal look. Using a pencil, dots are made in all the corners of the design. Then, using the ruler, I measure from corner to corner and evenly space out the rivets. Notice how lightly I sprayed the black and white. It looks more concentrated from various angles, but in this picture, you can see just how thinly it was applied.

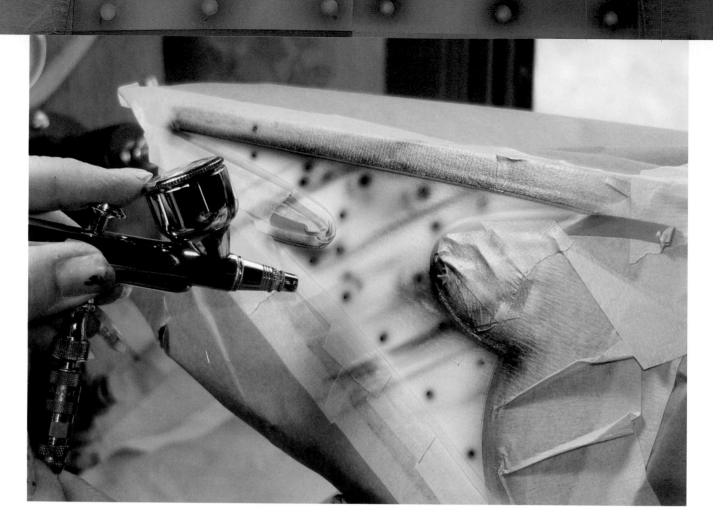

Above: *OK, here's where those dots from Chapter 4 come in handy. With the thinned black loaded in the airbrush, line up the end of the airbrush with each dot. Pull gently back on the trigger and spray a small hazy circle over each dot. Next, imagine how metal looks after it has been drilled and riveted. The metal around each hole will be slightly raised to create shallow hollows around each rivet. Airbrush impressions (very lightly) of the hollows around some of the holes using black. Don't do it on all of the holes because it would be too uniform. The metal surface should have a rough, random look to it. Then, with the thinned down white paint, very lightly airbrush a slight highlight between the "hollow" and the dot. Again, keep it random. The combination of white for high points and black for hollows is very effective. Note the dot that was sprayed on the green masking tape on the upper left side. That was where I checked the spray of the airbrush to make sure it was spraying nice and even, and not grainy. If you start spraying and see the paint landing in a grainy spray instead of a soft, even spray, stop spraying. Refer to Chapter 14, Problem #5.*

When looking at these photos, pay close attention to how I hold the airbrush, how I angle it for various airbrush strokes, and how I support my hands while I'm airbrushing. As you become familiar with airbrushing, you'll find what feels comfortable for you and which airbrush positions give you the best result for the kind of stroke you're making.

Opposite: *Now, here's the little trick. Make up some circle stencils using vinyl mask material. These stencils will be used for the rivets. Why use this instead of frisket or a circle template? The circle template will allow some paint to sneak under it and this means the rivets will have a slight hazy edge to them. In order for the metal effect to look real, the rivet edges have to be very sharp. If using auto paint and regular frisket paper is used, adhesive may be left behind and cleaning the adhesive off could affect the artwork. If using non-solvent-based regular airbrush paint, you can use the frisket paper. This is why it is important to know your materials and how they will react with each other. Now you can use the circle template to draw out a few circles in the size needed. A number #4 X-Acto knife will easily cut them out.*

When working this small, the frisket paper can tear fairly easy. That's why I'll use vinyl stencil material for my hand-cut stencils. Here, I used my plotter to cut circles in the vinyl. Next, place the circle stencil over the center of the black dot. If it's hard to find the center, use a white pencil to mark the center. That will make it easier to line up the circle. White is softly airbrushed and directed at the center of the hole. Then black is very, very lightly sprayed around the edge of the circle. Next, with the white, spray a tiny highlight in the very center. Note the test sprays on my circle stencil? I'm constantly testing the airbrush pattern before I spray, especially when airbrushing soft highlights. I'm looking for a soft dot, not a bunch of grainy specks. By turning the airbrush away from the paint surface, I'll "clear" out the airbrush by spraying a quick blast of paint through the brush. Clearing the airbrush removes the buildup of paint on the airbrush tip. For water-based paints, you'll have to pick the paint off by hand.

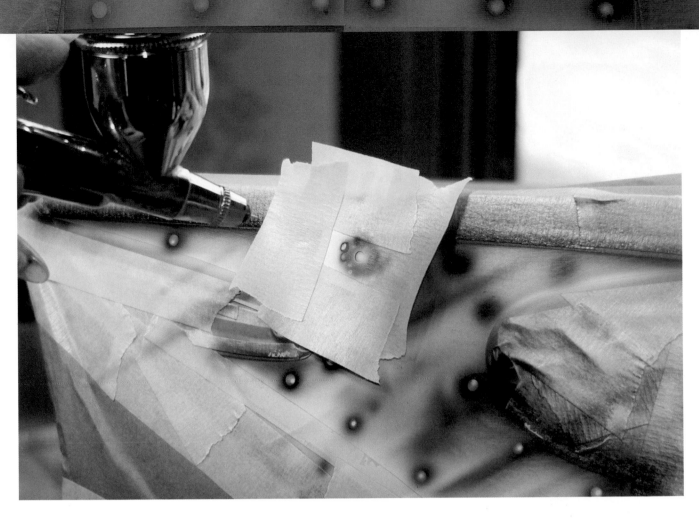

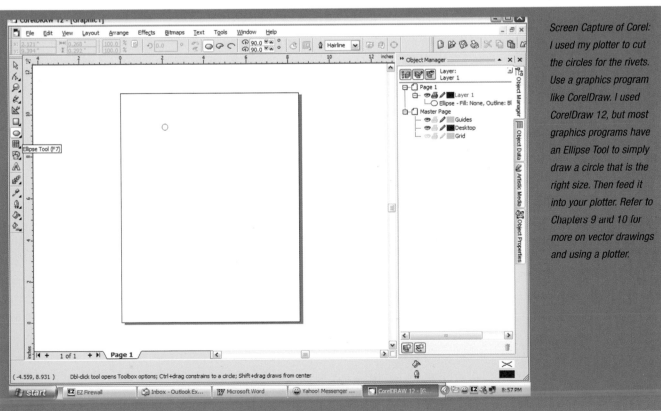

Screen Capture of Corel: I used my plotter to cut the circles for the rivets. Use a graphics program like CorelDraw. I used CorelDraw 12, but most graphics programs have an Ellipse Tool to simply draw a circle that is the right size. Then feed it into your plotter. Refer to Chapters 9 and 10 for more on vector drawings and using a plotter.

Right: *The finished rivets. The surface is starting to come to life.*

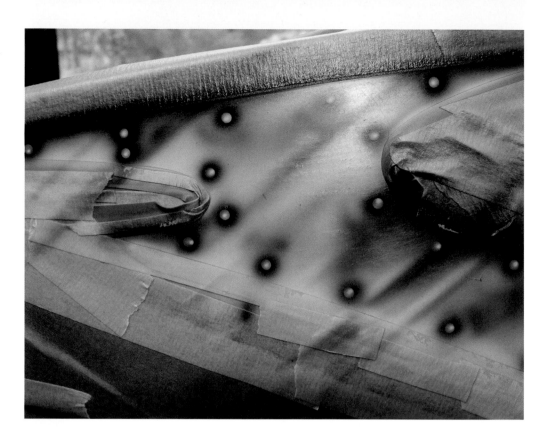

Below: *Next, the fineline tape over the sides is removed.*

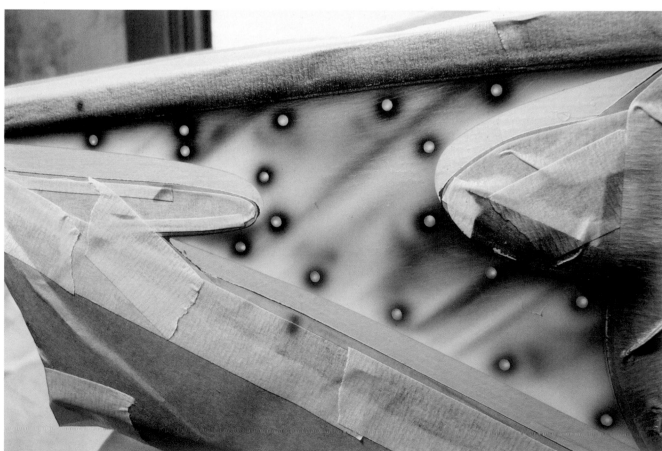

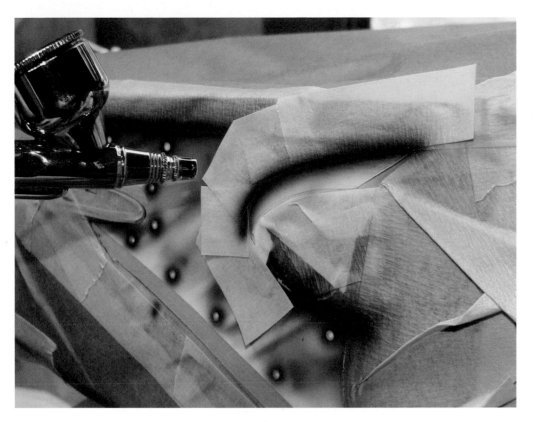

Left: *And the sides are taped off and airbrushed. Black is sprayed just below the edge of the "top surface" of the graphic as that part is in shadow. A small bit of white is very lightly sprayed along the lower edge.*

Below: *Spraying along the edges. The 3-D effect is starting to show. Note the position of my hands and how I support and steady the airbrush in order to get a smooth, even tone across the edges.*

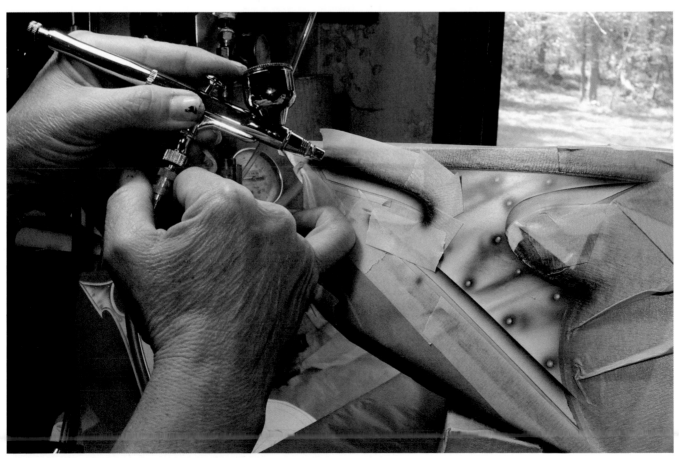

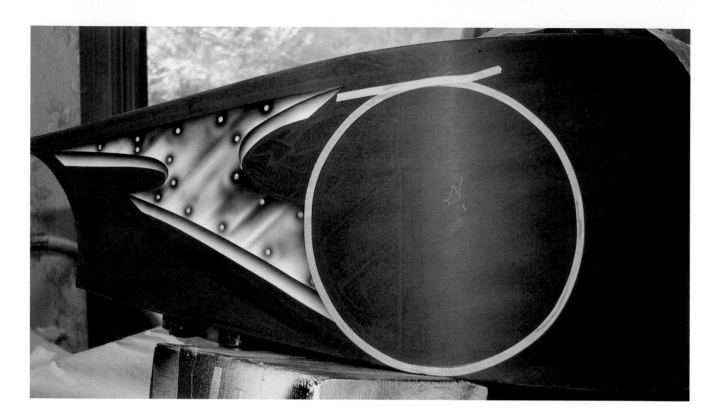

The masking and tape is removed. First, remove the masking paper. Then remove the tape by pulling it back against itself. Next, using ⅛-inch green fineline tape, I masked off the circle using the pencil line from the compass as a guide.

Above: *My goal is for this circle to look like an old, beat-up metal panel made up of four pieces of metal riveted together and held in place by a riveted metal ring. Using the compass, the ring is drawn inside the circle. Note the pad of masking tape under the point of the compass.* **Right:** *Using the ⅛-inch tape, the inner circle is taped off. Note how I use my fingernail to burnish down the tape as I stretch it around the curve of the circle. The trick to successful curve taping is to gently pull or stretch the tape as you run it along the curve.*

Left: *Now, with the black and the white paint, I fog in the circle. First, black is sprayed to cover up the red base. Next, white goes on lightly and is airbrushed at an angle. A light shading of black is airbrushed around the edge of the circle to create a shadow and a little more white is airbrushed. Just play around with light shading to form the base or surface for the metal effect.* **Right:** *The circle will be split into four quarters. The quarter on the upper left has already been airbrushed. Here, the right quarter is taped off using ¼-inch green fineline tape and is ready to be masked off and airbrushed.*

Left: *OK, now this is the tricky part, and it is handy to have photos of beat-up metal or even a piece of metal that has been hammered and dented. Painting these bumps in the metal is a lot like painting the folds in fabric. It's all lights and darks, low points and high points. Airbrush black in the areas where you imagine the low points of the dents to be. With the black, I sketch out where the dents will be. Dots are also sprayed along the edges because there will be rivets in those places. The trick is to spray softly, lightly, with both the dark and light colors.* **Right:** *White is now sprayed in between the black areas. Make sure the white is nice and thin. Go very easy. Start very lightly when airbrushing the white. The transition between the white and black has to be very, very gradual. Note how I'm still testing my airbrush spray on the tape before I spray on the painted surface. The trick here is to spray light!*

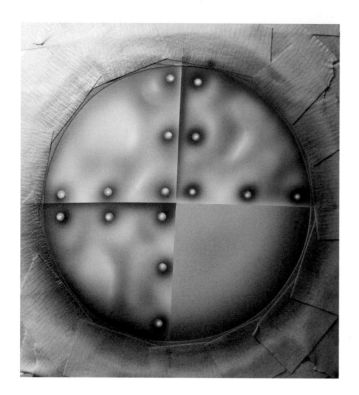

Left: *Three quarters are done. Check out the seams of the quarters. For airbrushing to look real, you have to determine the correct light direction. I usually imagine my light source to be coming from the upper left. See how the edges of the upper left quarter are airbrushed with white? Next to it on the upper right, the vertical edge of that quarter is in shadow and the bottom edge is lit up. Down and over to the left, the top edge of the lower left quarter is in shadow as the bottom edge of the upper quarter is shading it. The rivets are painted on using the same technique as shown previously in the chapter. Note how subtly the black and white are airbrushed.* Right: *The last quarter is airbrushed in. All the edges are sprayed with black as they are in shadow. The very subtle shading of light and dark gives the surface an illusion of actual dimension and form. Note the white marks in the middle of the black dots help in lining up the circle stencils. The riveted areas are ready to be "riveted."*

Left: *The inner circle of tape is removed. Funny what a little black and white paint can do—it looks like metal.* Right: *Now the metal circle is taped off, and the outer part is revealed and masked off.*

The same principles of airbrushing apply. Figure out where your darks and lights need to be and then paint them there. The upper part of the circle is in shadow, and light catches the lower edge. White is very lightly sprayed along the straight side of a template to create a reflection line. Again, keep these lines random.

Well, the metal graphic looks good and the metal circle looks good, but they do not look good together. The design just looks awkward, so a change must be made. Clear coat was applied over the silver leaf of the graphic. The circle will be sanded off, and the artwork on the oil tank will be redesigned to suit it better.

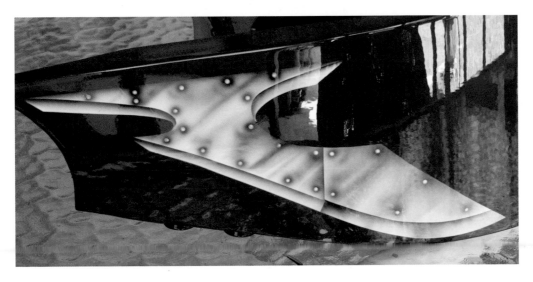

Here's the tank after I redid the artwork. This project shows that while sometimes an idea works on paper, in reality it doesn't look quite right.

77

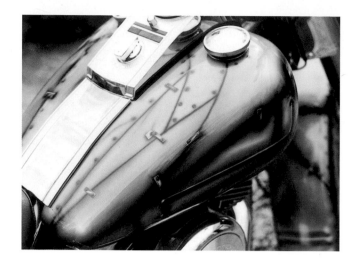

An early metal effect that I airbrushed about 15 years ago.

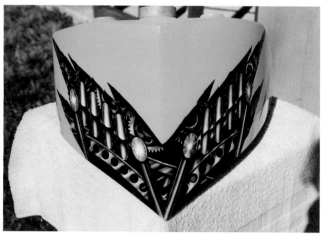

More examples of metal effect.

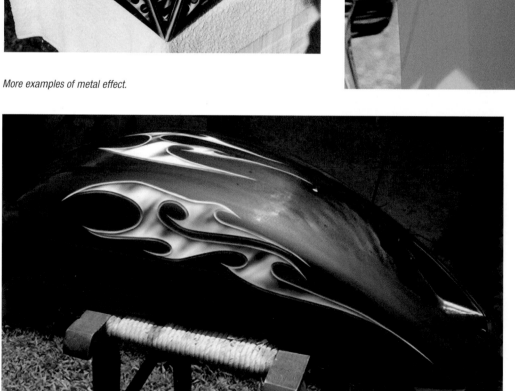

Metal effect flames.

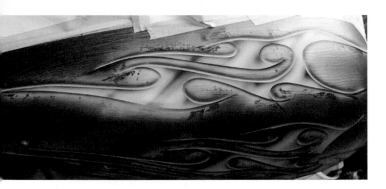

This is what the metal flames looked like before the stencil material was removed. Big difference.

Here's a granite-textured surface that was airbrushed.

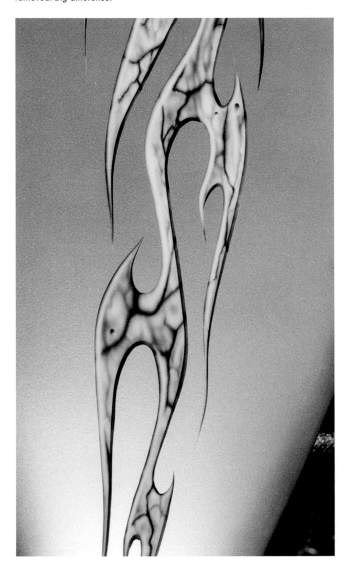

This bone-effect surface is pretty fun to airbrush because it is mostly done freehand. Note the highlight running along the edge combined with the soft black shadow next to it. They give the artwork a form that makes it look three-dimensional.

Another vacation photo that was taken years ago that came in handy for figuring out how to paint rock texture.

CHAPTER 7
WORKING WITH STENCIL LAYERS

As seen in Chapter 2, there are many different items that can be used as stencils or masks. In this chapter, you'll see how to work in multiple layers of stencil using three different materials. Airbrushing a flower is one of the simplest things to paint, yet the use of multiple masks results in surprisingly detailed results.

MATERIALS AND EQUIPMENT

- Light box
- SATAgraph 3 airbrush
- Iwata HP-C Plus airbrush
- Pencil
- Masking tape
- #4 X-Acto knife
- Iwata Eclipse airbrush
- Cutting mat
- Grafix frisket film

Above: *This is a photo I took many years ago in my garden. It will be used as a reference for painting a rose.* **Below:** *First off, I use a copier to enlarge the photo to the size needed. Then a piece of frisket paper is cut the same size as the enlarged copy, taped over the photo, and placed on a light box. A pen is used to trace the main lines of the rose, the individual petals, and the outline.*

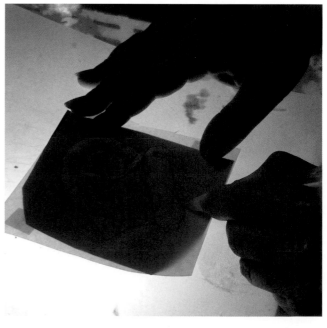

Left: *There are many things going on in this artwork, but the roses stand out. Getting results like this is simpler than it appears.*

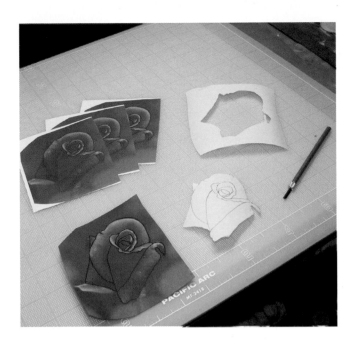

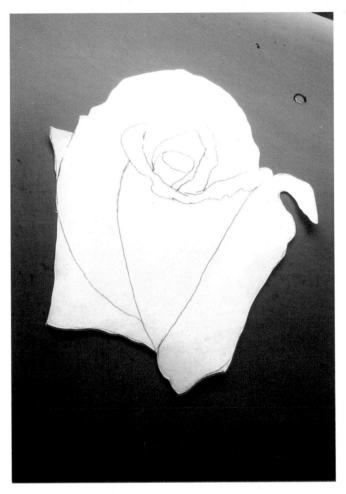

Above: *The rose is cut out of the stencil using a #4 X-Acto knife and a cutting mat. I've also made a few paper copies of the rose to use as stencil pieces in case I need them.* Right: *The cutout rose is placed on the artwork surface using a piece of rolled masking tape to secure it.* Below: *The stencil outline is now placed around the cutout. Due to the curved surface, the stencil is cut apart and then applied around the cutout rose. Any gaps in the frisket are covered with the masking tape.*

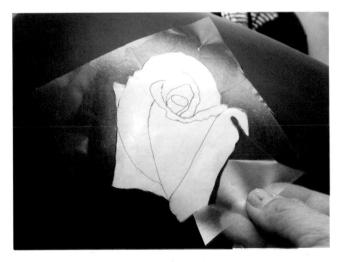

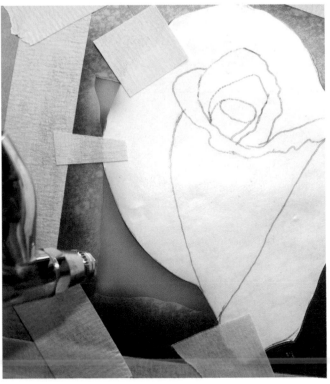

Right: *Here I'm using solvent-based auto paints, and the mixing ratios of added reducer are only for auto paints. For the rose colors, I mix up a pink using opaque red with some white and some transparent red/purple. For the shading, I use transparent red cherry thinned about 175%, plus some black thinned down about 200% for any dark shadows. The cutout portion of the rose will be used to create masks for the rose petals. I'll start with the lowest petal and work my way up. Look at the way the light hits the petal and airbrush that first. Don't fill the space with paint. Using the pink paint mix, airbrush across the petal only, allowing the overspray to fade towards the edges.*

Left: *Then, with the thinned cherry, fade in around the edges and along the body of the rose. A slight touch of black is sprayed along the taped cutout.* **Right:** *Here's what it looks like when the cutout is taken away.*

Left: *Basically, this process will be repeated for each petal, starting with the outer petals and working in. Next, the right side is done in the same way. Airbrush the pink through the middle of the petal. Then shade the edges.* **Right:** *The outer layers that have already been sprayed are masked off using either tape or clear transfer tape. The transfer tape is put down and then trimmed with an X-Acto knife. I use a combination of transfer tape and masking tape.*

Left: *Another petal is trimmed from the cutout using fine scissors, and it masks off the inside edge of the petal. The painting process is repeated. Airbrush the pink where the petal curls around, and shade with cherry and black where it rolls back.* **Right:** *On some of the petals, the edges have a line of lighter tone. The trimmed-off piece is held up near the edge, slightly offset, and pink is very lightly airbrushed along the gap.*

Left: *Here's what the petal looks like finished.* **Right:** *Clear transfer tape masks off what was just done and another piece, the body of the rose, is cut from the cutout. The remainder of the cutout is taped in place, and the process is again repeated.*

Above: *The body is finished. Another petal is trimmed from the cutout and it is taped in place again. The body will be masked off with transfer tape.*

Above right: *Look closely at your reference photo and airbrush what you see. Here there is a soft glow on the very edge, so a soft line is airbrushed along the edge.*

Right: *Looking at the photo, the next petal has a hard edge, so the piece from that petal is used to create the light edge.*

Left: *The smaller the pieces get, the harder it is to hold them down so that paint doesn't sneak in underneath. A #4 X-Acto knife is used to hold down the tiny inner cutout piece as I airbrush the dark shadow along its edge.*

Below left: *Finally, the cutout piece is too small, and a curve on an Artool Freehand Shield is used to spray the last petal.*
Below: *Here is the finished rose.*

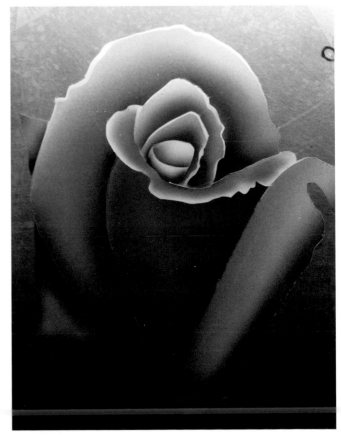

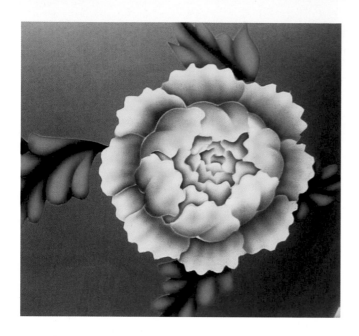

Here is a stylized chrysanthemum that was airbrushed using the same process.

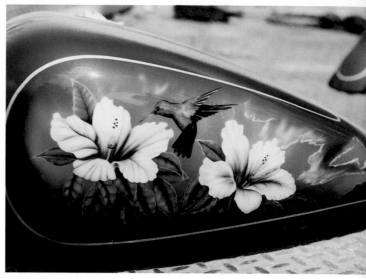

Look for various objects that are easier to airbrush than others. These lilies have fewer petals, and that makes them an easier flower to paint than a rose.

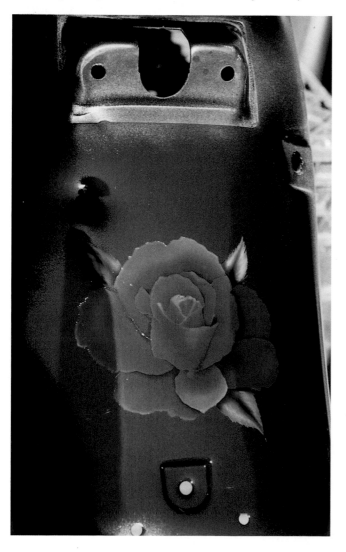

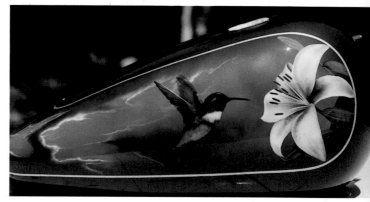

Above: *It's easy to get good results when airbrushing flowers this big.*

Left: *I had a great reference photo for this perfect rose, which is the reason it came out so well.*

CHAPTER 8
AIRBRUSHING A WOLF

Animals are one of the most popular things to airbrush. Airbrushing is all about texture, and using the airbrush to create the illusion of different surfaces. Duplicating the soft, layered effect of fur can be very challenging. At times I have used precisely cut, "ragged edged" stencils and combined their use with freehand strokes. If you are airbrushing a fur effect for the first time, be prepared to spend some time experimenting with your stroke. Hold the airbrush at a sharp angle to the surface and try to softly airbrush in the direction that the fur grows.

Do not get discouraged. This skill is something that will take time to perfect. Airbrushing fur also means that those dagger strokes will come in handy. Keep your paint thin and the pressure low. The biggest mistake people make is that the strokes look sharp and "blobby." Poor strokes are from too much pressure and not keeping the stroke soft. Don't try to draw out each piece of fur. You're airbrushing groupings of fur. Study the finished pictures in this chapter and note how the fur is airbrushed. There are very few long, drawn out strokes with the airbrush. It is mostly short, soft groupings of different tones, with a few long strokes thrown in randomly.

Your first wolf may look like a fuzzy dog. The trick will be in the eyes. The eyes need to be clear and sharp.

MATERIAL AND EQUIPMENT

- White base coat
- Black base coat
- Burnt sienna base coat
- Brown/black mix base coat
- Grafix frisket paper
- Masking tape
- Pencil
- Fineline permanent marker
- White Stabilo pencil

- SATAgraph 3 airbrush
- SATAgraph 1 airbrush
- Iwata HP-C Plus airbrush
- Richpen 213C airbrush
- Light table
- X-Acto #4 stencil knife
- Cutting mat
- Coast Airbrush storage bottles
- E-Z Mix cups

This wolf was airbrushed using a combination of freehand and stencil techniques for the fur. The backing from the overall stencil was saved and used. If you look closely at the fur, you can see the sharp edges where the paint was sprayed against the stencil.

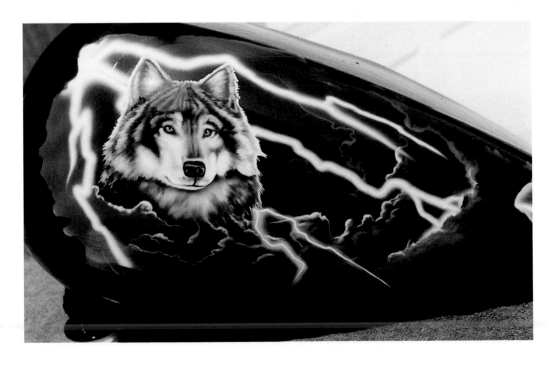

Right: *I have an extensive reference file of wolf material that I have collected over the years including books, cards, pictures torn out of magazines, and photos stored online. I usually draw up the wolf I need, then go through the books looking for wolves that have comparable features. Those photos, if in a book, get marked with sticky notes and other photos are put aside. I usually narrow the photos down to just a couple. Never directly copy anyone's photographs. Use them for reference and inspiration only.*

Below: *The first wolf face I ever painted came out great. But I mistakenly painted it upside down on the part, a motorcycle dash. As a result, I still have the dash. Here, I've done a drawing based on that original painting.*

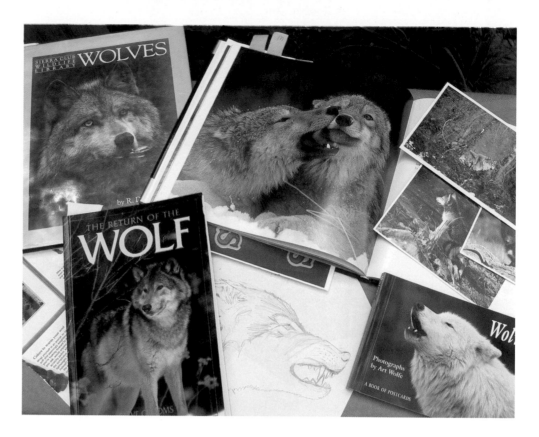

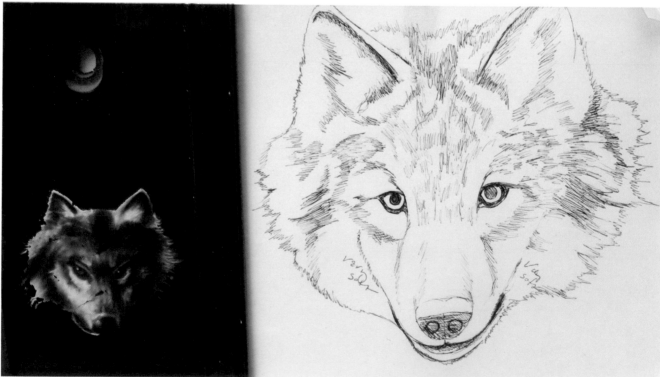

Always keep the backing from your frisket material. It will come in handy for freehand shading and shield use.

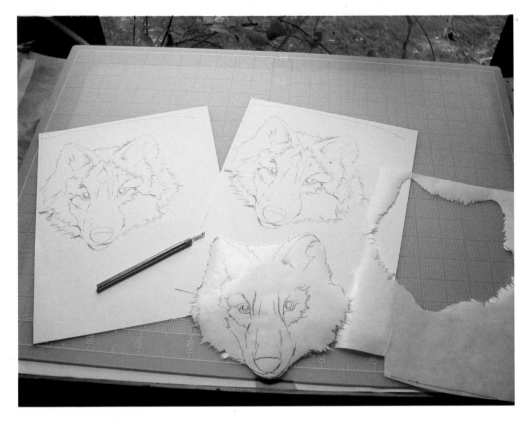

Left: *Using a light table, a piece of frisket paper is placed over my drawing, and the drawing is traced using an ink pen or permanent marker. The stencil is cut out using a #4 X-Acto knife on a cutting mat. The surface of the mat allows for fine detail in cutting the edges of the stencil. Keep the "furry fringe" random on the edge of the stencil. The fringes should be going in different directions and be various lengths. Also, paper copies are made of the drawing. The copies will be used as hand-held stencils and shields. Details like the fur edges and eyes will be cut out.* **Below:** *The cutout from the main stencil is placed on the tank with tape and lined up. I decided to add paws, so it looks as if the wolf is jumping out from the darkness.*

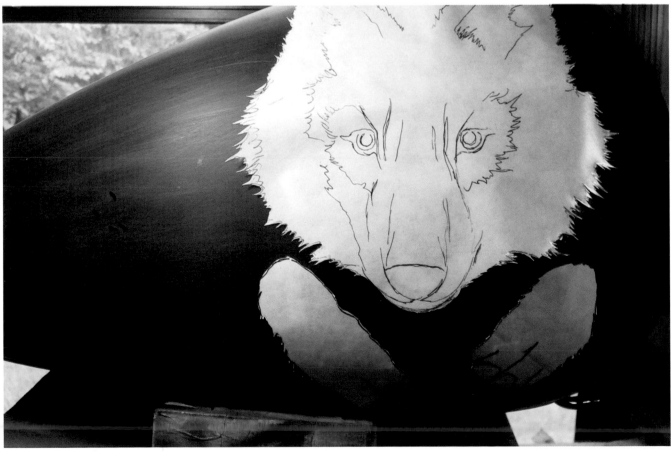

Next, the backing is removed from the frisket material and the stencil is placed around the wolf cutout. Remember not to throw the backing away so that it can be used as a freehand shield for fur outlines. Since the tank is round, the stencil needs to be cut apart and then assembled around the wolf face. Even if this were a flat surface, I still would cut the stencil, maybe in half or into quarters. It's just easier to lay down the stencil pieces when they are not so large. The stencil tends to flop over and stick to itself. If it is smaller, it tends not to do that. There are gaps, because the pieces don't line up perfectly. Any spaces are taped up, and the rest of the tank is masked off with masking paper.

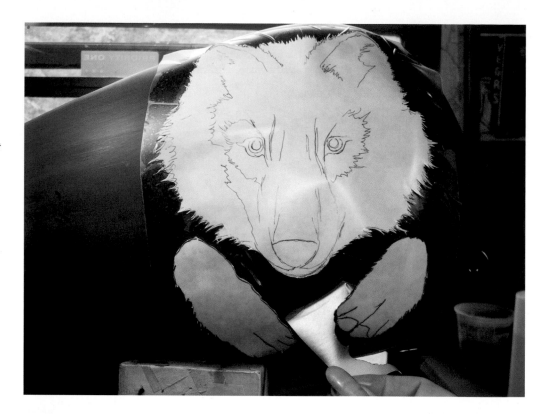

I usually start with several mixtures of paint, so that one is thicker for overall painting and the other is thinner for detail shading. Here I'm using white and black base coat. White is squirted into an E-Z Mix cup, and a little black is added, but not too much. This mix will be the main color for the wolf. It is loaded into a gravity-feed airbrush and lightly but evenly sprayed over the entire face. Do not worry about coverage here. Go light to avoid a heavy paint edge.

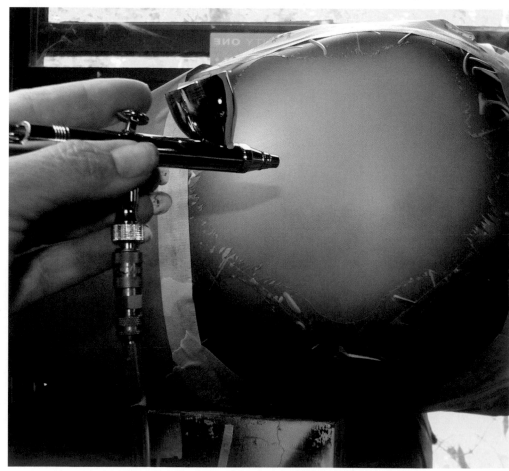

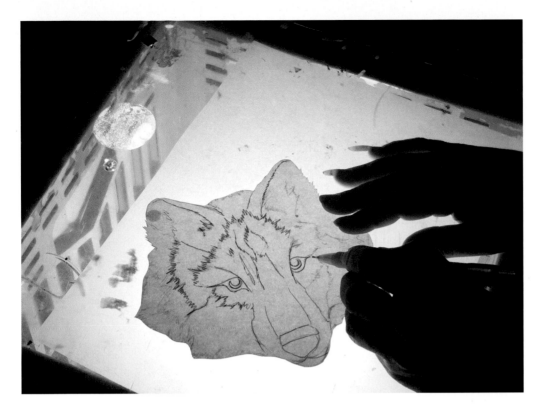

Left: *One of the wolf face copies is cut out, flipped over, and placed on a light table. Use a soft lead pencil to trace all the details on the reverse side: eyes, nose, and fur.*

Below: *The copy is placed over the stencil on the tank and taped in place. Use an ink pen or pencil to trace along the lines and transfer the details to the surface of the painting.*

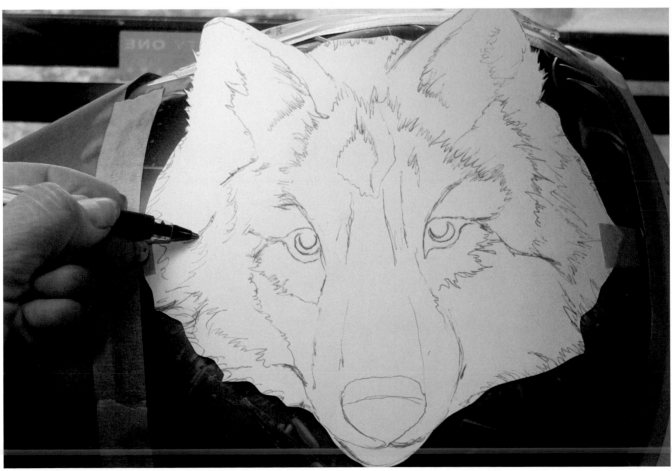

91

Most of the time the image can be very light, so I have to go over it with a pencil. Now it's basically a matter of "filling in the blanks." I'll start by airbrushing black over the lines.

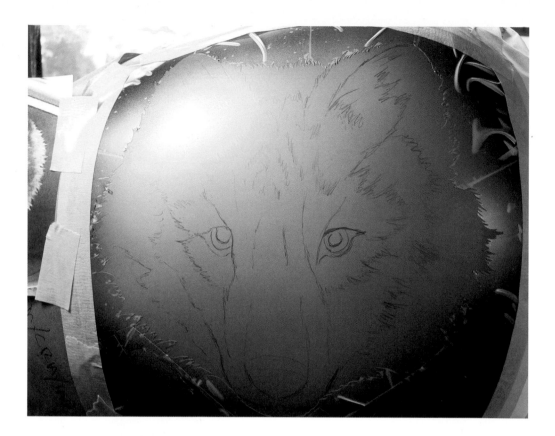

Several tricks are going on here. The crown cap or spray regulator has been removed from the airbrush, which makes it possible to get right up close to the surface. Because I am so close, I have to be careful with the air pressure. I'm using a thinned down black (thinned about 175 percent) and the pressure is 17 pounds. Also, I hold the airbrush at a very sharp angle to the surface so that it is nearly parallel. In this photo, I'm roughing in the face. I simply go over the pencil lines with black. My reference photos are close by so I can see how the fur lies around the face.

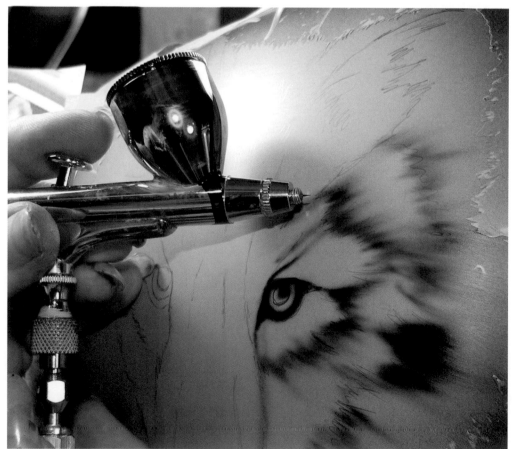

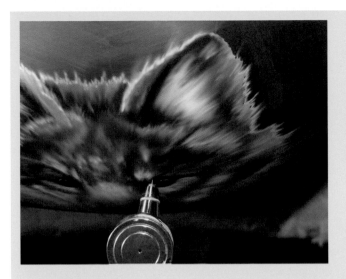

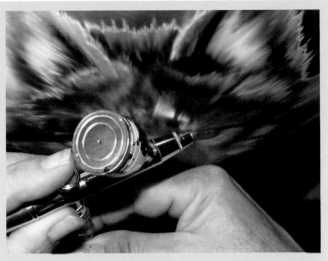

Left: *Most airbrush techniques have the artist holding the airbrush at a 90-degree angle to the surface. I find for most close-up detail work, this angle doesn't give me the best results.* **Right:** *For extreme detail airbrushing, where I need very fine lines, I hold the airbrush nearly parallel to the surface, so that the paint is coming out in the direction of the lines I am spraying. This angle allows the paint to fall more naturally onto the surface to create a softer, yet more even, line. Note how I'm holding the airbrush with two hands. One hand holds the airbrush, and the other supports the airbrush at the hose to help steady and guide the other hand. Try this technique to see if it improves your airbrush strokes. Please also note that these pictures accurately show the airbrush strokes for the various lengths of fur.*

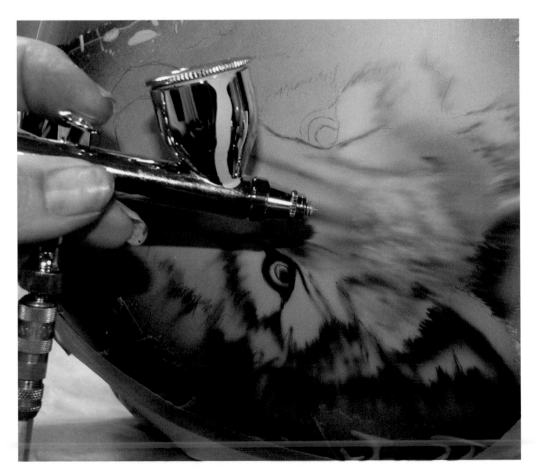

No, this picture is not sideways. I have turned the tank sideways. I find it is easier for me to airbrush from side to side rather than up and down. Instead of fighting a weakness, I simply turn my work surface. This adjustment is not always possible, but most of the time I can turn the work surface to suit my airbrush technique. Now I have started filling in between the black using the gray color I mixed. Note the short strokes. I'm just randomly skipping around here and applying little bits of gray.

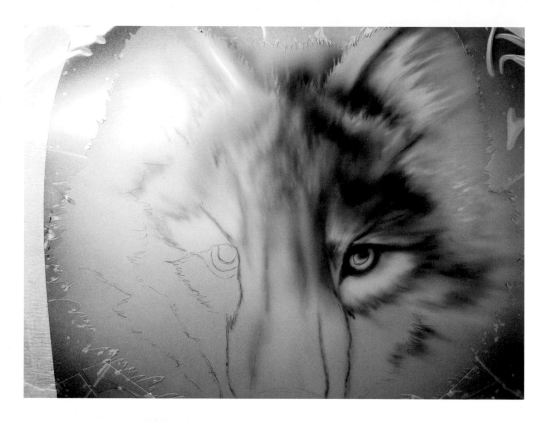

My technique is working pretty well. I'm airbrushing the light areas of fur rather than each hair. I'm keeping it random, light, and I am not overworking it. Note the left side of the right ear. This is one place where I'll use the backing as a shield. The finely cut fringe edge of the backing makes a perfect mask for the edge of the ear.

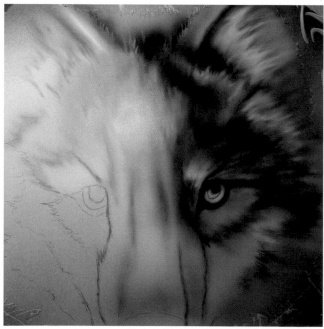

Slowly, the color layers are built up. Softly airbrush the black shadows, then switch to gray and fill in between the black. Now add some color. Brown/black mix is squirted into a mixing cup and some white is added. Then a few drops of burnt sienna are put in as well. Again, I refer to my photos and see that the brown in a wolf face is located in specific areas, but in a random sort of way. My brown mix is very thin, so I can layer it on without obscuring or covering what it is underneath.

I don't paint wolf faces every day; in fact, I can go years without painting one. I will only paint a wolf face if a customer requests it. Some things, like skull faces, I will paint very frequently. Sometimes I do get out of practice with things I don't paint very often. Yes, artists do get rusty at painting certain things if they only paint them occasionally. The more you paint a certain subject, the further you explore it, and the more you perfect your technique. Never forget, art is a journey. I have not taken the wolf face journey in about two or three years. So, I'm taking my time and making sure I have as much help as possible. This means having the best "directions." Nearby my work area, I have photos of my best wolf murals and the most effective reference photos I can find. Most importantly, I do not freak out when I find that it doesn't look the way I want it to after I've painted for awhile. Actually, I was pleased with this mural. I took my time with it, really studied my earlier work, and asked questions. Why did it look so good? What did I do differently compared to wolf murals I was not happy with?

94

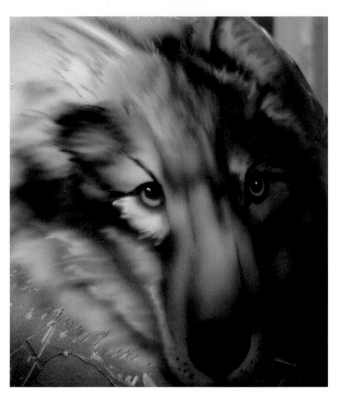

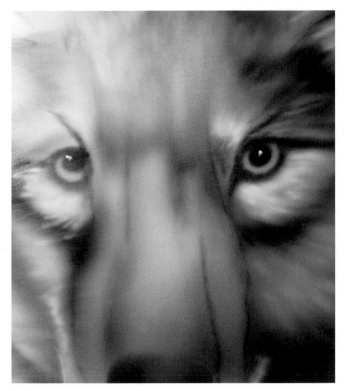

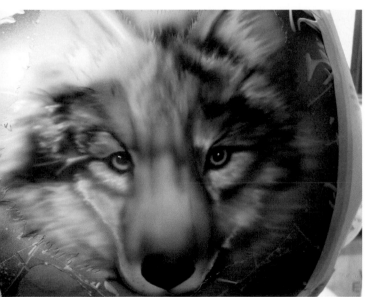

Top left: *OK, I've tried out my technique on the right side of the face and I like the results. So it's on to the left side. Go over the pencil lines with the black and fill in with the gray. Note how light the gray looks against the black. That's not white, even though it appears to be nearly white.* **Top right:** *This photo really shows the lightness of the paint strokes. They're very soft. I'm really trying hard not to overwork this face. The eyes have been airbrushed freehand. More gray is layered over the brown that was airbrushed under the eyes.* **Above left:** *Whoa, this baby is almost done. I still have to turn the tank sideways and work on the muzzle and ears. I learned a lot today from thinking about and looking at that first wolf face I painted so many years ago. That face was completed in less than two hours. I kept the strokes light and random then, and I'm doing the same thing now.* **Above right:** *Here I'm working on the ear and airbrushing lines of gray fur. Long strokes were used where needed, and short strokes were added elsewhere. Black is shadowed in behind the long ear hairs and then a little more gray is airbrushed in as well. I go back and forth layering colors. This is where it is handy to have more than one airbrush. Or you can use a dual-action siphon-feed airbrush and easily switch colors by changing bottles.*

I even turn my reference photo sideways. Look at it as airbrushing parts of the wolf face and working on one part at a time. The muzzle is airbrushed by using a technique that involves sort of skipping around with short strokes of color. At the end of the muzzle down near the nose, the hairs are very short so the paint is airbrushed more as small areas of color, rather than actual strokes of the airbrush.

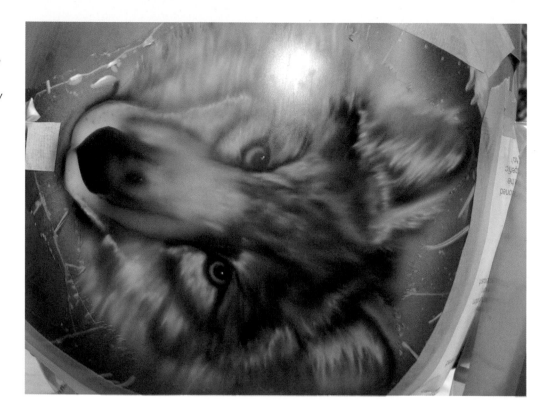

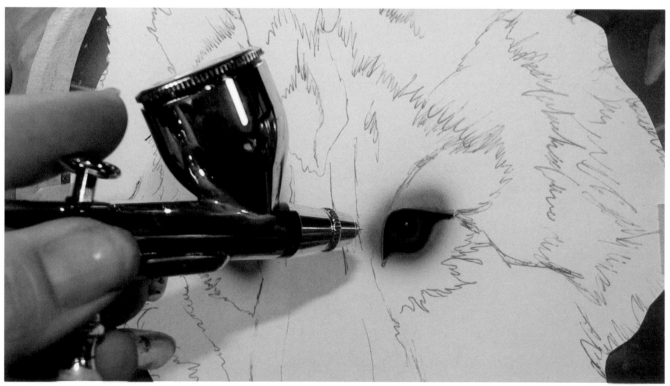

Now for the eyes. As the eyes are roughed in, I will use the stencil I made but not much paint will be sprayed. Thinned black is lightly airbrushed around the edges of the opening. Don't just heavily airbrush black over the whole thing. You want the eyes to blend in. Next, brown irises are cut from another copy. The light brown mix is very lightly sprayed over the holes, followed by a layer of transparent burnt sienna. Finally, the holes for the pupils are cut from another copy and these are sprayed with black.

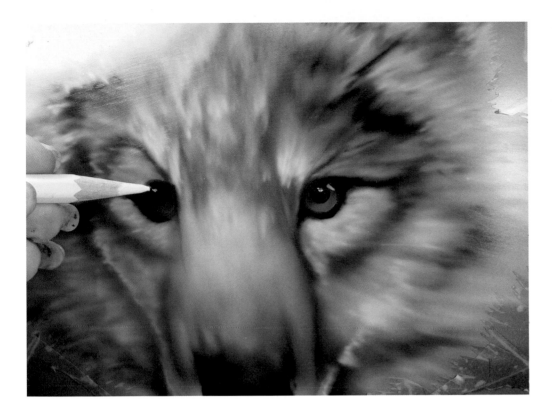

In this photo, you can clearly see how the stencils defined the individual areas of the eyes. For the highlights, I use the sharp point of a white Stabilo pencil. Looking at the reference photos, I see that there is not just one highlight in each eye; there are two with one little, round shape and one long shape. These are drawn in using the white Stabilo. This photo also shows the short, soft skipping strokes that were used with the muzzle and forehead. Look carefully at the airbrush strokes around the eyes—no sharp or distinct lines—just soft, light strokes of paint.

This is one of those Murphy's Law for Artists things. If, by chance, you do a killer awesome airbrushing, chances are you'll do something completely stupid and ruin what was perfection. This has happened to me far too many times. It doesn't mean you're stupid, but this is the way life works, and it's not fair. Be prepared for disaster, especially when things go unusually well. Such as now, when my wolf face looks so good. I'm just asking to knock over a can of thinner onto it, or trip while carrying an open bottle of paint and spill it on the tank. So I make sure that I protect the face while painting the paws, because if there's any time when my airbrush is going to unexpectedly blow out a big stream of paint all over the place, it is here and now. That face will not get ruined because I have put down not just one, but two, layers of paper to cover it. This kind of caution is caused by 27 years of experience with catastrophic airbrushing disasters.

Above: For airbrushing the paws, the face is masked off so that no overspray will ruin it. The paws are airbrushed using the same small techniques that were used with the face: soft strokes followed by transparent layers of color. **Right:** Here, the backing is used as a shield to create a furry texture. Not much paint is airbrushed against the shield. I'm keeping it very light.

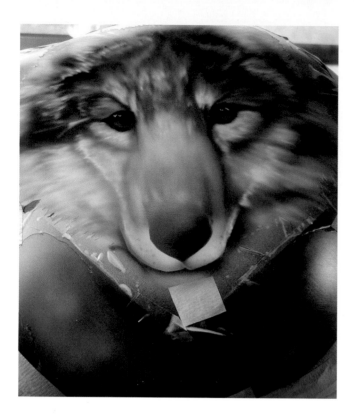

Left: *Oops! The paws are way too brown. The face is masked off again, and the gray and black are skip-shaded over the brown to soften the colors. See how the nose was masked off, and then sprayed? The nose was another place that a quickly cut paper stencil came in handy.* Right: *The wolf is mostly finished and the overall stencil is removed. Using my trusty SATAgraph 3, I softly airbrush the edges of the head, extend the furry edge onto the black background, and blend the hard edge that is left over from the stencil. I love the dreamy effect I'm getting here.*

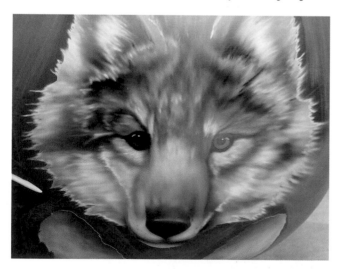

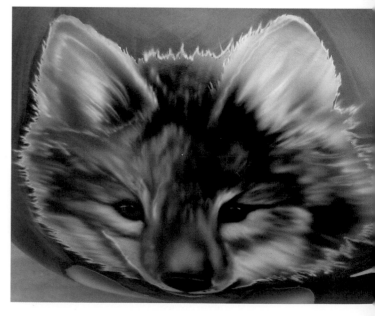

OK, this dude is done! It's beer time or wine cooler time or cookie time, or whatever reward you require. I am absolutely thrilled with the result, which is saying something because I have not been this happy with one of my wolf murals for a few years now. The funny thing is, this is a replacement tank for a tank that I painted about three years ago. I was never happy with the results of that first mural. It looked good, the customer loved it, but I know I could do better. Three years later, I got the chance.

Here's a shot from the other side of the tank, looking at it from a downward angle. It is very hard to take good photos of artwork on a curved surface. Reflections and glare obscure the detail, so I have tried several ways to show the detail and reduce the glare.

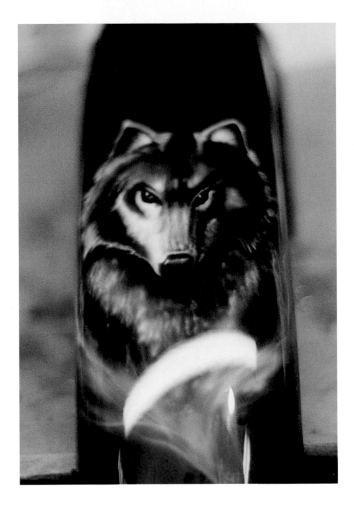

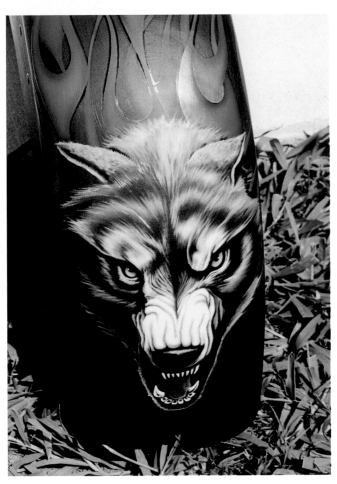

I painted this mural in 1992, about two years after I did the first one on the dash. Wolves are mystical creatures and sometimes a soft, not completely distinct painting looks better than trying to paint them in a photorealistic way.

This wolf face is pretty big, and I airbrushed most of it freehand. Stencils were used for the eyes, brows, nose, teeth, and mouth. I turned this fender around in all kinds of directions to make it easier for me to paint the long, furry strokes you see all over this guy.

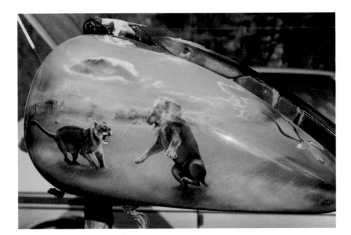

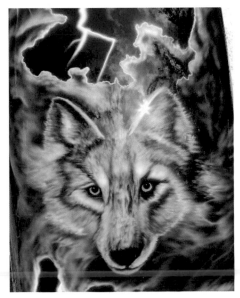

These techniques can be used for anything with fur, such as these lions. The main advantage is to have good reference material. I have photo books on lions, tigers, panthers, you name it. Do not try to airbrush an animal without a good photo.

One last wolf photo. This is a similar wolf, but instead of traditional colors, the airbrushing is done in black and white. Then transparent purple is carefully airbrushed over it. The purple is not a solid layer, it is just colored in over the dark areas. The wolf looks as if he is coming out from the clouds.

CHAPTER 9
CREATING A VECTOR DRAWING AND USING A PLOTTER

Some of the sharply detailed, airbrushed artworks seen today would not be possible without the use of a cutting plotter. A plotter is a machine with a blade that cuts vinyl material. These machines have been used in sign shops for many years, but it's only been in the past few years that they have become common in the airbrush artist's studio. The spread in popularity was due to the price. Plotters used to be very expensive, but in recent years, small hobby plotters like a Roland Stika model can be found for less than $500.

Go to an online sign supply website like www.signwarehouse.com and look through all the many choices available. There is a plotter for every budget and need. I am brand-new to the world of plotters and computer graphics, so I asked many experienced computer graphic artists for their recommendations before I chose a plotter and graphic program to create vector drawings.

I went with a Roland Camm 1 GX-24. It's a 24-inch desktop plotter, but I also bought the stand for it. The plotter was $1,695 and the stand was $300. The reason you need a stand is that the plotter will need the freedom to move the vinyl back and forth as it cuts. The plotter will push a length of material out, then pull it back, then start to cut it, and move it back and forth as it cuts.

Now, despite the fact that I write books and magazine articles, I do not have a big budget shop. I keep the overhead low because I do not have a high-volume flow of work. My budget requires that I have to put a lot of thought into the equipment I buy. It has to be very good quality because the equipment has to last. But I cannot spend big bucks for something that may get used once a year. My purchase of the plotter, stand, and graphics program was one of the biggest one-time equipment purchases I have ever made.

Here is a complex logo that would have been a nightmare to paint without the use of a plotter-cut stencil. Each color had to be masked off from the surrounding area. The borders around the letters are less than $1/32$-inch wide. Yet, the edge of each letter and shape are sharp and clean.

Left: This is the logo for the Kyle Petty Charity Ride. I had to paint a motorcycle for the Chick-fil-A Company, one of the ride sponsors. They needed this logo on the sides of the tank. Now, there is no way my plotter could read this image, so it had to be converted to a vector drawing. Right: Here is the finished vector drawing. A vector drawing that is this detailed is not easy for a beginner.

The graphics program I choose was CorelDraw 12 Graphics Suite. It can be found for between $180 to $300, depending on where you shop online. Corel has also just released a new program, CorelDraw Graphics Suite X3, which is retailing for about $350 to $400 and is supposed to be great for tracing vector drawings. It is best to ask around, and find a graphic program that is easy to use. Many people recommend CorelDraw 9 because it is good for beginners due to its very easy-to-use Help section. CorelDraw 9 is an older program, and it's not that easy to find. Your best bet is to look on eBay.

A VECTOR DRAWING

What is a vector drawing? Very simply, a vector drawing is an image consisting of groups of lines that a plotter can read. A plotter cannot read a regular image. It needs to see the lines that it has to cut. For example, see the following pictures.

CREATING A VECTOR DRAWING

This tutorial uses CorelDraw, but many of the programs out there like Adobe Illustrator use very similar tools. I am a total beginner at this, so I enlisted the help of someone who really knows this stuff. Allan Edwards is a self-taught

painter who operated Creative Cycle Works Custom Paint until December 2005. On September 29, 2005, his home and business located in the New Orleans area were affected by Hurricane Katrina. Since that time, Allan has continued to pursue his airbrushing although Creative Cycle Works is closed.

Creative Cycle Works specialized in high-end bicycle paint and airbrushing for the most demanding customers. Allan's work can be seen at www.blinkdesigns.com and he's willing to share his step-by-step process for creating a vector drawing. It is a very basic overview, but it should provide enough knowledge to help you get started on teaching yourself more about the process of vector drawings. Remember, whatever program you choose will have a tutorial guide. Use it and learn.

It can be frustrating to learn how to create a vector drawing. Don't be afraid to experiment; try clicking on tools to see what happens. Better yet, take a course in whatever program you choose. Community colleges are a great resource for taking coursework. Some of the bigger sign supply shops even have one-on-one lessons you can take. I highly recommend taking lessons or a course. There are books available, but investing $50 for an hour of learning to draw exactly what you need will pay off big down the road. This

COREL TOOLS

Listed below are the tools that will be used in the tutorial. These tools are from CorelDraw, but similar tools exist in other vector graphic programs like Adobe Illustrator. A full explanation of all tools in the program can be found in the Help section of the application.

Some tools are grouped together in a Fly Out bar that can be found by locating the arrow at the bottom right of the button on the toolbar. Hover over the button and click it to display the Fly Out bar. Click on the desired tool, and the Fly Out bar will close. All of the tools listed can be found in the CorelDraw toolbox. When a tool is selected, the Property Bar along the top of the screen will display the available properties for the selected tool.

Pick Tool: Select Objects to move or resize.

*Tip: Press **shift** to select multiple objects. You can also click and drag a marquee box around the objects to be selected. The Pick tool can be quickly selected by pressing the **spacebar**.*

Shape Tool: Edit nodes and paths to change the shape of objects.

*Tip: Press **shift** to select multiple nodes. You can also click and drag a marquee box around the objects to be selected. The shape tool can be quickly selected by pressing F10.*

Knife Tool: Break an object into more than one object, which will allow the objects to be reshaped or deleted.

Zoom Tool: Allows magnification of objects.

Tip: Left-click to zoom in and right-click to zoom out. You can also click and drag a marquee box around the objects to zoom only that area.

Bezier Tool: Draw curves by placing nodes and editing the line segments between the nodes.

Outline Tool: Change the color, size, and shape of outlines.

102

advice is a just a little something to help you get started.

Allan will show how he makes a drawing using a playing card. He'll be drawing the spade shape, but every line on the card can be drawn using the same tools to manipulate the program.

HOW TO CREATE A VECTOR GRAPHIC FOR THE PLOTTER WITH THE CORELDRAW BEZIER TOOL

When you are required to create a mask for an intricate design, or even a simple repetitive design, the plotter is the way to go. Consider the plotter as just another tool that is no different than using a ruler to draw a straight line. To create a successful vector graphic, you will need to plan the order in which the colors are painted and design the graphic accordingly. Chapter 10 of this book shows the use of a plotter-cut stencil and may help in the designing of a graphic. This tutorial will give you a basic understanding of the CorelDraw Bezier tool, along with other tools you'll need to complete a drawing.

So, what is a vector graphic? A vector graphic is an image that is created using mathematical equations to define the lines and curves in the drawing. These graphics are created using illustration applications such as CorelDraw and Adobe Illustrator.

In comparison, bitmap images are created pixel-by-pixel in paint applications. Most plotters require vector graphics to cut the outline of the image.

1. Create a new graphic in CorelDraw by selecting **File—New** from the menu.

 2. Select the **Outline** tool from the tool bar and change the line color to a color that can be seen easily over the image to be imported. Adjust the width of the line to allow easier viewing, if needed.

3. Import your image into the document by selecting **File—Import** from the menu. You should now see the image you have selected in the Drawing Window.

*4. Right-click on the image and select **Lock Object** from the menu. Locking the image allows you to work without accidentally moving your background image.*

*5. Select the **Zoom** tool from the tool bar and zoom in on the area that you would like to draw. Zoom into a specific area by holding the left mouse button and dragging a marquee box around the image. Zoom out by clicking the right mouse button. Here, we are selecting the spade.*

What is an anchor point? An anchor point appears as a square dot on a line. You build off these dots to manipulate a vector drawing. The point remains stationary when you stretch, scale, mirror, or skew an object. Anchor points correspond to the eight handles that display when an object is selected, as well as the center of a selection box marked by an X. These points can be divided and split.

6. Select the Bezier tool from the tool bar. It will be located in the curves flyout on the toolbar.

Tip: Hover your mouse pointer over the buttons, and the tool name will be displayed. If the tool has a small arrow on the bottom right, click the arrow to display the flyout bar and the tools that are grouped together.

You now want to create anchor points that follow along the image to create the line segments that will be edited. To put in an anchor point, simply left-click on the image whereever you want to put a point. Put an anchor point in areas that require a change of direction, such as a corner or where a curve starts or stops. To complete the last segment, click on the first anchor point created or press the escape key to end the segment. In the image, you can see the anchor points and connecting line segments are ready to be edited.

Keep in mind that you are drawing a colored line. You need to choose a line color that will contrast against the background. Corel will automatically choose black for your line, but that will not show up against the black spade. How do you change your line color? Look down in the lower right corner of the screen. You'll see a pen tip with a bucket over it. There are color boxes to the right of the pen image. The pen image and box are for the outline you are drawing. Double left-click on that lower box, and a color menu box will pop up. Select the color that will show up against the background.

ANCHOR POINT

CONTROL HANDLES

7. Select the **Shape** tool from the Shape Edit flyout on the toolbar to allow editing of the line segments.

Tip: Pressing F10 on the keyboard will also activate the tool.

Select your drawing by clicking with the Shape tool on one of the newly created line segments.

Right-click on any line segment that you wish to edit and select To Curve from the menu. This tool will activate the control points for each segment that you select.

Left-click on the anchor at either end of the segment you wish to edit, and the control points and handles will be visible. The handles appear as little squares along the line.

8. Press and hold the left mouse button on the control point, and then drag the handle to adjust the shape of the line segment to match your reference image. Click on the next anchor point to access the handles for that segment. Now you can also move or adjust the line by putting the Shape tool cursor over the line and holding down the left mouse button. Between moving the line this way, and adjusting the line with the handles, you'll see just how easy it is to get the line to fit whatever shape you want. If you do something and the handles disappear, simply left-click on the anchor point, and they'll come back up. Also keep an eye on the toolbar that runs along the left side of the screen. If things don't work right or disappear, check to make sure the correct tool is still selected. Sometimes I'll click on something and notice that the tool setting has unexpectedly changed. Just go back and re-select the tool that you need.

9. Continue to adjust all of the line segments until your drawing matches the reference. All of the handles are shown in the image to illustrate the changes made to the line segments.

10. The vector drawing is now complete with all of the line segments edited to match the reference.

11. The background image has been unlocked and deleted to leave only the vector lines. To do this, use the Pick tool and right-click the background image and select unlock. Just the opposite of locking. To delete the background image, just press the Delete key on your keyboard. Sometimes you may have to move the image you've drawn away from the background in order to select the background. To do this, select the Pick tool and left-click on the drawing. Nine little boxes will come up around the drawing, and there will be an "X" in the middle. Left-click on the "X" and hold the button down. Move it to the side and see what you are moving. Is it the drawing you did or the background? Most times, it will be the drawing and part of the background will be out from under the drawing. De-select by left-clicking over to the side where the page is white. Now right-click the background and unlock it. Next, press the Delete key. Now the spade is ready for cutting on the plotter.

Using the same tools and techniques, the card image has been completed by zooming and working one area at a time. This drawing took about three hours to do.

The bottom is the same as the top, so only the top half of the card was drawn. Then it was flipped over and reversed for the bottom half.

HOW TO CUT AND DELETE A LINE SEGMENT

When designing for the plotter, it is important to remember that most plotters will cut all of the outlines even if they pass under another object. The Knife tool is used to remove portions of the line segments that should not be cut with the plotter.

1. Select the Knife tool from the **Shape Edit** flyout on the toolbar.

2. On the Property Bar above the drawing screen, locate the Leave as One Object and Auto Close On Cut buttons. Turn both buttons to the off position.

3. Left-click the spot to be cut with the Knife tool to create the cut point or points.

4. Press **Escape** on the keyboard to de-select the line segment.

 5. Select the **Pick** tool from the toolbar, and select the area to be deleted by left-clicking on the line segment.

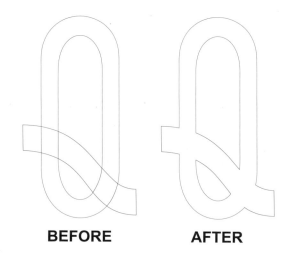

BEFORE **AFTER**

6. Press the **Delete** key on the keyboard to delete the unwanted line segment.

7. Continue cutting segments until all unwanted areas are removed.

SETTING UP A PLOTTER

Here is my brand-new Roland Camm 1 GX-24 plotter. It is set up on the stand and ready to use. Carefully pick a good location for the plotter. Do not put it in direct sunlight or where it can be exposed to paint overspray. I have all of my computer equipment in a room that is separate from the room where I airbrush. Make sure the rear of the unit is not obstructed.

Your plotter will come with a detailed instruction booklet for setting it up. For this Camm 1, I connected the power cable first. It also comes with a CD that loads the drivers onto my computer. It's easy to use—just put the CD into the computer's CD drive and follow the directions on the screen. The USB cable will not be connected until you run the software. Most plotters come with some kind of cutting program software as well. Mine came with CutStudio, which has a plug-in for Corel. The CutStudio software installs a button on the CorelDraw toolbar. That means I can create a vector drawing in Corel, and then click on the CutStudio button. CutStudio will open up and my drawing will be on it, ready for cutting.

The positioning of my desktop computer is with the back facing out. Then I can easily access it to plug or unplug cables as needed. I'm holding the USB cable for the plotter.

Here is some material loaded into the plotter. Now you can see why I paid extra to have the stand. This was a rather long stencil, and the plotter needed room to move the material back and forth.

This photo shows just how much room I left between the wall and plotter. That's a good 10 inches.

There are several chapters in this book that feature the use of a plotter. Chapter 10 is a step-by-step guide to using a plotter.

EXAMPLES OF ARTWORK USING A PLOTTER

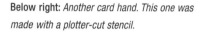

Right: *Here is a tank I did for the old Charlotte Hornets NBA team using a plotter-cut stencil.*

Below left: *Here is a hand of cards that I painted many years ago. I did not use a plotter, and it shows. It still looks good, but imagine if I had used a plotter to paint that spade. It would have been perfect.*

Below right: *Another card hand. This one was made with a plotter-cut stencil.*

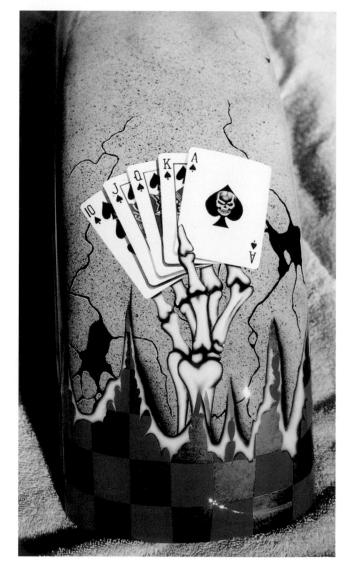

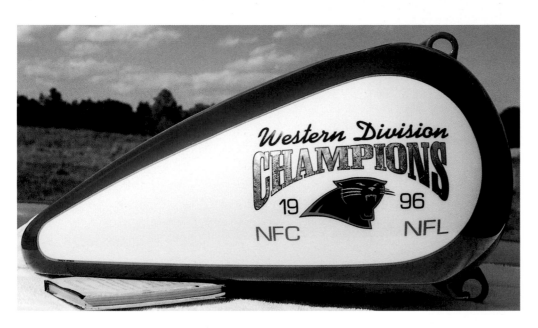

A bike tank for the Carolina Panthers. You can tell right away that a plotter was used.

Left: *The fender for the team bike. A quality plotter will cut very fine details like the tiny lettering for the team's 1996 season record seen here.* **Above:** *A big advantage to using your computer and plotter for your lettering is that there are so many fonts available. You can simply look through the fonts and find a cool style of lettering for whatever mood you want to convey. All you need to do is use the Text tool on your graphics program.*

CHAPTER 10
USING COMPLEX STENCILS: AIRBRUSHING ON A GUITAR

This chapter deals with airbrushing very detailed subject matter using a complex stencil. I like painting guitars…usually. The instrument is a perfect size—it's not too big, not too small, and the flat surfaces make great canvases.

Guitars do have their challenges though. It can be tricky getting a stencil to fit tight around the curved edge. Dealing with the pickguard can be difficult if it's part of the paint job. Pickguards are usually aluminum or plastic and need careful preparation. Plus, if stencils are used for the artwork, it can be difficult to get the mask to run smooth and flat over the step from the guitar surface to the pickguard surface.

Certain guitars must be finished with specific finishes, such as nitrocellulose lacquer, because the paint can affect the sound. Always ask the customer or a guitar expert which paint or finish should be used. For this project, I'll be using

MATERIAL AND EQUIPMENT
- Gerber mask (vinyl masking film)
- White base coat
- Black base coat
- Transparent blue or candy blue toner
- ⅛-inch 3M Green Fineline Tape
- SATAgraph 3 airbrush
- Iwata HP-C airbrush
- Uncle Bill's Sliver Gripper tweezers
- Circle template
- Eraser template
- X-Acto #4 or #11 stencil knife
- 6-inch steel ruler
- Roland GX-24 Camm 1 plotter
- Coast Airbrush storage bottles
- E-Z Mix 8-ounce cups

This is the victim, a brand-new Fender Stratocaster. The pickguard is removed and all surfaces are wiped very thoroughly with a gentle post-paint cleaner like House of Kolor (HOK) KC-20 and quality paper towels. I made sure to change the paper towels frequently, and I wiped the surface until it squeaked. It is then damp sanded (not wet sanded) with 600-grit paper. I was careful to avoid getting any moisture on the bare wood surfaces or in the holes. I used masking tape to protect the area where the neck bolts on and to prevent any water from touching it.

acrylic automotive base coats for the artwork and urethane clear coat for the finish.

Consideration must be given to the pickups and such, to determine what will be covered on the surface and how artwork should be designed around such things. As I go through the step-by-step, I'll detail the pesky problems to watch out for.

This step-by-step overview details painting an already painted guitar. This guitar is straight from the factory. The metal pickguard is a special order item for this guitar because guitars usually come with plastic pickguards.

Please note: This example uses a guitar and automotive paint, but these techniques can be used on practically any surface with any opaque paints. If you are uncertain, always check to see how your stencil material and/or the paint will react to the surface where it's being applied. This technique can be used to paint any detailed artwork that features mechanical subject matter like cars, trucks, industrial machinery, tools, etc.

Be clear about your measurements, especially if you are working with someone else. For example, if I had been working with a graphic artist, and that person was creating a vector drawing and cutting a stencil, it would be a major mistake if they used different points of reference compared to the measurements that I had used. Double-check to make sure you and whoever you are working with are using the same points of reference and that the measurement is correct. When it's 4 p.m., most stores are getting ready to close for the day. It's not the time to lay down a stencil on a project, and then find out that the stencil is the wrong size.

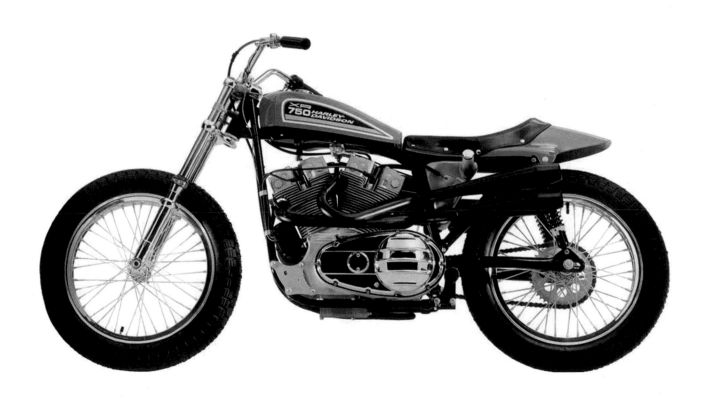

This guitar will be a tribute to legendary dirt-track racer Jay Springsteen. Jay is considered one of the best AMA Grand National flat track racers of all time. He's a three-time AMA Grand National Champion with over 40 National Championship flat track race wins. Much of his career was spent on the factory team for Harley-Davidson. It will be raffled off at the Third Annual Sandia Classic Motorcycle Race. This is the image that Grandma's Music and Sound wants me to use.

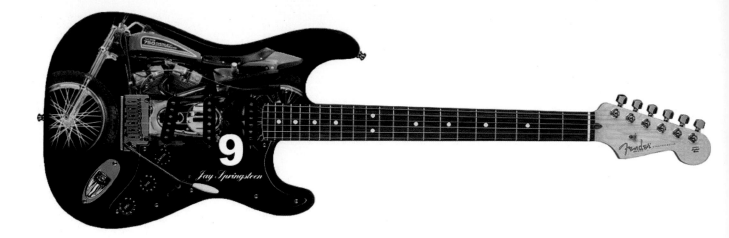

This is the design layout Grandma's Music sent me. This degree of detail requires that I use a stencil cut out with a plotter. Even with a professionally cut stencil, this job will require great patience. I make black-and-white enlarged copies of the original motorcycle photo in various sizes. Then I cut them out, put them down on the guitar, and find the correct size to fit on the guitar. The design needs to be 22 inches long from wheel to wheel. Now I have the measurement that I need for the stencil. Here, I'm measuring from the front of the front tire to the rear of the rear tire.

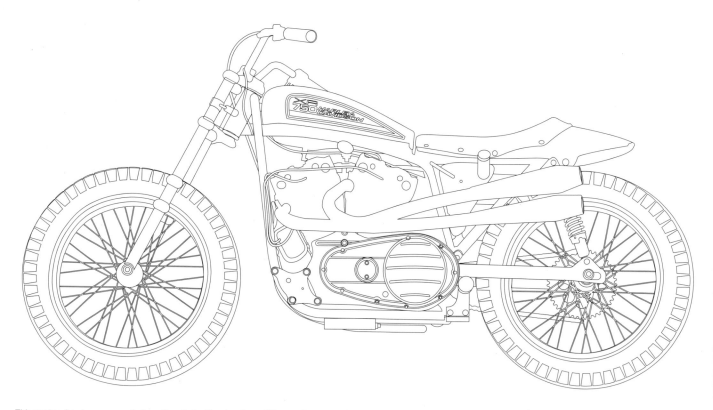

This vector drawing was made from the photo. The drawing will be used to make the stencil. Refer to Chapter 9 for vector drawing and plotter advice.

The amount of material to cut depends on each situation and each stencil. Use common sense. You don't want to stop in the middle of a job and cut more stencil, yet it makes no sense to go through a whole roll of mask for one large, simple stencil. For some situations, it may be a good idea to cut extra stencils for the more complex areas and not the whole design.

Three stencil copies are cut on a plotter using Gerber mask, which is a low-tack vinyl made especially for stencils. I cut three stencils because I will most likely need extra parts. Plus, the stencil is not very large, so to cut several does not use that much more material. If this were very large, say the size of a car hood, I might just make two. Another consideration is the complexity of the stencil—there are lots of little pieces to lose that I may need later. The stencils are not weeded, which means that all the cut pieces are left in place on the stencil. Also, transfer tape has not been laid out across the stencil yet. I will need to draw on the stencil before the transfer tape is

added because it will obscure any lines. Here, I have drawn a line around the outermost outline of the stencil. This line runs next to the cut line, but it does not touch it anywhere. The cut lines are hard to see and will be completely obscured once the transfer tape is applied.

Next, transfer tape is laid out across the stencil, and a squeegee is used to remove any air bubbles. Pull the squeegee across the material to force the bubbles over to the edge and out from under the material. Transfer tape helps to hold the stencil pieces in place after the backing is removed.

Above: *I cut along the lines I drew, removed all of the extra material, and left only the stencil. Here it is next to the paper copy I used to size the stencil. You can see on the copy where I laid the pickguard on it and traced with pencil. The pickup areas have been cut out to help in lining it up in place on the guitar.* **Right:** *The paper copy is lined up over the stencil. See where the holes for the pickups have been cut from the copy? Now the pickup areas are drawn on the stencil by tracing around the cutouts in the paper copy.*

The pickup areas are cut out and used to line up the stencil on the guitar. Since the pickguard is being painted, it is screwed in place on the guitar. Now for the scary part—removing the backing and sticking the stencil on the guitar. This is tricky because if a part of the stencil touches the surface before it is lined up, it can be a real pain to remove it without damaging the stencil. If that does happen, don't panic. Just be very careful and pull up the area. I use tweezers to grab onto the stencil and pull it up. While pulling, try not to stretch the stencil out of shape.

If part of the stencil did drop down and stick to the surface, and then became stretched out after you removed it, you can still do damage control. Grab the finest scissors you have and cut the stencil. Next, use tweezers to handle the end of the cut piece. Lay those pieces down where they belong and allow them to overlap each other. Then, using a very fine stencil knife like an X-Acto #4, gently trim the stencil to the shape it needs to be. Cut away the excess stretched material. Make sure not to cut into the surface below the stencil. What if that area of the stencil is completely ruined? Then simply cut more stencil of only that area. Next, cut away the damaged stencil and patch in the new stencil. Never panic. Sit back, take a deep breath, and think your way out of frustrating situations.

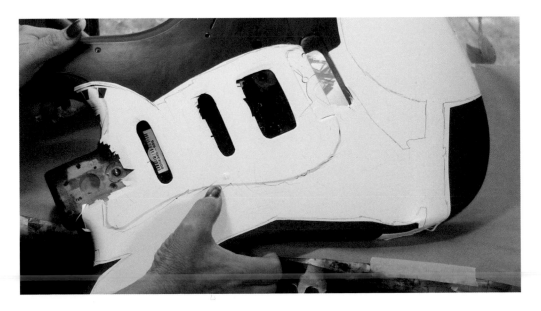

The guitar is upside down here, so don't let that be confusing. The stencil has been stuck to the surface. The area around the pickguard is a difficult place for sticking the stencil. I use a fingernail to "stretch" the stencil material into that edge. When airbrushing in the area around the edge of the pick guard, I'll have to make sure the stencil is stuck down.

The stencil will need to be cut where it wraps around the curve of the guitar. I'll wipe the squeegee firmly across the surface to really make sure that all the little bits of the stencil are stuck to the guitar surface. Only then is the transfer tape carefully peeled off. Watch to make sure that pieces of the stencil are not coming up with the tape. I use tweezers to grab any parts and stick them back into place. Then mask off the rest of the guitar.

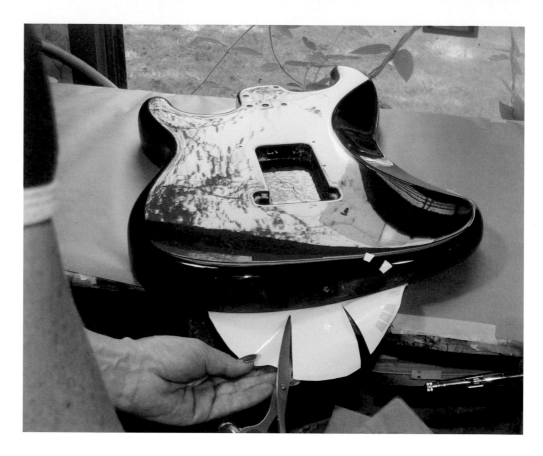

Chapter 6 has many handy tips for spraying metal effects. Go through that chapter and play with metal before trying to airbrush complex metal subject matter like motorcycles or cars.

Basically, doing this artwork will be a matter of taking up pieces of stencil, airbrushing, and then putting them back after the paint is dry. Automotive-type base coat paint is normally used for guitar painting, and it dries fast. First off, mix up some white base coat and some black base coat. Thin both mixtures down about 125 percent. Pour off some of each mixture into another container (make sure to use solvent-proof containers like E-Z Mix cups) and thin it down further about 150 to 200 percent.

A thinned-down transparent blue/black mix will also be used. For this, a very small amount of reduced black is added to the reduced blue. It's just enough to take the edge off of the blue so that it is more subtle and less bold. I'll have five mixtures of various viscosities: two white, two black, and one blue/black. The thicker one will be used for overall shading, and the thinner one for fine detailing.

I'm starting with the front end. It looks more confusing than it actually is. Because it can get confusing, my reference photo is close by. I can look over and see exactly what I need to duplicate. Since this is an illustration of a photo, it can be stylized. It would take far longer than the budget for this project allows to do a true, photorealistic painting. Using four airbrushes that are each loaded with a different paint mixture will help to speed things along.

The key words to remember when working on reproducing metal effects are *gentle* and *light*. Go easy. Don't spray a thick coat of color anywhere.

When doing commercial airbrush projects, always keep the budget in mind. Yes, you want to do the best job possible, but think of ways to speed the process without taking risky shortcuts. For this project here, I kept it as simple as possible. I did not paint every little wire or connection. Some complex areas, like the end of the hoses, were simplified. Not every little bolt head was airbrushed. Now, if this had been a photorealistic project, strict attention to that kind of detail would have to be followed.

First, look at the reference photo. How and where does the light reflect on the part? Decide where you want to start. Here, I start on the front end of the bike. Using the tweezers, pick up a piece of the stencil. I've removed a piece of stencil that forms the side view of the lower triple tree. Do not lose these little pieces as you remove them. Place them close to your work area because you will need them later. I stick them to the shiny backing that was removed from the stencil or over on the green masking tape.

Next, I use the thicker white paint to lightly spray the revealed area. Now the stencil piece, which was removed, is used as a mask. I place it to cover the bottom half of the oval, and I leave only the top half revealed. The thinned white is sprayed along that edge, and it creates a reflection line. The stencil piece is left in place and two vertical reflections are very softly sprayed. The piece is removed, and a slight reflection is sprayed along the bottom right corner.

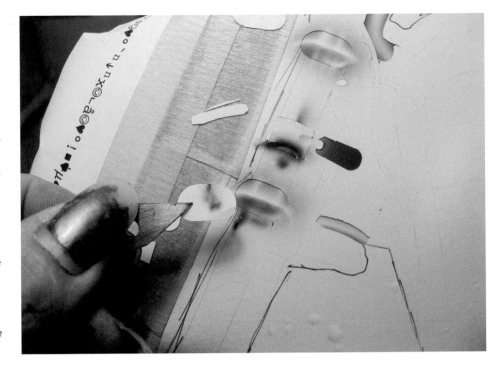

With the thin black mixture, a very small amount is sprayed around the very top and under the hard reflection line. Then the piece is put back to mask off the top again, and the hard white line is touched up slightly with white to remove any black overspray. Now the piece is put back into place, and it completely covers the work I just did.

Once that is done, I move on to the top triple tree. A few other small pieces are removed from the stencil. A soft, white highlight is sprayed through the middle of the small crescent area to the right. Very soft blacks will be sprayed top and bottom of that highlight to create the rounded effect of that part. To the upper right, you can see where I started spraying the handlebar with white by airbrushing a white light through the middle of that cutout.

After these parts are airbrushed and the paint is dry, the pieces which were removed are replaced.

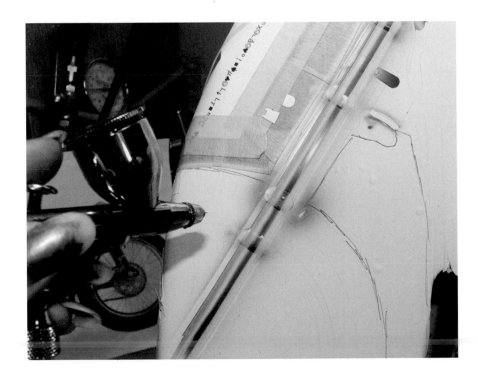

Next, the material covering the left downtube, or leg, of the front end is removed. Make sure the parts that are airbrushed are covered. What if you lose one of those little pieces? That is why you made an extra stencil. Just grab what you need off of it and stick it in place.

Now I notice the downtubes have these vertical reflections. The whole tube is softly sprayed with the thinned white aimed at the very center of the tube. Then the reflections are masked off with fineline tape. First, the black paint is sprayed, and then the white paint is added. Go easy, especially with the black. Just spray a little!

The transparent blue is used very liberally. Look at the motorcycle photo and see how much midtone shows up. Here, on these tubes, a barely noticeable shading of blue is applied. The blue is more of an accent to build up the darker tones. I use it on top of the soft black shading to soften the transition into the white.

Left: The black is also used to spray a shadow under the previously painted areas of the front end because these parts hang over the downtubes and cast a soft shadow. The removed piece of the downtube has the perfect contour to be used as a mask for those shadows. At the top, you can see where the shadow has already been done. For much of the shadow and highlight work, I'll use a business card to give them a "soft" hard edge, which is an edge that is defined but not too sharp. Once these parts are done, the stencil pieces that were removed are put back into place. Since the vinyl film has a low-tack adhesive, it doesn't stick hard enough to disturb the newly applied artwork. Right: Next, I'll paint the right side of the front end. This is partially hidden behind the parts that have already been painted. First, the pieces of the downtubes are removed. White is softly sprayed along the high point, which runs down the center of the exposed areas.

So what do you do when you're working on a project like this, you remove a stencil piece, and paint comes off with it? First, make sure you are using a paint mask or stencil material, not sign material, which is not designed to be removed. If the base coat is pulling up from the surface of the painted object, then you've got serious problems that are addressed in my earlier books. If paint used for the artwork is pulling up, then chances are the painted base surface was not properly prepared. Hopefully, you'll be alerted to this early on in the artwork process. This is why you made several stencils. There is no easy trick for fixing this. Just remove the stencil and re-prep the surface. Then start fresh with a new stencil.

Repeat the process used with the first leg. Here, the black reflection is being applied. Use care when pulling up the fineline tape. I keep the tweezers very handy and use them to hold down or replace pieces of the stencil that want to come up with the tape.

Left: *After the tube is painted, the blue is applied so minimally that it is not noticed but it does add a metallic look to the parts. Gently apply shadow by airbrushing thinned-down black along the previously painted tube. Remember to replace the removed stencil pieces.*

Middle: *I tend to jump around to paint the parts that are quicker to airbrush. Here I'm working on the bottom of the gas tank. Notice the hard line of white? I used the removed stencil pieces as shields to create edges and form. The gas line stencil piece is placed over that area, only it is slightly offset to reveal a thin area that is sprayed white. A business card is used as a shield to get the shadow that separates the L-shaped part (crossover vent tube) from the gas line. It is also used for the hard white lines that detail the petcock area, which is farther to the right. The same technique is used to bring out the form under the tank. Note the white hard line. The contour matches the stencil piece that was removed. It is lined up to define that area, then white is only sprayed on what appears to be the high point. This creates a "bump" form and gives a 3-D effect.*

Left: *Here you can see the stencil piece in place as I airbrush white to create the edge of the petcock. Wow, there are so many little pieces of stencil I have yet to work through. Not getting overwhelmed by the tedious nature of complex subject matter can be the biggest obstacle in airbrushing projects.*

Left: *I've worked on a few simple areas, so now it's on to the harder stuff. The larger areas of the artwork are more noticeable than the small stuff. If I can get the wheels and tires to look good, then the detail of smaller parts won't be as noticeable . . . so on to the tires. First, the knob pieces of the tire stencil are removed. Thinned white is very softly airbrushed. Then black is shadowed in. This is where looking at the photo while you are painting is critical. Over on the far left, behind the guitar, the photo of the motorcycle can be seen. I place the photo as close to my work area as possible. The photo will show you where to apply the lights and darks. It's a road map of how and where to apply your paint.* Right: *Darker shadows are applied to the top and bottom areas. Later, I will regret the shadows that were applied on the upper half of the tire.*

Left: *After I'm done shadowing the knobs, the removed stencil pieces are replaced using the tweezers.* Right: *Now the rest of the tire stencil is pulled away. As always, use care when peeling up these pieces, because they will be reused. If necessary, hold the piece with your fingers and use the tweezers to help pull up finer parts of the stencil piece, like the thin lines between the knobs. I start out by spraying thinned white lightly around the tire and aiming the spray at the high point on the sidewall. Next, thinned black is lightly layered over it.*

A rough circle is cut out of paper and used as a shield to airbrush a shadow under the knobs.

A business card is used to create hard-lined shadows under the knobs. I'll use the business card for many of the soft or hard edges of the shadows and highlights.

Check the edges of the business card before using it as a shield. How cleanly is the edge cut? If it is rough or ragged, find a card with a smooth, clean edge. Unless, of course, a rough edge is what you want.

The "knob" shadows are finished. But I see that I need to softly brighten up the highlight that follows along the curve of the tire. I'll hit that with the thinned white. Then I'll add more shadow along the inner circle of the tire. A rim will be painted, and that will cast this shadow, so it must be painted.

Below: *The overall tire stencil piece is replaced. Then, one by one, I'll pick up the knob pieces and offset them, then lightly airbrush white to create a highlighted edge. This is the trick that will give the tire a more realistic effect. Remember, this is not photorealism. This is stylization. You want it to appear real, but with a softer, more mystic feel. Now the tire is done.*

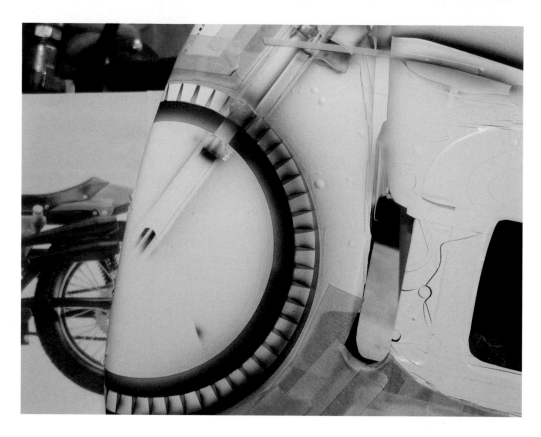

Right: *Here, I start to work on the tedious stuff. The stencil covering the right-side lower leg is peeled up and carefully placed off to the side, on the backing. The pieces are laid down so that they will be easy to sort out and put back later. Keep a stencil knife handy when removing any stencil over the wheel spokes. There will most likely be places where a piece is still attached to the main stencil because it wasn't completely cut. Look for uncut areas whenever working with very fine stencil detail. Don't force the piece out because it will stretch out of shape. With the help of a business card, the vertical reflections are airbrushed.*

When should you paint the tedious or "make you run away screaming" stuff? Artists handle this stuff in various ways. Some do that ultra-fine detail work first to get it out of the way. Others put it off for last. I like to get warmed up on a few "easier" details. When I feel sharp, I dive into the deep end like airbrushing the fine detail on this wheel. If you take your time, view the area as individual pieces, and finish an area completely before moving on to the next part, it seems less intimidating. There'll be times when you have the patience for this kind of work. Trying to airbrush lots of minute details when you're tired or cranky will result in artwork that is not your best effort.

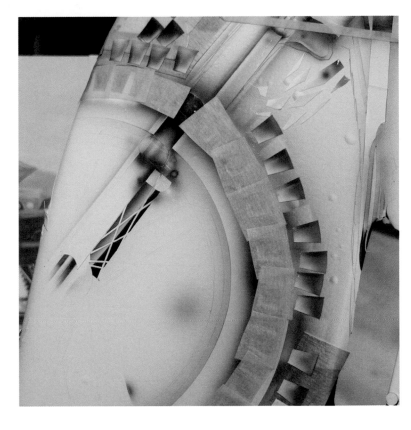

The reflections are kept simple here because it could get too busy with the spokes cutting across the area. I'll add a little more white at the back of the tube, and then slightly shadow with black.

After the stencil pieces are replaced, the hub stencil pieces are removed. I lightly shade them with white, and then shadow under where the leg and axle intersect. A very small circle template is used for the white dots where the spokes hook up. The hub stencil piece is replaced, and each individual circle of the axle end is removed and airbrushed with either white or black. The piece is put back and the process is repeated until the circles are done.

Left: *OK, now the fun part—airbrushing the spokes. Each piece of stencil spoke is removed. With the tweezers in one hand and the stencil knife in the other, I pick up each spoke and leave the pieces in between them in place on the surface. Then I lightly shade them with white. The main tool I use for this step is an eraser template, which is a flat piece of metal with shapes cut out in it. I use the clean, shaped edge. It fits down into the grooves of the spokes. See how I place it in the photo? Then black is softly airbrushed. I'm spraying the shadow under the place where one spoke crosses over another. Use the reference photo as a guide to see which spokes cross over each other. Don't just "wing" it. The proper pattern in the spokes will aid in the realism factor. I work my way around the wheel.* Right: *Don't bother trying to put the spoke stencil back into place. Simply run $1/8$-inch fineline tape around the inner circumference of the rim and tape off the spokes. Now the lip or edge of the rim is airbrushed. There are three circles in a row that make up the lip. I do the white first and replace the stencil piece I removed. I remove the middle one and lightly airbrush a haze of white, followed by a very thin shading of black. The circle is covered by its stencil piece and the process is repeated with white. Look for the shadows in the reference photo and don't forget to paint them.*

When spraying reflection highlight dots, always test your airbrush off to the side on masking material to:

Make sure the needle isn't sticking. If it is, a big blast of wet paint might shoot out and ruin some of your hard work.

Make sure the paint is not too grainy or too thin. If it's too grainy, the reflection will not have that soft effect. It it's too thin, the paint will not have the sparkle it needs.

I always check my airbrush before I do any kind of fine detail work. It will become second nature to always test your spray over to the side, away from the paint area, before finding out a nasty surprise awaits you.

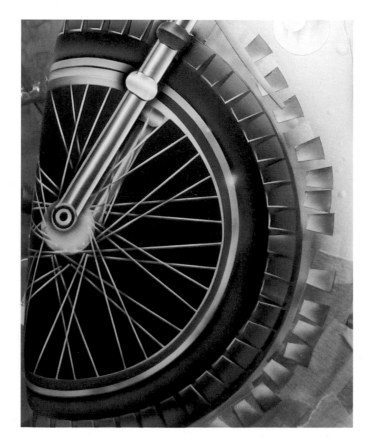

After the wheel is done, the material over the tire is removed. Check the shadows and re-spray any that are not dark enough. Then a white, starlike reflection is sprayed on the very edge of the rim. This detail is where spraying those practice dots will come in handy. Here's the finished wheel. The three circles that make up the rim can be seen.

Now it's time to airbrush the motor. The stencil pieces for the jugs (the finned sections of the motor) and heads (the tops of the finned area) are removed. I leave the stencil pieces for the plug wires, and for the round details in the heads, in place. A thin haze of white, then blue/black, is sprayed over the motor.

For the rest, I look over to the photo and airbrush what I see. The soft, white highlights run up vertically and define each side of the opening for the plug areas of the heads. The jugs are masked off with a handheld shield as I spray the heads (the blocky area over the finned area). Then a small bit of masking tape protects the jugs while I spray the black area of the square plug opening in the middle of each head. I hold

either a business card or template edge over the freshly sprayed highlights, and I lightly spray black on each side of the opening.

To paint the fins that cover the jugs, use two strips of ⅛-inch green fineline tape. Run the pieces of tape parallel on the heads to form the fin shadow and define the fins on the jugs. Use a small ruler to space the fins. Just go down the jug with a pencil to space and mark the location of each fin line.

I also have started airbrushing on the primary cover, the two circles down below. The mask over the circle on the right is removed, leaving the narrow pieces for the horizontal fin pieces in place. White is lightly sprayed and the fin stencil pieces are removed. Now highlights are airbrushed with white and blue/black, but you can still see where the fins are placed. Then the fin pieces are put back. As the fins are raised over the surface of the cover, the shadows are airbrushed under them by softly shading with thinned black.

It is a lot less complex than it looks once it is broken down into separate areas. I'm just going through the various pieces on the motor and using the same method of removing pieces, painting that area, and then replacing the pieces. This way, the lines stay crisp and artwork overspray can't travel to other parts of the painting.

To airbrush the circles on the heads, the head stencil pieces were replaced and white, blue, and black were sprayed. It was simple to do the exhaust pipes. Once the motor was finished, those stencil pieces were replaced. Then the mask covering the pipes was removed. Since the surface is already black, the white highlight running along the pipes was airbrushed and the sides were shadowed with black. Next, the pipe stencil piece was replaced and shadows were airbrushed under the pipe on the right jug. The left side is next.

I've already started shadowing under the plug wires. Note how the primary cover looks now that the fin pieces are removed after the shadowing. I could have spent more time on this motor, but the guitar was due for a big event and the clock was ticking.

Right: *Here is a close-up of the work on the rear tire using the eraser template to airbrush defined shadows under the tire knobs. Note the light area in between the knobs. The tire is a series of gray tones.*

Below: *The oil tank airbrushes rather quickly. White paint is airbrushed and then lightly shaded with the darker colors to build up the form of the tank. The oil tank mask is replaced, and then the spout and the spring are airbrushed. The neat reflection line on the spout is created by using the metal template as a shield. The tab for the spring is made by cutting a tab-shaped shield from a business card and very lightly spraying black paint. The hole is made using a circle template.*

Try not to solidly spray an object. For example, the orange parts on this tank and fender were only sprayed along the high points of the parts. That starts to create the shadowed areas, like where the tank curves from side to top. Then only a slight shading of a darker shadow color will be needed. All the thinly applied paint leaves very little of a paint edge to deal with.

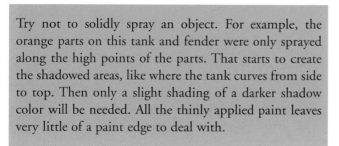

The Roland plotter can actually cut out extremely small details. These letters are tiny. I had to use the stencil knife a lot to cut away the vinyl as I removed the letters. The lettered panel is masked off and white is sprayed. Then the lettered panel is taped off. I don't even try to put those letters back. The stencil remains to cover the stripe around the panel. A subtle orange color is mixed up by blending a little white and black into orange base coat. After the orange is sprayed, the stencil pieces are put back in place, and the stencil over the stripe is removed. White is sprayed for the stripe.

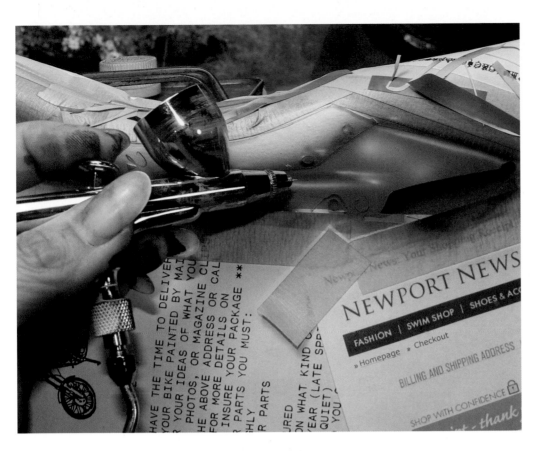

Here's a situation where it is critical that I know what to expect when the trigger of the airbrush is pulled back. This orange part looks so perfect. It would be awful if a blob of white paint came out of the airbrush as I was trying to paint these very soft highlights. Before spraying each highlight, the spray of the airbrush is tested on the stencil material off to the side. Stay soft with these highlights. The dark area of the fender's underside was easy to airbrush. After the orange was sprayed, the stencil piece for the top side of the fender was put back in place. The black was lightly airbrushed to create the shadowed area under the fender. Then the stencil pieces for the fender are put back in place.

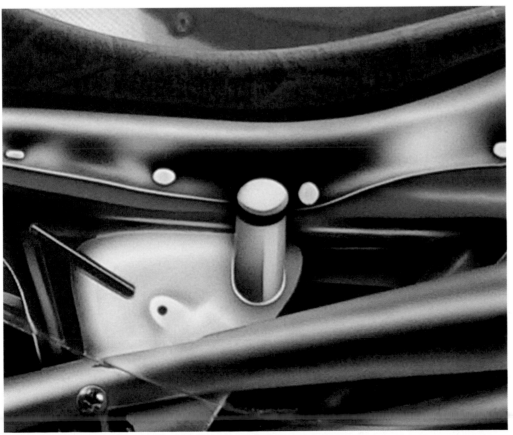

Here's a close-up of the seat detail. It's simple enough when broken down. First, the stencil pieces for the seat are removed, the white highlights are airbrushed, and the black is airbrushed to deepen the shadows. A soft, white highlight is drawn for the round, top edge of the seat. Circle templates are used for the rivets. The bead (the white edge) along the bottom of the seat is created by using the seat stencil piece as a shield, offsetting it, and spraying white paint.

Then the entire stencil is carefully peeled away. Here's what I have so far. Any areas I'm not happy with, I'll rework after the first round of clear coat is done. Now it's time to put on the name and number.

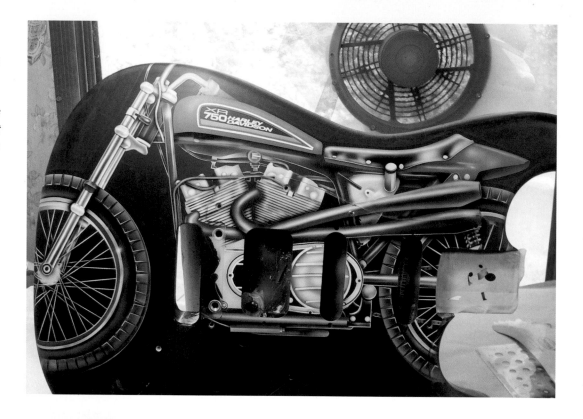

The layout picture is taped right near where I need to apply the lettering. I figure out the position of the guitar so that it is level. Wooden blocks, airbrush boxes, books, or anything can be used under the guitar to position it correctly.

The stencil for the name is taped to the guitar and lined up. I use a 15-inch steel ruler to make sure the stencil is level. Then I'll run tape around the edges of the stencil. This taped "box" that is formed will be used when I replace the stencil after the backing is peeled off. The backing is not removed first because I like to attach the lettering stencil and then look at it from several angles to make sure it's level. Since the letters can't be seen, a line is drawn under the letters. The transfer tape is removed from the stencil after it's stuck to the surface and the letters are peeled out. The number 9 is put into place, the rest of the guitar is masked off, and the white is airbrushed.

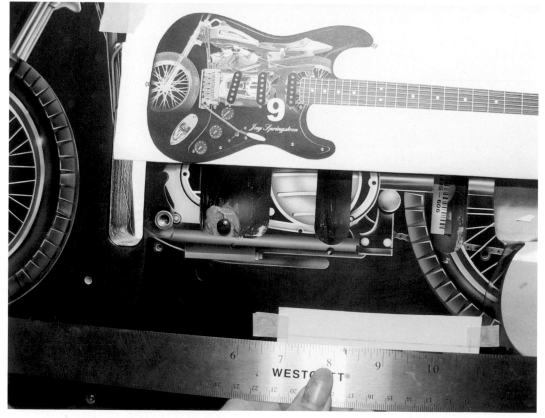

130

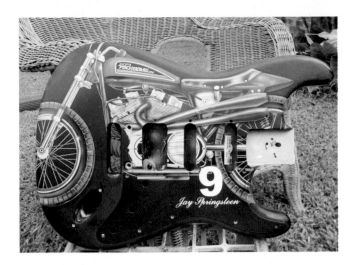

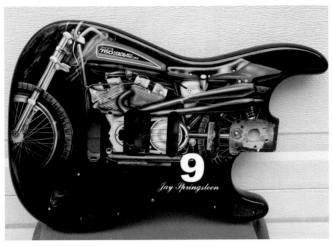

OK, the hard part is over. In the layout they gave me, the bottom of the wheels fade into shadow. I'm going to leave that step for after urethane clear coating. I may end up spraying too much shadow, and with clear coat on my artwork the shadow can simply be sanded away and redone correctly. The pickguard will be removed and cleared apart from the guitar body. Be sure not to fill the little screw holes in the pickguard with clear. If the pickguard is laid down on a flat surface, chances are the holes will fill up with paint. I take a 1-quart paint can and use a piece of 2-inch masking tape rolled into a circle to stick the pickguard to the top of the can.

After the clear is dry, it is wet sanded with 600-grit paper, and the black is faded in around the bottoms of the tires. The upper part of the artwork is damp sanded with 800-grit to remove an overspray from the black fade. Here's the final product after the clear is finished.

The clear was done in two steps. The first round of clear was four to five coats to level out the paint edges. The wheels have been faded into the background and any rework is complete. The second round was a clear finish. Before putting the pickguard back into the guitar, I make sure it is fully dry.

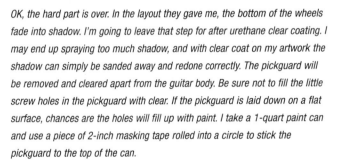

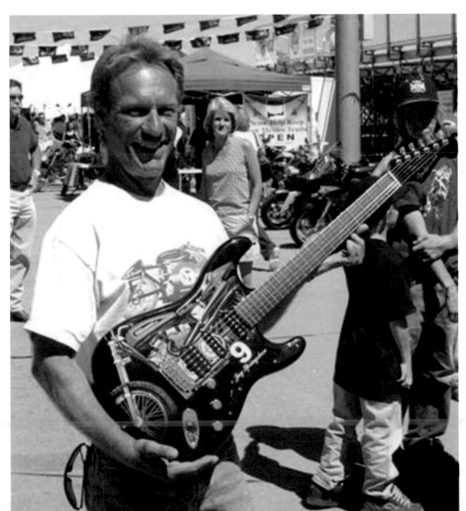

Jay Springsteen with the assembled guitar. This guitar was raffled off at the Third Annual Sandia Classic Motorcycle Race on September 18, 2005, in Albuquerque, New Mexico. The raffle raised $2,500 dollars for the AHRMA Benevolent Fund and the Garret Iverson Fund. The guitar was designed and donated by Grandma's Music and Sound and Chick's Harley-Davidson.

CHAPTER 11
USING LIQUID FRISKET OR SPRAY MASK

Liquid mask works great on hard-to-mask surfaces, like the ribbed side of a trailer or curved surfaces. It is used quite a bit in automotive airbrushing. Unlike frisket film, which is a flat sheet, liquid frisket will stick and stay down. Basically, it is a liquid that is applied to protect an area of a painting from overspray. There are two kinds of liquid frisket, the kind meant for use on paper-type surfaces (brands like Liquid Mask and Misket) and the kind made for using on hard, impervious surfaces, such as Spray Mask and SprayLat. Some artists even use rubber cement as frisket. Refer to Chapter 2 for information about various kinds of liquid frisket.

Artwork done using liquid frisket.

MATERIAL AND EQUIPMENT
- Tracing paper
- Lead pencil
- Metalflake Company's Spray Mask
- ⅛-inch 3M green masking tape
- ¾-inch masking tape
- House of Kolor KK-15 Teal Kandy Koncentrate
- House of Kolor KK-10 Purple Kandy Koncentrate
- Black base coat
- SATAgraph 2 airbrush
- Iwata HP-C airbrush
- Richpen 213C airbrush
- SATA dekor artbrush
- 2-inch cheap paint brush
- #4 X-Acto stencil knife
- Uncle Bill's Sliver Grippers
- Light table or window
- Seamstress measuring tape (soft tape measure used in sewing)

Liquid frisket is also very useful for some highly detailed kinds of artwork. For example, to create a stencil or mask of tree branches, barbed wire strands, or a thorny wreath. It's far easier to cut them directly on the surface out of liquid mask compared to trying to cut a paper stencil and then having to deal with those stencil pieces.

LIQUID MASK FOR PAPER
Frisket is usually made from a combination of ammonia and acrylic rubber. The ammonia evaporates, and the rubber dries, which leaves a film that protects areas from undesired paint. Liquid frisket usually contains ammonia and can discolor colored papers. Always test on a spare piece of paper so you can be sure of how it will react with your paper or with the artwork on the paper. Make sure the frisket does not damage artwork that is already painted.

Adhesion increases over time, so don't leave frisket on paper surfaces for long periods of time. Also, the harder the surface of the paper, the less likely the liquid frisket will affect it. Hot press illustration and bristol boards work great with frisket.

This old painting on illustration board from 1978 is a simple way to show how liquid mask can be used. The highlights were created by painting on the liquid mask with a small, round artist's brush. Yeah, the painting got trashed later on, but it's still cool.

When the artwork is finished, the frisket is removed by rubbing it. It should ball up and roll, or you can use tweezers to grab it and peel it off. As for brushes, it is best to use a cheap brush, because this stuff will ruin a brush very quickly. You can use a wide, flat brush or the flat side of a pipe cleaner to cover large surfaces and cut out your stencil, or brush it on with a small brush and create highlights in the painting.

There are endless ways this material can be used. You can write your name in liquid frisket, do your painting, and then peel up the frisket—there's your name in white. For a fine, precise line, a writing quill or chisel-shaped stalk of bamboo works better than a brush. Just rinse and wipe them off to clean. The Masquepen (seen in Chapter 2) has a nib that works like a quill.

If using a brush, first coat it in some type of soap. Ivory bar soap seems to work well and will not affect the liquid frisket. If the frisket needs to be mixed, stir it. Avoid shaking the container of liquid because it will cause bubbles to form. The bubbles burst when the liquid is drying and that will expose some of the paper.

Put the coat on thickly enough to cover, but don't apply it too thickly. If it is too thick, a skin will form over the top and leave the underside coat of the frisket still wet. This wetness makes the frisket difficult to work with. It will not cut cleanly, and it will be messy when it is removed. It can also allow the frisket to sink more deeply into the fibers of the paper and cause tearing when it is later removed.

In warm weather the frisket will dry quickly, so make sure your brushes don't start clotting. Rinse the brush with warm water and re-soap if the brush clogs up and clots.

RUBBER CEMENT

Some artists like to use rubber cement for frisket. It covers well, but it can be hard to see the coverage. The main purpose for using rubber cement is to obtain odd textural effects. You can "thin" down the material 50/50 with rubber cement thinner. (Do NOT use paint thinner!)

It is usually applied with a cotton swab, disposable cheap brushes, or a foam brush for large areas. After the first coat has dried, it may be rubbed lightly to create depressions in the surface. Applying a coat of paint will result in a textured paint effect that looks like holes. Multiple applications will create wild textures.

Testing your tools and materials on spare or extra surfaces is always the best idea, but when using liquid frisket, testing is a must! Testing is the best and quickest way to truly learn how to use your tools and materials. There are so many variables in airbrushing that cannot be controlled. An artist's best knowledge can only be gained from actual experience. Know the product.

LIQUID FRISKET FOR HARD SURFACES

Metalflake Company's Spray Mask is just one kind of liquid frisket. There are others, but I have not used them. I have found (for me) that the more expensive liquid masks work better. But that's just my opinion. Each one is different, so be sure to test your liquid mask on a spare surface before using it. Spray Mask is a water-based product that works great for hard surfaces. Just be careful to not get the applied material wet. Here I'm using the surface of a motorcycle fender and solvent-based automotive paint with Spray Mask as the stencil. I'm trying to get a graphic that looks like a liquid web wrapping around itself.

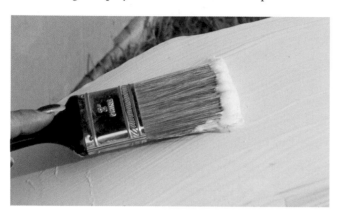

I'll brush on a layer of Metalflake Company's Spray Mask using a cheap, 2-inch paintbrush. I'll brush on four coats and allow each coat to dry clear before applying the next coat.

This is the drawing I drew up before painting these parts. My drawing will help to plan what I should paint first.

The surface of this fender is masked off with Spray Mask. Start out by covering the parts with Spray Mask using ¾-inch masking tape to border off the areas you want to appear. Don't try and apply this material without putting down a tape border first, or it will be difficult to remove.

With a 2-inch paintbrush, apply four coats of Spray Mask. Allow each coat to dry before applying the next. It will dry to a transparent, bluish color. Next, take tracing paper and wrap it around the tank or fender. You may need to tape two pieces together to make it fit. Now draw out the desired design.

The tracing paper is used because I like playing with my designs and fine-tuning them until they truly fit the space. I usually end up with lines all over the place, and it can get confusing trying to sort out the final design from all the undesired lines. By using tracing paper, I have room to maneuver and further rework the design without making a mess.

Mark the position of the tracing paper before removing it so that it can be easily taped back into place later. The drawing is

flipped over, and the image is traced in pencil on the reverse side. Flip the drawing back over and put it back into place on the fender. The design is traced with a pen. This transfers the design to the spray mask surface of the fender. See how the center of the fender is marked? It helps to know the center of the artwork area in order to lay out a symmetrical design.

The tracing paper is removed from the fender and I redraw the design, fine tuning it as I go. Use ⅛-inch green masking tape to help get the lines straight. If this design had a lot of very straight lines, I would have used ¼-inch green fineline tape because it is firmer tape and holds a straight line better. Just run tape along the lines and trace along it.

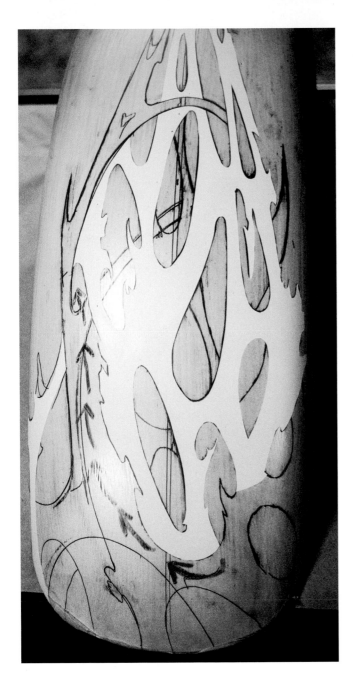

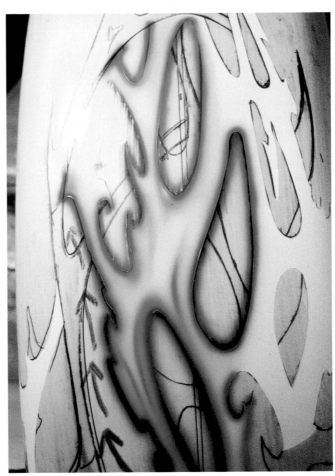

I find the biggest area of unbroken liquid webbing and mark it #1. The other layers are marked 2, 3, and so on, so that I know the order of which layer to paint next and to help identify the layers. Cut out the first layer using a #4 X-Acto knife, but be careful not to cut through overlapping layers. If you do, it will leave a cut impression in a place where there is no line. That's why the layers are marked.

If you do end up cutting through other layers, don't panic. Keep working and retouch it after the first round of clear coat. The clear will fill the cut line and the rework will completely hide the mistake. Knowing how hard to press when cutting is something that is learned over time. You will want to cut hard enough to go through the layers of mask, but not hard enough to cut into the surface. Testing your technique before working on the "real" stuff is mandatory.

For my artwork, I'll be using House of Kolor Kandy Koncentrates mixed with House of Kolor SG-100 Intercoat Clear. As for figuring out how much Koncentrate to mix in, pour a small amount into the clear—maybe just a quick, short pour. It's better to go too light than to get too dark. You'll know right away if it is too dark because it will be too bold against the white, not soft and subtle. If it's too dark, it will appear spotty when you try to blend it. If it is too light, the surface will start to look "runny" because there is not enough color, and you're applying too much clear at once.

I'll start off with KK-17 Teal and clear mixed thinly. I also airbrush the color lightly, starting along the edges, and work my way around the open area to build up the shadows. Note how there appear to be dark areas as if the liquid was sagging in places. I try to imagine how the liquid would flow around the holes. These areas are airbrushed by pushing in the trigger to get air pressure flowing. There is no material coming out yet. The airbrush is swept across where I want the shadowed ripple to be. As I move the airbrush, I begin to pull back the trigger to start the paint flowing. The dagger strokes will come in handy for this part. As the stroke goes across the surface, the movement brings the airbrush back up, and the trigger goes forward to cut off the paint.

Before trying this kind of soft shading, practice off to the side and make strokes until you get the hang of applying the shadows. This same technique can be used to airbrush folds or ripples in fabric surfaces. The whole trick is to build up the surface gradually. It will get a whole lot darker as I go on.

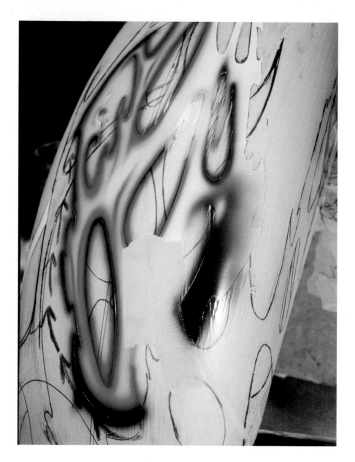

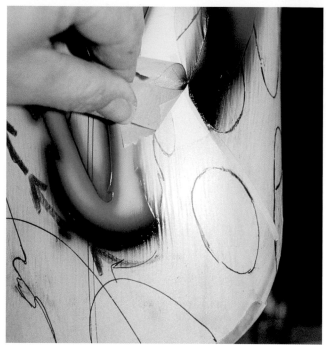

Here I'm removing the tape. First, the masking tape gets peeled away. Then I pick up the end of the fineline tape with the tweezers and pull it back. I keep a stencil knife in my other hand so that I'm ready to push down any stencil material that the tape tries to bring up.

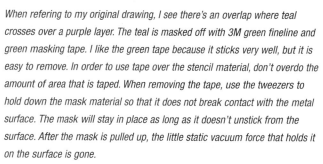

When refering to my original drawing, I see there's an overlap where teal crosses over a purple layer. The teal is masked off with 3M green fineline and green masking tape. I like the green tape because it sticks very well, but it is easy to remove. In order to use tape over the stencil material, don't overdo the amount of area that is taped. When removing the tape, use the tweezers to hold down the mask material so that it does not break contact with the metal surface. The mask will stay in place as long as it doesn't unstick from the surface. After the mask is pulled up, the little static vacuum force that holds it on the surface is gone.

If any mask does come loose while untaping, stop. With a small pair of scissors, trim away the lifted material before any more comes loose. Use a fingernail or the blunt end of a stencil knife to burnish down the edge of the material and stick it back to the surface. Cut and trim a piece of frisket paper to replace the missing stencil area. Don't freak when it happens. As you get used to working with Spray Mask, you'll discover all the little quirks about making this product work for you.

The edges of the tape are bent up and form a spray break to direct the overspray up and away from the surface. Purple is sprayed, and it should be darker where it comes from under the tape. Try to only paint the area close to the overlap. If you get too ambitious and keep going, the overspray will land around the tape and create unwanted lines. Mix the black base coat very thinly with the reducer. Airbrush along the line of the fineline tape. Just one pass ought to do it; a dark, black shadow is desired here. Just create a darker tone because too much black will stand out and ruin the gradual transitions.

Now the next layer of the stencil is cut away to reveal more of the webbing. Cut enough away so that you have room to work. Make sure not to get too close to the cut line because the overspray will leave a shaded line.

136

Left: *Tape off the purple layer so that the teal overlayer can be airbrushed. Refer to the first photo in the chapter and see how the layers wrap under and over one another. The teal layer that goes over the purple also wraps back around and goes under it so that is taped off too. Now more teal can be painted. The part that goes under the purple gets darker shading and a little black.* Right: *The finished result of that shading. Now this process is repeated throughout the first layer.*

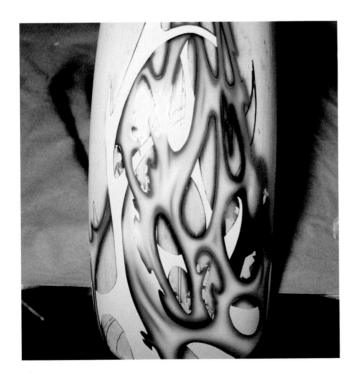
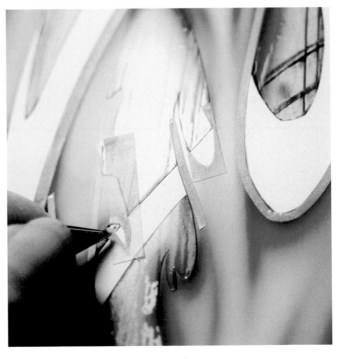

Left: *All the previously revealed areas are painted. Next, another long piece of unbroken webbing is cut and removed.* Right: *The overlaps have to be taped off. Here ¼-inch green fineline is put down and trimmed to fit a small pointed area that overlaps. You can see where the fineline tape has been taped into place around what needs to be protected.*

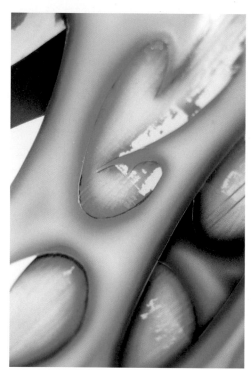

Left: Here it is: the layer that was peeled away. It's all taped off and ready for shading. This string of webbing covers a lot of area, so I used tape and masking paper to cover everything. No overspray will get on what was already painted and the lines will be sharp. **Right:** Next, I go through to peel, tape off, and paint any little bits of webbing I can, like this little layer that shows inside this oval.

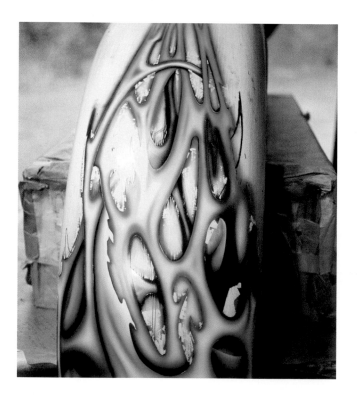

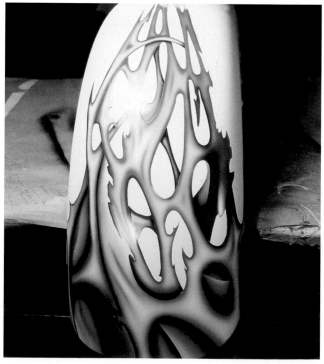

Left: Here's what it looks like so far. Note the stencil still in place. **Right:** The stencil is completely removed. Wow, the teal web looks darkly stark against the white. It's amazing how much lighter the teal looked before the stencil was removed.

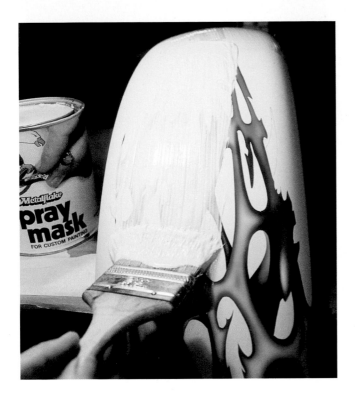

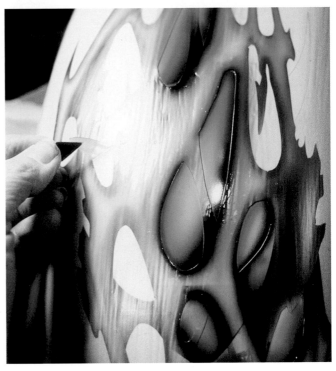

Left: *Four more layers of Spray Mask are brushed on and each coat is allowed to dry before the next is applied.* Right: *Now the bottom layer is airbrushed. On the right side of the fender, you can see where I've used the teal and black to build up an even fade. This bottom layer will be darker than the upper layers. One by one, cut out the white areas and airbrush. I use the tweezers to grab the cut material and lift.*

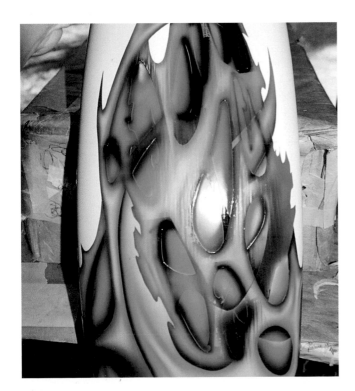

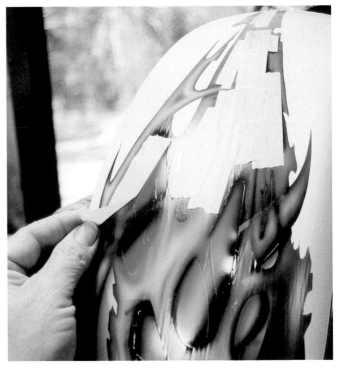

Left: *The webbing is completed, but the white is too stark against the web. It loses the three-dimensional effect I'm shooting for. A softer transition is needed.*
Right: *The mask remains in place, and any open or revealed areas that are not covered by the mask are taped up.*

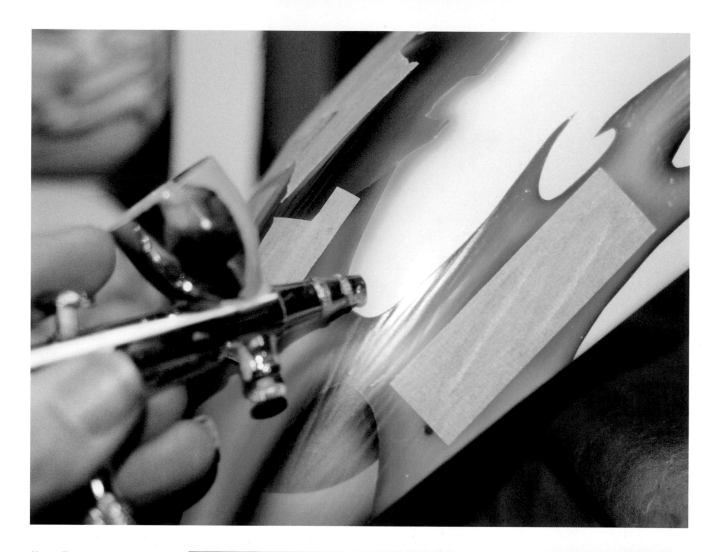

Above: *The teal candy mix is loaded into an Iwata HP-C and sprayed around the edges of the stencil. Airbrushing this part is very tricky because the teal shadow needs to be very soft. If it's too dark, it will appear spotty.*

Right: *I find that the airbrush is not the best tool for this pattern because it covers too small an area. I grab one of my favorite tools, SATA's dekor artbrush. The pattern of the artbrush is between an airbrush and mini spray gun. It works great for this task of spreading the teal fade out so that it covers more area, while also being softer and more gradual.*

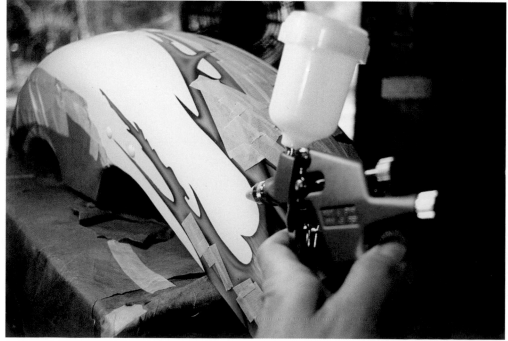

140

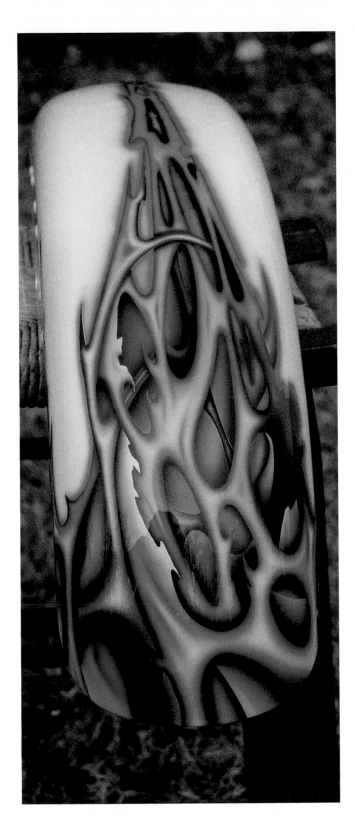

Use care and planning when you are working out your color designs. Will hot colors or cool colors be used? For this project, I've stayed with all cool colors, and the paint job has a nice, icy look. If I had used a "warmer" color as a base for the white, it would not have worked so well with the teal and purple. In fact, it may have clashed with those colors. Hot colors can be mixed with cool ones, but for cases like this, it is best to plan your colors and make sure they complement each other.

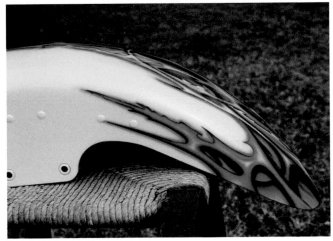

The layout of this design fits the fender very nicely and complements its lines with the way it wraps around the sides. Note how I tried to stay away from the rivets. When working with rivets, if at all possible, keep the design lines away from them because rivets are difficult to tape. The tape always wants to lift.

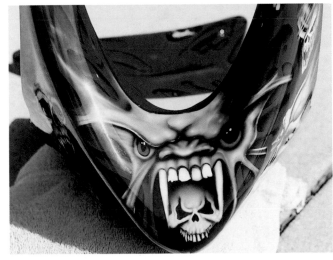

This is the finished result. The white base that was used is House of Kolor Snowwhite Pearl. It is a very "cool" tone of pearl white. A pearl white with a gold or creamy tone would not have worked as well with these colors because they are very cool colors.

This weird creature was painted using liquid frisket and working in the layers just like I did the fender in this chapter.

Above: *Here's a hint at how I started working on the purple webbing. The design was all drawn out on the mask material.* **Below:** *Layer by layer, just like with the white fender, each layer was cut and airbrushed. This is the finished fender. Look how amazing this looks with just two colors, black and dark purple, airbrushed over the base.*

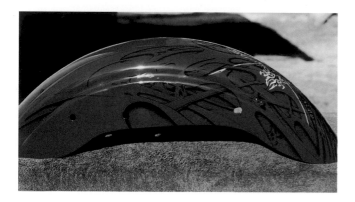

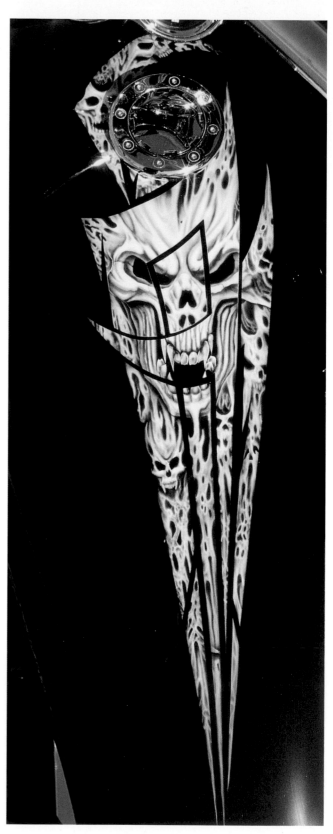

Liquid frisket was used for the tribal outline of this graphic, and paper stencils were used for the skulls inside it.

142

CHAPTER 12
AIRBRUSHING AN EAGLE

One of the easiest things for a new airbrusher to paint is an eagle portrait. It is easy to get great results the first time. It is also a good way to learn how using a combination of hand-held shields and freehand airbrushing can create real form and the illusion of layers.

As with any realistic subject matter, it is crucial to have a good reference photo. I also recommend looking closely to see how other artists handled the elements of the painting. Robert Gorski, an airbrush artist in Connecticut, was a big influence in my eagle painting. I was visiting his shop one day, almost 20 years ago, and was blown away by his soft shading of white tones. He'd do a snowy mountain peak and airbrush soft tones of blue, purple, and gray. The results were dreamy, mystic murals. Then, on the way home, I spotted a van with a wild eagle mural on the side. It was definitely Bob's work. The eagle was flying over snowy mountains. I stopped, took a few pictures, and have been strongly influenced by those photos ever since. I've seen many different ways of painting eagles over the years and studied many of them.

Chances are, the first eagle you airbrush will not be the best. As you gain more experience and find what works best for your technique, you'll find that rendering eagles and birds is among the most enjoyable airbrush experiences there are. This example is done on a metal surface using liquid Spray Mask as a frisket and automotive base coat paint. The basic technique can be done on any surface with any

MATERIAL AND EQUIPMENT
- Metalflake Company Spray Mask
- White opaque paint
- Black opaque paint
- Yellow opaque or transparent paint
- House of Kolor KK-07 Root Beer Kandy Koncentrate (or any transparent burnt sienna color)
- ⅛-, ⅛-, and ¼-inch 3M green fineline tape
- ¾- and 2-inch green masking tape
- SATAgraph 3 airbrush
- Iwata HP-C Plus airbrush
- #4 X-Acto knife
- Fine detail scissors
- Cheap 2-inch paintbrush
- Pencil
- Pen or finepoint Sharpie
- Magnets
- White Stabilo Pencil
- Circle template
- Uncle Bill's Sliver Gripper Tweezers
- Coast Airbrush storage bottles
- E-Z Mix cups

frisket material and any paint. For paper surfaces, use frisket film and paint designed for use on paper.

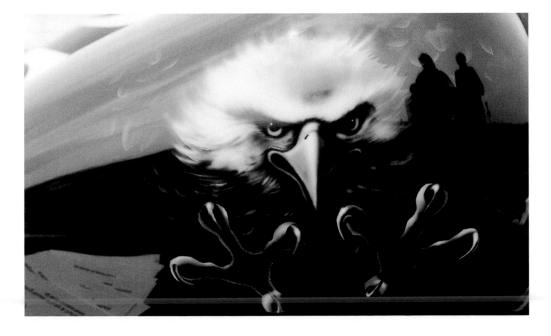

What makes this mural work is the fact that it was done over a dark background.

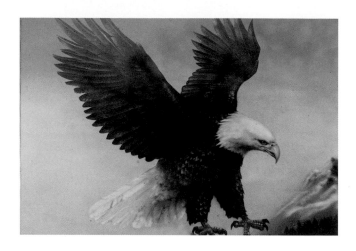

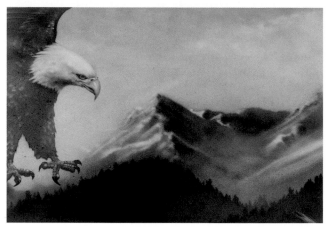

Left: *This is the photo that was taken in 1987. It is the artwork of Robert Gorski. It is nearly a road map of how to correctly airbrush an eagle and mountains. If you look closely, you can see how the repeated use of simple stencils combines to bring this mural to life. First, the feathers were airbrushed with the stencils, and then light freehand shading in tones of brown and purple softened up the feathers. The freehand shading furthers the illusion of reality and gives the mural a very mystical mood.* **Right:** *Here is a close-up of those icy mountains Robert painted.*

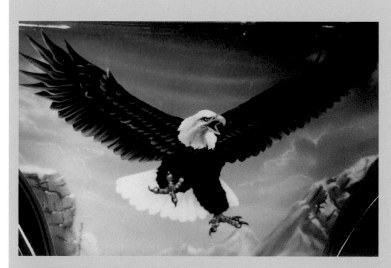

When painting birds, break the bird up into parts. Look for parts that overlap, such as the feathers in the wings. A nice trick for painting wings is to draw up a few different feather shapes and vary the edges. In the photos here, you can see how each feather was separately masked off. To create the look of the eagle flying, a rounded feather shape was cut, held in place, and paint was airbrushed along the edge. Then the shield was moved over, and the process was repeated, again and again. The feathers in the chief's bonnet are another example of that technique. I started at the bottom, put down a stencil that was held in place by magnets, and sprayed the feather. Then I'd simply move up an inch, lay down a mask with a different edge, and repeat the process until I reached the top. The eagle is the work of Robert Gorski, my big inspiration for painting eagles.

Left: *I need an eagle bursting out of the flames on this red motorcycle tank. For the primary stencil, I brush on four layers of Spray Mask liquid frisket and allow it to dry. When the flames were laid out on the tank, I left space for the eagle head in the flame design. I had already picked the eagle I would use. Remember, if you are using a photo that is not your own, the subject matter must be changed. In this case, the beak was shortened, and the eagle became my interpretation of what was in the picture. It was used as a technical reference only. A cutout of the photocopy or drawing is placed into position on the tank and a piece of rolled tape holds it in place. With a pen or permanent marker, trace around the cutout.* **Right:** *The cutout is taken away, and this is what the area looks like. You can see how the outline fits right in place within the design of the flames. Why is it done this way? Why not make the eagle overlap the flames? Paint edges are a nasty problem. They will haunt you no matter how many layers of paint you use to cover them. Whenever possible, try to design artwork that works with your paint edges, and not against them.*

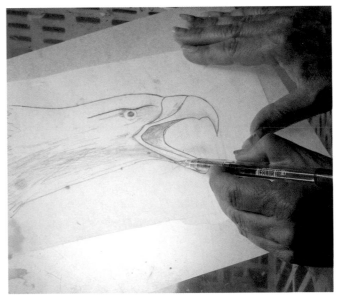

Left: *This is where I make my changes. Unfortunately, I did not make the changes until after I had cut along the outline with a #4 X-Acto knife. Oops! Cut through the mask, but try not to cut into the surface of the paint under it. I peeled out the unneeded stencil material using the tweezers to grab the material. Then, with 1/16- and 1/8-inch green fineline tape, I made my changes. I did not want to cut right on top of the flame's paint edge at the rear of the eagle head. I carefully pulled back the stencil and trimmed it away with fine detail scissors. Then, with the fineline tape, I could accurately mask off right along the edge of the flame. For the places where the feathers will overlap the flame, I cut feather notches in the 1/4-inch tape.* **Right:** *Take a copy of the drawing or photo, and turn it over onto a light table or tape it to a window. Use a lead pencil to trace along the main lines of the design. The lines will be used to transfer the various elements of the reference to the surface of the artwork.*

Next, the mural area is completely masked off. Yes, even though there is Spray Mask on the tank. It does not cover the entire surface, and overspray will travel to land wherever there is uncovered area. Several paint mixtures are made up. I'll be using automotive base coat for the artwork, but any opaque paint will work fine if you are not painting your eagle on a metal surface. Two mixes of base coat white and then base coat black are made up; one is for overall shading that is thinned down 150 percent, and the other one is for fine detail to be thinned about 200 percent. Lightly airbrush the thicker white over the artwork area. Place the traced copy over it and trace along the lines with a pencil. The pencil material on the back of the copy will transfer the detail lines of the eagle head to the artwork surface.

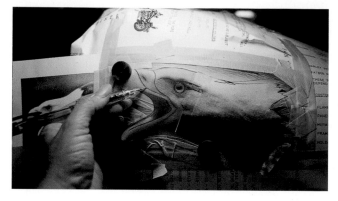

Remember that each brand of paint and each kind of paint is different. The mixture ratios I list here might not work for your paint. Judge your mixtures by how thick the paint can be sprayed with the airbrush needle pulled back just a little, so that very little paint comes out, like when you are airbrushing fine detail. If the paint spatters or comes out grainy, add more of whatever thinning medium you're using (reducer for auto paint, water for water colors, Flash Reducer for Auto Air, and so on). The thinner the paint is, the less air pressure that is needed. Adjust your mixture then adjust your air. There will be times when you will make very small air pressure adjustments of 5 psi or less when you switch to a thinner paint mixture. Then you'll have to crank your pressure back up when you use the thicker mixture again.

Above: *Several copies are made up from the drawing. These will be used as paper masks for things like the beak, eye, and brow of the eagle. The beak and brow are cut out from one of the copies and lined up in place on the eagle head. Magnets hold them down. Now the thinner black is sprayed along the brow to create the hollow that falls back from the eye. Avoid spraying too much along the stencil. End your paint stroke just before you want the line to end. Overspray will travel and extend your line farther than you would think.* **Right:** *The lines of the feathers are very lightly airbrushed in. The tones build up very gradually. Here it is shown at the start of the process. Now is the time to think about how the light hits the eagle head and what will be in shadow. A good reference photo paired with a little common sense will help in this area.*

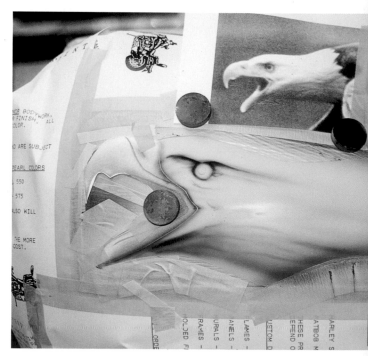

Not all airbrush artists do this. But it makes it easier for me to paint uniform lines of tone. For the straight lines of shadow and light I need here, I'll hold the airbrush in a position that makes it easier for me to keep those lines balanced and even. I hold the airbrush nearly parallel to the surface, and airbrush back and forth. See Chapter 8 for photo examples.

More black is airbrushed on. I notice that the groupings of feathers are separated by shadows. Rather than airbrush every feather, I airbrush the groups. First, I shade in the shadows that fall in between the groupings. I softly go over the shadows; the air pressure regulator is set at a very low psi (maybe 15 psi) because the black paint I'm using is very thin.

I hold the airbrush nearly parallel to the surface, pull back the trigger just a little bit, and spray. The paint to comes out at an angle that complements the direction of the shadows. Refer to Chapter 8 for a sidebar that shows this airbrush technique. The bottom of the eagle head catches more shadow than the top and the shadows are darker there. Always know your light direction. Also, areas that will be "higher" than the feathered surface are identified. The beak and the flame edge will need to look like they are over the feathers, so I airbrush shadow along those edges.

Now white is airbrushed in, using the same technique as what was used with the black. I aim the airbrush for the very center of each feather group, in between the black lines. Keep the spray light and as fine as possible; add soft overspray because airbrushing these fine lines will help to blend them. For that reason, aim the airbrush at only the very center of the light areas. If the light areas in between the black shadows were completely filled in, it would be too harsh and stark.

Now airbrushing the white will result in overspray that lands on the black. No matter how softly you airbrush, the white will travel. You'll need to go over areas of black that need to be pure black. Don't get too crazy, just refine the deepest parts of the shadows. Here the brow shield has been put in place, and I'll lightly airbrush black along the edge, just above the eye.

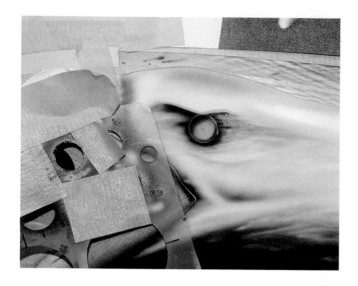

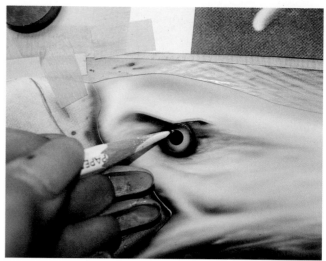

Left: Next the eye is painted. I find the right size of circle template to use. The other circles next to the one I chose are taped off. If the other circles are not taped, overspray from the eye will pass through those circles and land on the surface. Here I'm using a very thinned-down yellow mix, and a transparent root-beer brown or burnt sienna color that I obtained by mixing some House of Kolor KK-07 Root Beer Kandy Koncentrate with House of Kolor Intercoat Clear. This mix is also thinned down about 150 percent. For fine art applications, any transparent burnt sienna color will work. First, I very lightly spray the eye with white. Imagine a ring of lightness just inside the border of the eye. Aim the airbrush there and spray white. Now, lightly shade it with yellow—it won't take much. With the burnt sienna or root beer, airbrush around the edge of the eye and aim for that edge. Do not evenly cover the yellow with the brown tone. You want a soft fade. Right: Now find a circle on the template that is the size needed for the eye's pupil. Hold it very tightly against the surface because a sharp edge is needed. Or, if you have a plotter, cut a circle stencil. Here I used the template and then sprayed black. Keep the air pressure light because you don't want to force the paint to run out past the edge of the circle from under the template. Use a very sharp white Stabilo pencil to draw the highlight by softly touching the pencil to the surface and leaving a small dot.

Left: Next the beak will be sprayed. A paper copy is cut so that it can be used to mask off the beak. Straight yellow is not the color of a bird's beak. A soft, grayed-down yellow tone is needed. To obtain that shade, I pour some yellow into a mixing cup and add a little white to soften it. Then brown and a touch of black are added. I'm using very small amounts of paint. I keep my mixed paints in Coast Airbrush squirt bottles, which makes it easy to squirt in just a bit of the needed colors. Now I have a yellow that is more of an ochre color, which is a nice name for muddy yellow. I take some of the paper copies and cut out the beak's detail from them, such as the inside of the mouth and the bump of the nostrils. The piece that covers the inside of the mouth is put into place and the beak color I mixed is sprayed. Right: Colors that will be used to shade and highlight the beak: burnt sienna (root beer color), white, and black. These colors are thinned down about 200 percent for this step. Now, here is where it gets tricky. I keep my reference photo very close by so that I can glance from the photo to the painting, over and over. Locate the darker tones on the beak in the photo then, with the burnt sienna, very lightly start to airbrush them in, build them up slowly, and start at the undersides of the beak because that part will be in shadow. Next, locate the highlights and very lightly airbrush thinned white along the top ridge of the beak, while curving down to the point. The white will be nearly transparent. Build the highlight slowly. The trick is to go light and keep the air pressure low, but not so low that the paint spatters.

What should you do if you airbrush too heavy and/or go too far with a shadow or highlight? That is the reason you always start very lightly with shading, It's easy to go back with your original color and rework the area. What if the flaw is dark and not light? That's when it's time to sit back, take a break, and think for a few moments. In cases like that, the flaw cannot be fixed by simply spraying on the original color. Pour some of the original color off into a cup. It will need to be darkened or lighted, depending on the darkness or lightness of the flaw itself. Mix a correcting color and start your rework by airbrushing very lightly and carefully. There is no easy answer here, but a color wheel is a great help. You need to identify which color is too much, and lightly airbrush a color that will counteract it.

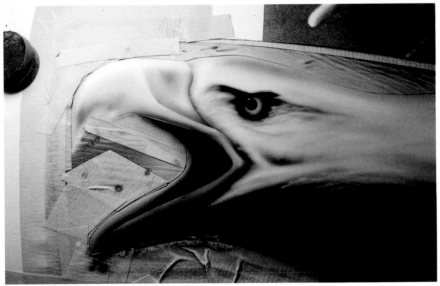

Above: *Now the outside of the beak is taped off with the other part of the paper stencil that was used to mask off the inside of the mouth. From this angle not much detail is seen, so it airbrushes fairly fast. It's just dark shading with the beak color and a soft white highlight, which runs along the upper edge seen on the left side of the mouth.*
Left: *The same technique of masking off a part of the beak is used for the bump on the beak that contains the nostrils. Again, refer to the reference material and then softly shade it with burnt sienna, black, and highlight with white.*

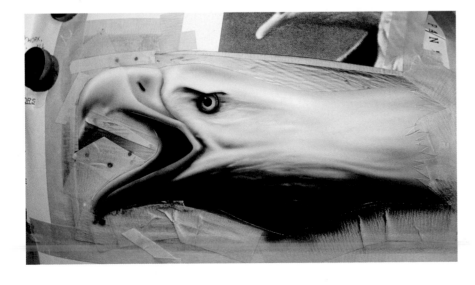

The hole for the nostril is cut from one of the many paper copies and held in place by a magnet with black lightly airbrushed. OK, this bad boy looks done.

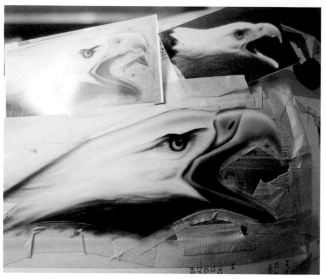

Above left: *So what if I need to airbrush the same eagle head on the other side of the tank? If I have a computer, it is very easy. A digital photo is taken of the artwork I just did. Then I load it into my computer and open it up. I use Photoshop but you can use nearly any graphics program, even MS Paint. The photo is simply flipped or reversed. Now I have a great reference to use for the other side. The photo is printed out and taped on the tank right above where I'm working. What about the paper copy stencils I made? I just flip them over and use them again. Here you see the outline of the eagle head has been cut out of the Spray Mask film, and the reference photo is in place.* **Above right:** *This is the finished reverse side of the tank. It's not an exact match, but it is close, and that is good enough. Sometimes it's a good thing to have two sides that can be the same, yet different. Both sides have various elements that make them good.* **Below:** *Here is the finished tank with clear coat. The eagle looks like he's busting right out of those flames, and it's just what the customer wanted. If only every job went this smoothly!*

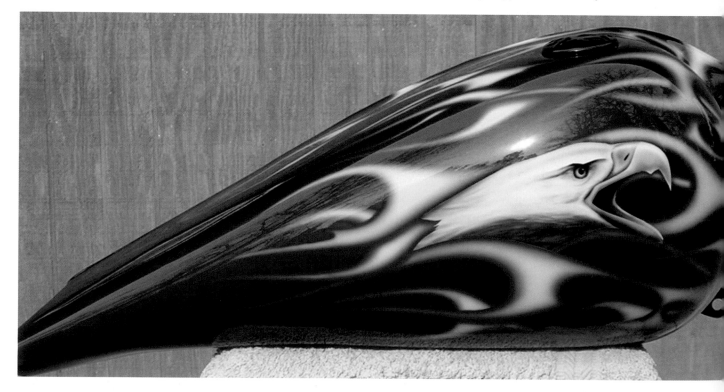

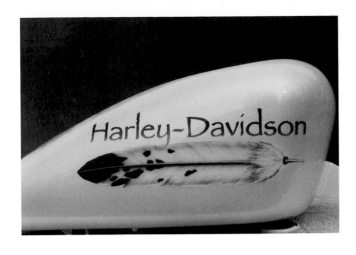

This is the drawing I used for the feathers seen in the previous photo. All the details were worked out on paper before any airbrushing was done.

Above: *More examples of airbrushed feathers. Here, the feathers have a soft feel.* **Below:** *These feathers have a more stylized look.*

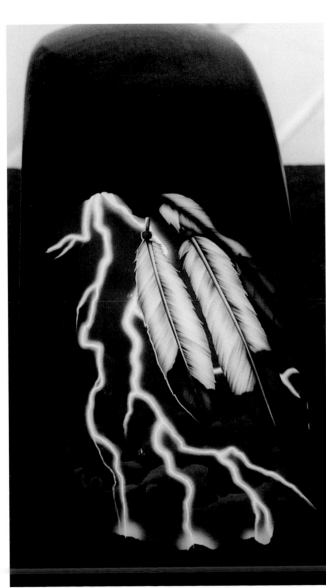

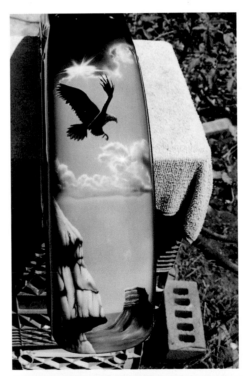

Left: *This fender features an eagle, but the rocks and clouds are really the attraction of this mural.*

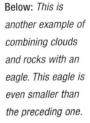

Below: *This is another example of combining clouds and rocks with an eagle. This eagle is even smaller than the preceding one.*

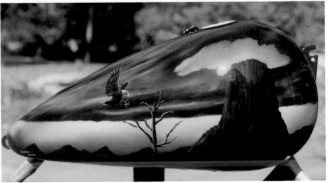

CHAPTER 13
PAINTING SKIN TONE AND THE HUMAN FACE

In this chapter, we will be using all the techniques that have been explained, plus a few new ones. For many artists, painting a person is very challenging. But, if you break the subject matter into sections and handle it one part at a time, it is much less intimidating. For this pin-up girl, we will need to paint many different textures: the hard leather of the boots, the soft leather of the jacket and gloves, the fabric of the pants, the metal gun, and the texture of the skin. Again, as I have said so many times before in this book, bringing these forms to life requires manipulation of the darks and lights.

Remember all those lingerie catalogs and girlie magazines that you throw away? Well, this is one place they will come in handy. Seriously, save some of these for your reference library. They are a great reference source for poses, and to see the way the light hits and plays off various body parts, the color of skin tone, and facial expressions. Just about any reference question you have concerning the female body can be answered in some of the photos you'll find. I have about a dozen or so catalogs and magazines. They don't take up much space.

Airbrushing skin tone is easier than you may think. With a few simple tricks and a lot of patience, anyone can get great results.

MATERIAL AND EQUIPMENT
- Grafix frisket paper
- Gerber mask vinyl film
- Sharpie fineline permanent marker
- TransferRite Ultra Clear transfer tape
- White paint
- Black paint
- Burnt sienna transparent paint
- Brown, red, and yellow paint
- Black Stabilo Pencil
- White Stabilo Pencil
- SATAgraph 3 airbrush
- SATAgraph 1 airbrush
- Iwata HP-C Plus Airbrush
- Light table
- Cutting mat
- X-Acto #4 and #11 stencil knives
- Artool Mini Freehand Shield #FH-5
- Fine detail scissors
- Magnets
- Metal eraser template
- Coast Airbrush storage bottles
- E-Z Mix cups

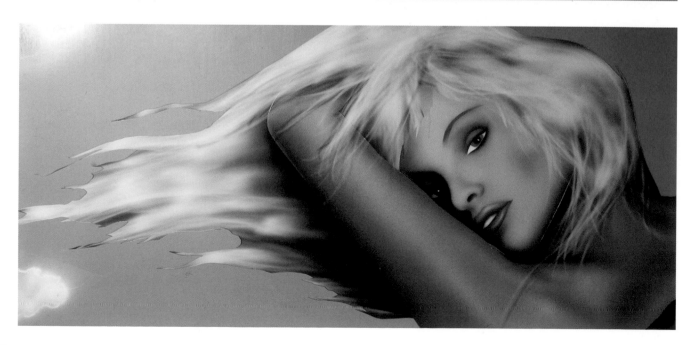

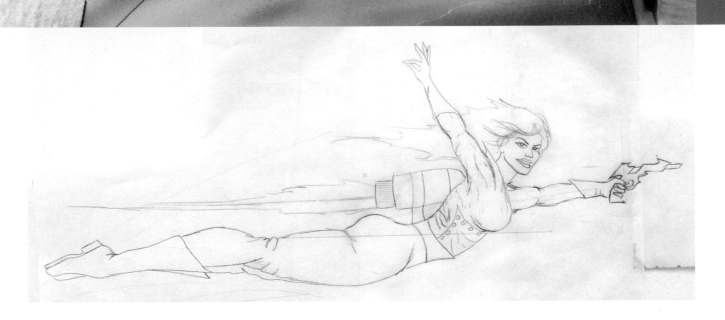

Don't worry about making your drawing the size you need when you first draw it. A drawing can easily be reduced or enlarged to a size that is needed by using your computer. If you don't have a computer, you can go to the drug store or the library to use their copy machine. Most of them can resize copies.

Now, the customer for this motorcycle tank wanted a flying woman, which is a nostalgic jetpack girl with an edge to her. He sent me quite a bit of reference material showing a rocket guy wearing leather boots, riding pants, and a 1930s-style leather jacket. I drew her up and gave her a nostalgic space-age gun. I measured how big I needed the woman to be to fit properly on the side of the tank and enlarged the original drawing. Once I had a few different sizes printed out, the girl was cut out and placed on the tank to see which size fits the space best.

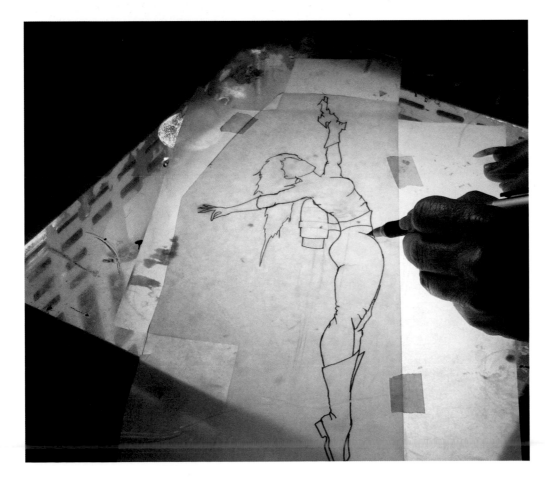

The mural will be on both sides of the tank, so two pieces of frisket film are needed. The drawing is placed on the light table, and the frisket film is taped to it. Tape the film to the drawing so that the film will stay aligned to the drawing. I use a fineline permanent marker to trace the drawing, but an ink pen can also be used.

Right: *For the other side of the tank, just flip the drawing over. Tape the frisket film to it, and trace. Now you have a right and a left side. Next, the tracings are placed on the cutting mat and cut out using an X-Acto #4 stencil knife.*

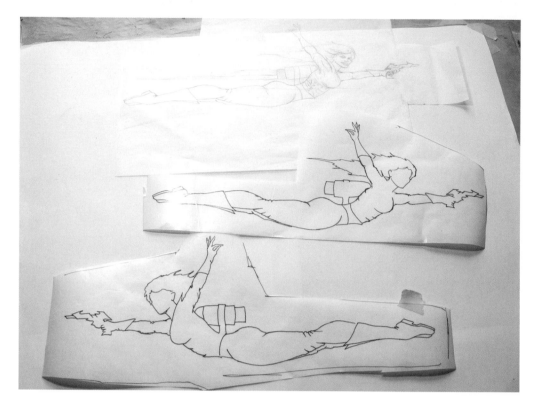

Below: *The piece that is cut out of the frisket is saved, so be careful when you cut the frisket. Do not cut the removed piece apart. Keep it intact, because it will be used throughout the whole process. I call this piece by a very technical name, the cutout. The cutout is taped in place on the side of the tank. The stencil will be laid around it.*

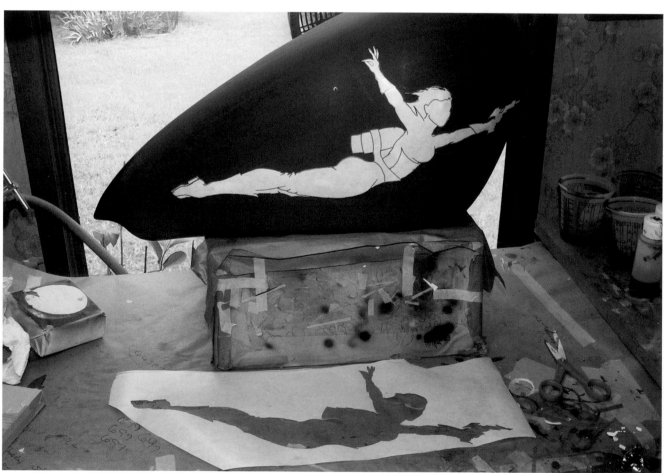

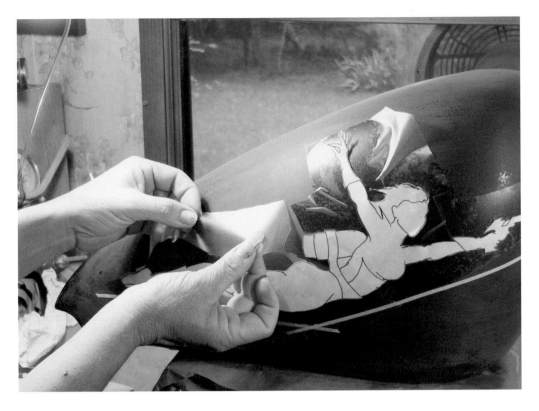

Left: *If you have a flat surface, it is much easier to apply the stencil. There is still a chance you might have to cut it apart. It can be frustrating because the stencil can tend to flop over and stick to itself. You can cut it into pieces and then each piece can be carefully aligned with the cutout. In the case of applying the stencil to curved surfaces like this tank, it must be cut apart in order to lay it flat.*

Below: *Here is the tank all taped off and ready for artwork. The cutout piece is put to the side because it will be used again. Plus I make about four paper copies of the drawing that are the same size as the cutout. These copies will be used as paper shields.*

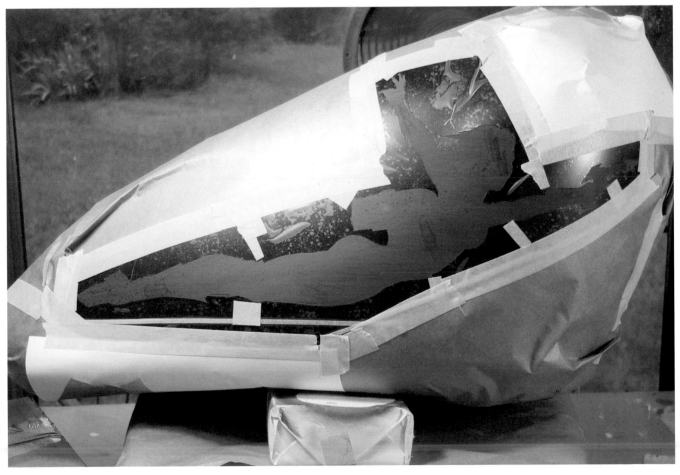

Right: *Now I'll mix up the colors. By the time I'm all done, I'll have gone through many custom mixes. I'm using automotive base coat paint, with some opaque and some transparent colors. I'm starting with the boots, so I'll mix those colors up first. I'll be using the opaque colors of white, black, and brown. The transparent colors are yellow, burnt sienna, and red. My custom mix, using those colors, are a mix of brown, black, and burnt sienna, and it is called brown/black or BB. This color is mainly what I use for most of my brown needs. It will be used in the boots, gloves, skin tone, and jacket. Remember that the BB or brown/black name is that particular mixed color.* **Below:** *Pieces for the boots are cut from the copies I made. The boots are trimmed from the frisket cutout and put aside. The rest of the cutout is taped in place on the tank to mask off the boot area. Note the trimmed paper copies of the boots taped above the girl. The heel and sole of the boot is trimmed from the boot.*

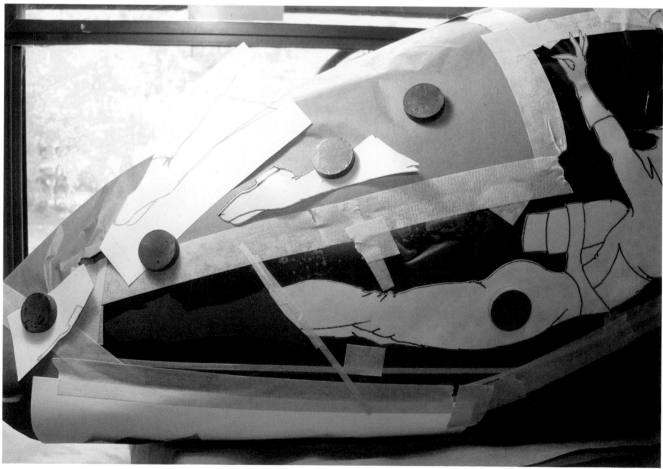

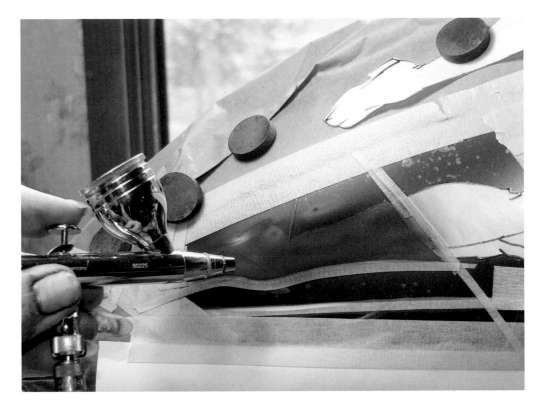

Left: *Using my trusty SATAgraph 3 airbrush, the brown/black is sprayed. I aim the airbrush toward the highlight areas on the boot. Look in the picture at where I am concentrating the spray.* **Below:** *Now, this may look confusing. I have turned the tank upside down and put the artwork in a direction that makes it easier for me to airbrush. Using the Artool FH-5 freehand mini shield, I find curves that match the lines of the wrinkles in the boot leather. If you look at the drawing, the boots have creases near the ankles and a long crease near the top. With the thinned black, I softly airbrush black against the curve of the shield. This little shield will be used throughout this mural.*

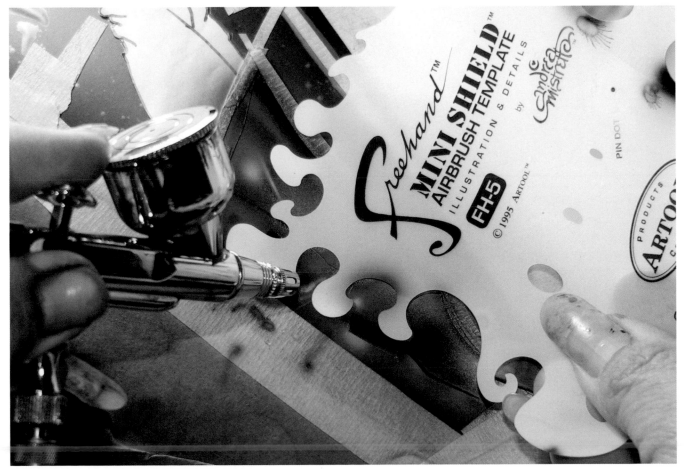

Now I need a soft, dull, yellow/brown color for the leather reflections. To get that color, I'll mix yellow and white, and then add a few drops of BB, burnt sienna, and black. This is reduced about 150–200 percent. Then, in between the dark crease lines, I'll softly airbrush a line of this color through the center in between the black lines. You can use the shield if you want, or try it freehand. I did use the shield for the long reflection highlight near the top of the boot. A shield is used for the hard line of the highlight near the toe and top of the foot. For the two soft round reflections, that's where those dots you sprayed

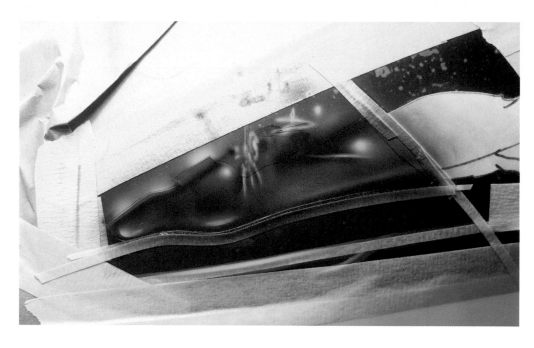

come in again. Note the paint airbrushed on the stencil material around the boots? That is where I tested my airbrush spray nearly every time before I sprayed. As you look through these photos, you will see all the little test dots and lines where I made sure that the airbrush was spraying correctly.

What pressure should you use when airbrushing? I've said all through this book that it depends on your paint and what you are trying to do. Here, I am working with very light tones of color. Most of the airbrushing on this pin-up girl is very fine, detailed shading. The paint is very thin because it has very little pigment in it. I only need a small amount of air pressure to apply the paint. Throughout most of this chapter, I'll be using 15–17 psi to airbrush. Remember that, as I work, I am constantly adjusting the pressure to suit the paint thickness, the technique, as well as whatever airbrush I'm using. Most of these adjustments will only be a pound or two. The key here is that fine detail work equals fine-tuning (small adjustments) to your paint and your techniques.

Now that the boots are done, it's time to paint the pants. Fineline tape and paper are used to mask the boots. The cutout is trimmed yet again, cutting the lower body away from the torso, which is used to mask off the upper body. A light coat of black is sprayed. A copy of the drawing is taped close by for easy reference.

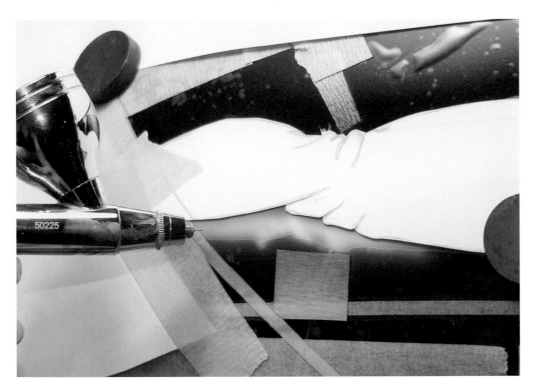

The legs are cut from another paper copy of the drawing and the lower leg is trimmed off. Take care when you cut these copies apart because you will be using both the positive and negative sides. The upper leg is taped in place on the girl to reveal the lower leg. I'm not using a pure white for these pants. I pour off some white into a cup and add a few drops of black and a few drops of brown mix. The airbrush is loaded with a very thin mix of the off-white color. I try to imagine where the folds in the cloth would be and airbrush the white for the top surface of those folds.

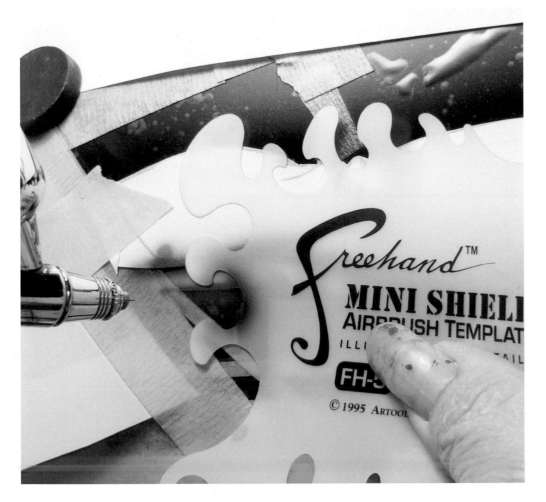

Next, out comes the mini shield. I place the edge of the shield on the bottoms or shadows of the fabric creases, and lightly airbrush very thin black paint. Go very easy because it won't take much paint. If you overdo it with the black, just go over it with some white.

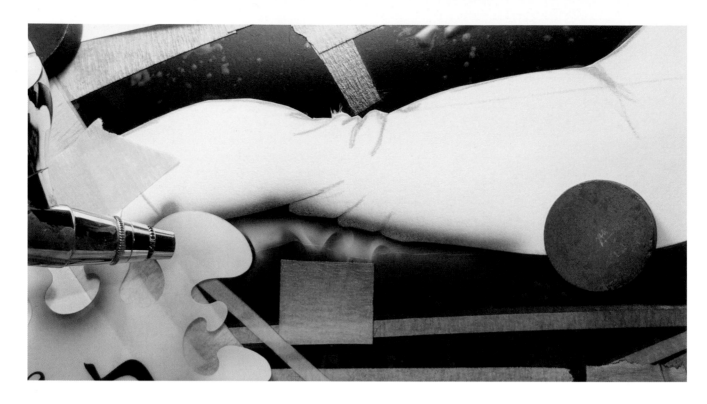

By now I have two different mixes of varying thicknesses of off-white, three mixes of white, and three mixes of black. I'm using the thinnest off-white (about 200 percent) for these highlights and I'm not spraying much at all. The highlights are so thin that they are transparent. See how well the little curves on the shield work here? Black is shadowed in along the bottom of the upper leg. This part is just about done.

The bottom leg is taped off using the clear transfer tape. The tape is trimmed using a #11 X-Acto knife. If I were using watercolors on illustration board, I'd use frisket paper instead. But with auto paint, the frisket might leave adhesive behind after it is removed. Now this is where having a lingerie catalog comes in handy. Simply look through the catalog for a woman with her legs in a similar position and use that as a reference for the muscles of her legs. The airbrush is loaded with an off-white (thinned 150 percent) and aimed at the middle of where I need the highlights to be.

160

Now for painting the lines of shadow. The trick is to use the shield, but DO NOT go very far down the edge of the curve. For example, here the shield is lined up at the back of the knee. I'll start airbrushing the black up on the stencil surface and bring the airbrush down to the edge of the shield onto the leg, but it will not travel the length of the crease. The reason is that the overspray will travel ahead of the black and land on the surface. Whenever you stop the stroke, the paint will fade off. You don't want the crease to cut all the way across the leg. When you start the stroke, point the airbrush up and away from the leg. Bring it down onto the leg about ⅛-inch and softly stop. Now move the shield to see what you have. If the black crease is too long, mix up a gray color and airbrush it over the black to cover it. You'll very quickly see what I mean. Keep the crease lines randomly at different angles.

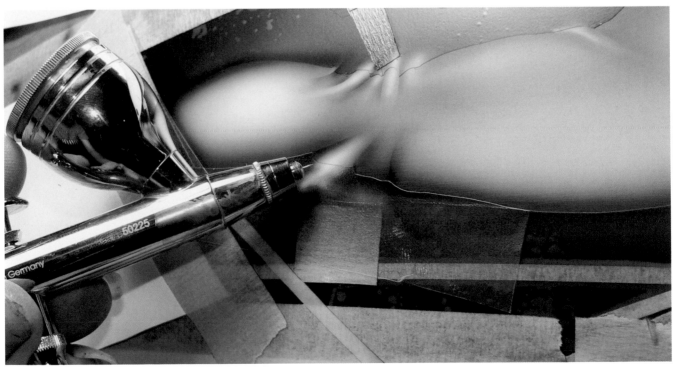

See how the black crease shadows do not go very far across the leg? Notice how the different crease angles give them a more natural look? Now I'll go back with the off-white and airbrush the highlights on the fabric. Soft shading under the leg gives the effect of roundness.

Now I go back, using the thinnest off-white and the shield, to airbrush a highlight along a crease. Just a soft touch of airbrushing will do. Next, the thinnest black is airbrushed only along the very darkest areas of shadow. Just use the shield to quickly and lightly go over the creases. All you want to do is take away some of the boldness from the white overspray that landed on those shadows. You may have to repeat these steps several times until you get the right balance of shading.

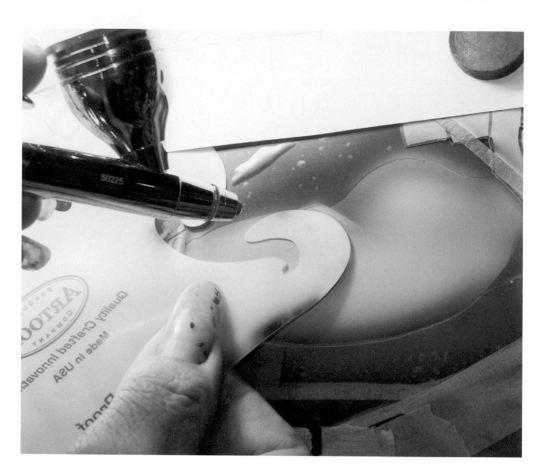

See the white line along the bottom of the upper leg? I simply took the upper leg section that I trimmed away when making the mask for the lower leg and held it offset a little so that it created a gap. Then I sprayed a small amount of off-white. This highlight is added because the lower leg is in shadow, but the bottom of the upper leg is also in shadow. So a soft highlight of white is sprayed to define the legs from one another. The mask from the lower legs is removed, and the legs are done.

Left: *Now the jacket area is masked off using trimmed copies and pieces of the frisket cutout.*

Below: *Hmm, where to get a reference for a leather jacket? Go to the closet, get out a leather jacket, pose in it, set the digital camera on self-timer, and take a reference picture or two. I used three different jackets. The jacket is done very much like the boots. Brown mix is sprayed first. This next step will take a few tries to get right. The trick is to copy the folds in the jacket. Just try to get a nice, natural layout of folds and creases. Lay down a curve on the minishield and lightly spray the yellow mix used for the boots. After the yellow mix is airbrushed, I take a thin burnt sienna mix to layer it over the jacket, which tones down the brightness of the yellow.*

The sleeve of the jacket does not stop right at the junction of the arm and back. The shield is used, and the yellow mix is airbrushed past that place. Don't overdo it on the amount of folds. Less is more.

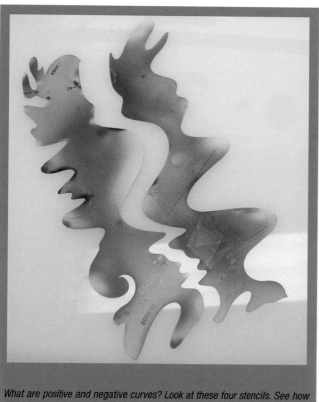

What are positive and negative curves? Look at these four stencils. See how one side of the curve matches the other? One curve is negative and one is positive. It doesn't matter which curve is which. All it means is that one curve fits against or corresponds to the other.

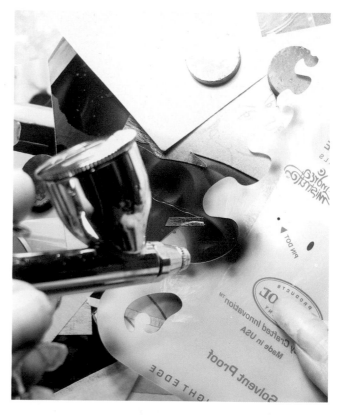

Now the black shadows are airbrushed using a negative curve that matches the positive curve that you laid down with the yellow mix. On this shield, the "nubs" that stick out match up to the curve, which is cut out next to it.

Left: *Using the minishield and a very thin mix of the yellow mix, lightly go back over the highlights of the folds and airbrush just the very middle of each fold. I used trimmed paper copies as shields to airbrush the flap on the front of the jacket. Now I need to add bottoms. You can use a circle template or hand cut little circles from a vinyl mask. I just used my plotter to cut out a few circles. The inside pieces of the circles, or positive pieces, are laid out in place where the buttons will be. Black is shadowed around them, since when a button passes through a button hole, it holds down the material around it.* **Right:** *To know where to place the stencil for the circle, use a white Stabilo to make a mark, so you can see through the hole to center the stencil. First, the yellow mix is sprayed. Then the lower half is shaded with a very thinned-down burnt sienna. I take the inner piece that I had removed and place it over the hole, offsetting it and leaving an open crescent shape along the bottom of the circle. This is very, very lightly shaded with thin black.*

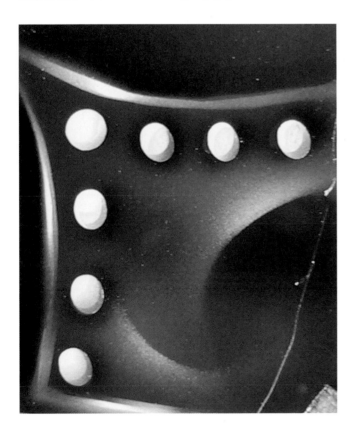
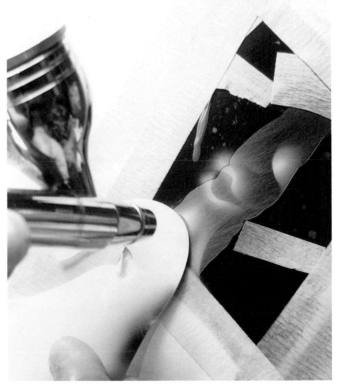

Left: *Here's a super close-up of the gold buttons. After the buttons are finished, a little more work is done to the flap. Using the paper stencils, I redefine the edges to give them more form by adding lighter highlights along the edges and centering the highlight along the middle of each side of the flap.* **Right:** *Now the same techniques of masking off a body part and using the minishield are repeated for the right arm. The yellow mix is airbrushed to define the highlights on the folds of leather.*

Left: *The burnt sienna is layered over that paint.* Right: *One thing to take into account is that the background for the girl is quite dark. The shadowed parts of her might not show up too well against it if they are completely in shadow. To define her, narrow "underhighlights" are applied to the lower sides of the girl. For the arm, the frisket cutout is placed a little offset and the yellow mix is very lightly airbrushed. The highlight doesn't need to be bright, just enough to define the outline of the body as if a dim light was shining up at it.*

Left: *The gun is taped off. Chapter 6 goes pretty in-depth on painting metal, so I won't get too involved here. Basically, white, black, and a thin blue/black mix are used. The gun is sprayed with black. Then very transparent white highlights are added.* Right: *The straight edge of the eraser template is used heavily here. Narrow reflection lines are airbrushed along the edges and concentrate on the highlight in the center of the line. A bright, contrast reflection line is airbrushed down the center of the gun.*

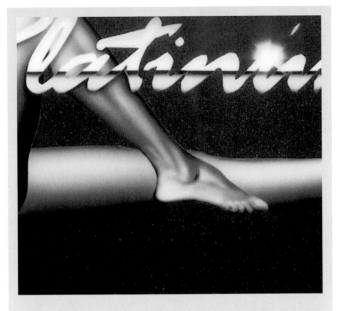

See, the finished gun—simple and quick. Look at just how small it is. The ¾-inch tape is right next to it. The upper body of the gun is less than a half-inch tall.

Attention to small detail can really make a big difference in how "real" your subject can appear. While it may seem easy to simply freehand fingers or other body parts that don't draw attention like the face, take a little extra time to give the small details a finished look. This ankle is not what most people would be looking at when viewing this mural. The little veins in the foot and the effective shading of muscle tone give this artwork a more polished look.

I need a stencil for her hand that is holding the gun. But a paper stencil won't give me the sharpness and definition I need. I don't want to use the frisket film, so I make a small stencil from Gerber mask by placing the original drawing on the light table and tracing the hand onto the piece of vinyl mask.

The same method that was used for the jacket is used for the glove. The fingers are easy to paint. First, apply the brown mix and then, using the thin yellow mix, aim the airbrush toward the center of the highlight that runs along the fingers. Just quickly airbrush a line across. Next, layer some of the transparent sienna on it and lightly airbrush a black shadow on the bottom side of each finger. Once the stencil is removed, gently airbrush a shadow on the underside of each finger on the surfaces of the gun.

Next, the jetpack is taped off and airbrushed using the same techniques as with the gun. Each section is taped off and airbrushed separately. First, white is airbrushed and a light wash of blue/black is applied over that. Then a straight edge is placed about halfway up the cylinder, and black is sprayed along the edge. The straight edge is switched so that the black is covered and then the white is sprayed.

PAINTING FACES AND SKIN TONE

Mixing up color for skin tone is far easier than it may seem. I have my own mixture for skin tone. Most paint companies have a burnt sienna or "root beer"–colored transparent toner or tint. (For automotive paint users, House of Kolor's is KK-07 Root Beer. PPG's is DMD 623.) Mix some of the color with white and then add just a touch of yellow and red. This mix can be easily adjusted to whatever skin tone is needed. Add some white to lighten it up or add more burnt sienna to darken it. I mix up several thicknesses of skin tone thinned down 150–200 percent. For the painting of skin textures and tones, the paints I'll be using are: the skin tone mix, burnt sienna, my brown/black mix, and a lightened skin tone (more white mixed in) for highlights. There are two mixes of each color; one is thinned down 150 percent and one is thinned 200 percent, plus a very thin mix of black.

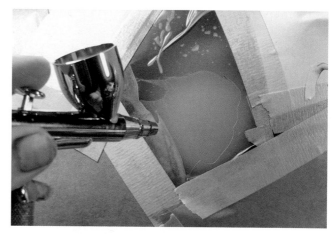

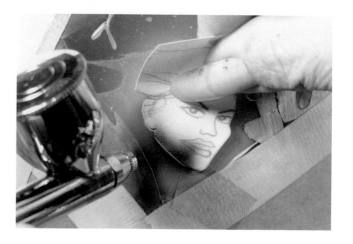

Right above: *Now for the hard part: the face. Several factors make this face a challenge to paint. The biggest complication is the small size of the face. A quarter would easily cover it. The face is sprayed with the skin tone.* **Right below:** *Here, a trimmed copy of the face is used to airbrush the shadows under the jaw on the neck. Burnt sienna and brown/black are airbrushed.*

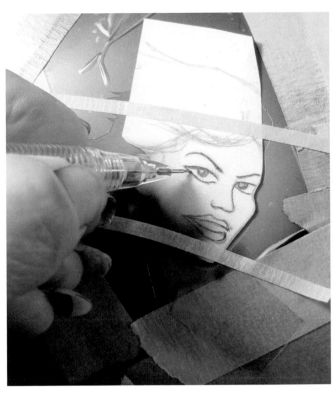

Left: *The result of shading the neck. Shading gives the face form and will make it easier to know where to place the features.* **Right:** *Next, one of the face copies is flipped over onto a light table, and the lines of the eyes, nose, brows, and lips are traced in pencil. Then it is lined up over the face area of the painting and taped in place. A pencil with a fine point is used to trace the face, which transfers the face design to the surface. It was at this point that I stopped taking photos of this side of the tank. I got into a zone and just kept working, playing around, and experimenting with the face technique here.*

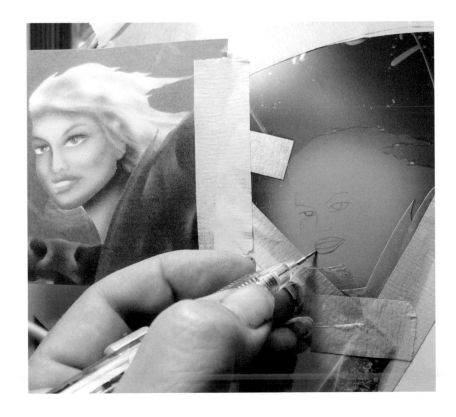

Getting in the "Zone." This happens when you least expect it. You'll look down and realize that this artwork is better than what you normally paint. When you reach the Zone, don't let yourself get distracted. Unplug the phone, shut your door, and work. This is when you will create your best art. Just go with it. Stay relaxed and don't overthink your art. Just paint and make the most of your time in the Zone.

The next group of in-process photos was taken when I worked on the other side of the tank, so the painting is reversed. The pencil tracing is very light, so I go over it with a pencil. Note the photo to the left. Once the opposite side was completed, I took a few pictures, loaded them into my computer, and used PhotoShop to reverse them. Then I had a great reference for the other side.

What is needed now are little stencils for the facial features. I'll cut and trim the paper copies of the drawing and of the reversed photo from the other side. Here I have trimmed the nose. Cut carefully because both the positive and the negative side of the stencil will be needed.

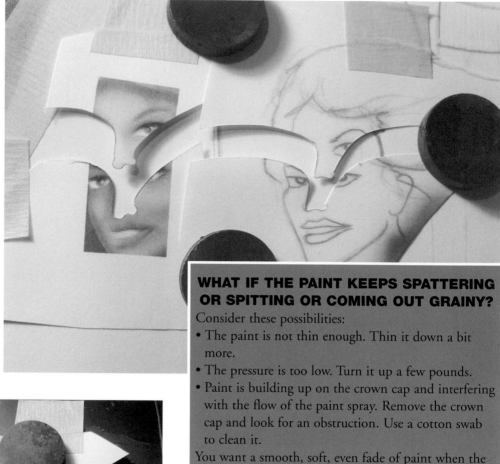

WHAT IF THE PAINT KEEPS SPATTERING OR SPITTING OR COMING OUT GRAINY?

Consider these possibilities:
- The paint is not thin enough. Thin it down a bit more.
- The pressure is too low. Turn it up a few pounds.
- Paint is building up on the crown cap and interfering with the flow of the paint spray. Remove the crown cap and look for an obstruction. Use a cotton swab to clean it.

You want a smooth, soft, even fade of paint when the shading is being done.

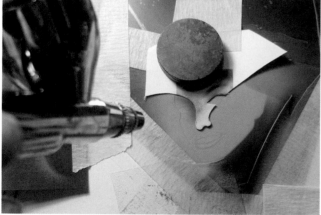

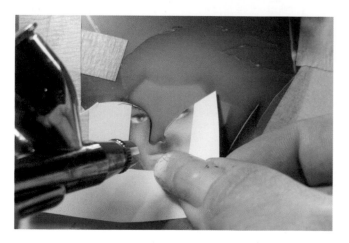

Left above: *The nose stencil is taped in place and the thinned burnt sienna is sprayed along the left side of nose. Note how the right eye is trimmed out of the stencil. This is so I can more accurately line up the stencil. Keep checking the air pressure. I'm using about 15 psi. Check to make sure that overspray is not landing on the right side of the nose. Don't be afraid to get that airbrush right up close to the surface. After the sienna is sprayed, it is followed with the thinned brown mix.* **Left below:** *Now this is where it is handy to have a very clear photo of a face for reference. Nearly every feature of the face is round, and this means that light will hit it and light up the high points and place other parts in varying degrees of shadow. For example, the nose is not one color. It appears as a graduation of tones. The lightest tones usually run down the center of the nose and in the middle of the nostril.*

The darker tones run along the sides of and under the nose, and around the outside of the nostril. The transition from light to dark is very gradual. It is even hard to see if you look closely at a photo. Keep the paint used for the shading thin and the pressure low. Make lots of small changes and only airbrush a very little paint each time. This rule will hold true for the entire face. Here I'm holding up the other side of the stencil and very lightly spraying sienna along the edge of the paper. I want a soft, very slight shadow running up the edge of the nose.

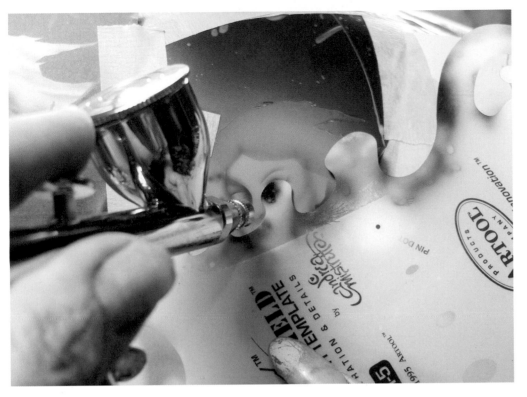

Left: *Much of the shading on the face is done using the minishield. Here I spray sienna at a point on a curve that perfectly matches the shape of the eyelid. I'll use the large nub to the right for the eyebrow.*

Below: *I'm not working on the lips yet, but I need them in place to help balance the face as I work. The lips are cut from a paper copy. Make sure the lips are not too big when they are cut out. Big lips will throw the face off balance and make it look fake. A sienna shadow is brought across the cheek and jaw. Very slowly, the face takes shape.*

Now get a little more aggressive with the shading. The whole face is very lightly airbrushed with a wash of sienna and the form is slowly built up with more sienna shading. Note how close the airbrush is to the surface. The crown cap is removed to allow me better control because I can see exactly how close I am to the surface, and I can airbrush some very fine lines of shading.

Left: *Here I'm airbrushing brown/black along the edge of the nose and deepening the shadow to add depth behind the nose.* Right: *There are two things going on here: First, the shading is effectively bringing out the form of the nose and the face. Note the shadow running along the side of the face next to the stencil edge. Also, note the overspray that is landing where it should not. Just above the right nostril, a slight slanting line can be seen. The stencil I was using is not trimmed enough, so the overspray is landing on a sharp edge and creating this line. Look back five photos to examine the stencil. I will have to trim it so that it is cut away right above the nostril, instead of running straight up it.*

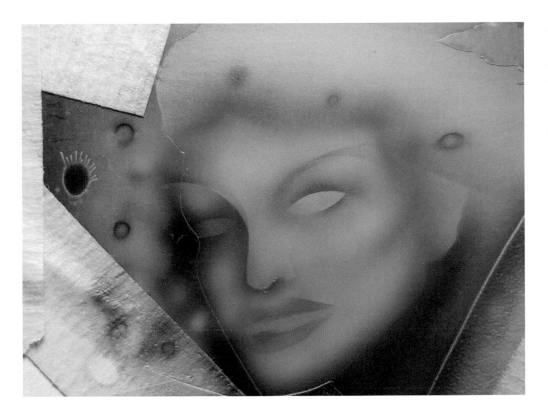

Now a very thin mixture of skin tone is airbrushed on the high points of the face. The minishield and paper stencils are used to mask off the areas as I airbrush. Note the little dots and such around the face on the stencil. I constantly test the spray before I paint. Over to the left, a big splat shape can be seen from one of my test sprays. The needle was blocked by a piece of paint, and a big stream of thinned paint came out. If I had not tested the airbrush spray first, I would have had a big mistake that I would have had to rework. So test, then spray, test, then spray.

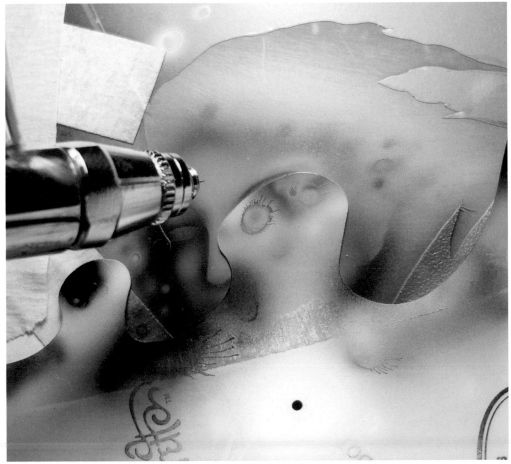

Spraying the eyebrow. The large curve here fit the brow, and sienna is lightly sprayed. Now look over to the left of the knob on the minishield. The large downward curve is a perfect reverse of the curve of the knob I'm using.

To create the line of the brow, I'll take the shield, reverse it, and hold it above the head so the inward curve fits against the brow and covers the area that is revealed here. Offset the shield so that a thin line of brow shows. Sienna is sprayed. Take away the stencil and check to make sure the brow is right, then repeat the procedures with the brown mix. Try to finish any shading around the eyes.

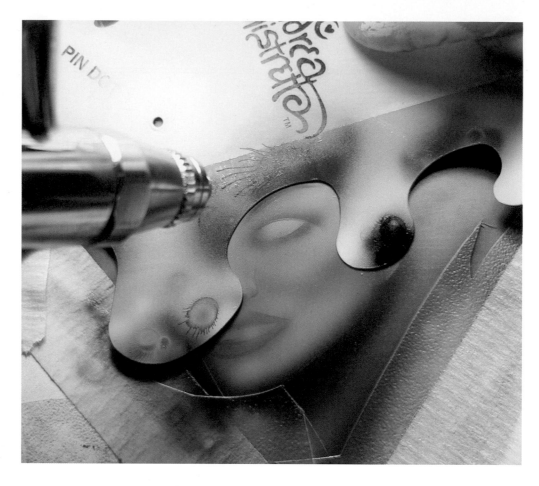

Now to paint the eyes themselves. I'm lucky here—I can use the stencil from the other side. Normally I'd take a piece of clear transfer tape, lay it over the face, and cut the material from the eyes. In fact, that is how this stencil was made. I'll paint one eye at a time. A thin wash of white is airbrushed over the eye. Eyes are not really white, so don't make them bright white. Leave the eye stencil in place when the iris and pupils are sprayed.

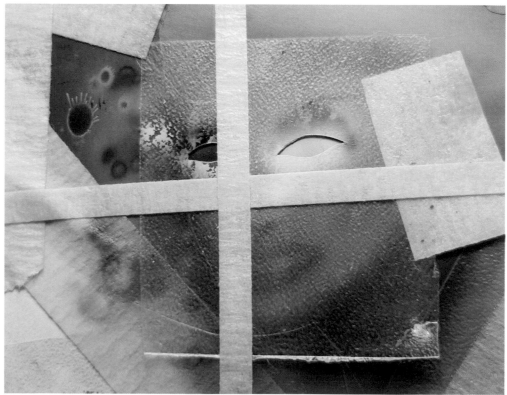

Left: *For the iris, the same circle stencil that was used for the jacket buttons will work but a circle template will also work. Note the little black dot in the middle of the hole. It was made with a black Stabilo pencil before the stencil was put in place. The stencil can be lined up where the iris needs to be. Now transparent sienna is sprayed. For the pupil, a smaller circle will be used. Black is sprayed for the pupil.* **Right:** *The sharpened point of a white Stabilo pencil is used for the highlight in the eye. Then, using the round curves of the minishield and a thin mix of black, very carefully and lightly shade black around the eyes. Do not shade all the way around. For the end corner of the eye, I use the sharp point on an Artool Matchmaker shield seen over to the left. Now, time to paint the other eye.*

After I finish the left eye, I need to apply the shadow over and under the eye, but I don't want the shadow to cross over the nose as it is right there. The paper shield masks off the nose, and the shadows can be airbrushed.

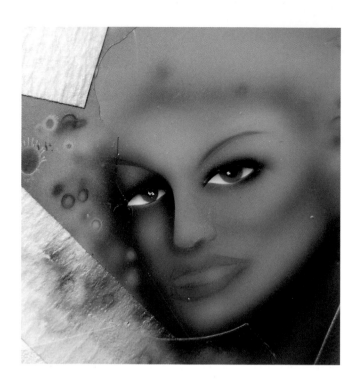
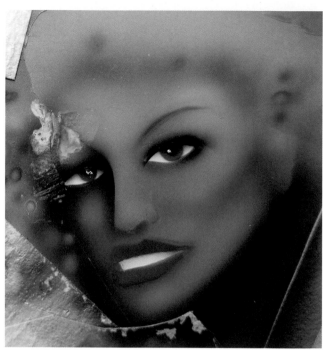

Left: Oops, I went a little too dark on the eye shadow! I put the nose stencil back and airbrushed a little skin tone over the eyelid using a curve on the minishield to mask off the eye itself. Then I redo the shading over the eye, only I keep it a little lighter this time. Right: Oh no! Somehow, some thinner got on the face and damaged the brow above the eye! It turns out that I had picked up a piece of stencil, and it was damp with thinner. The thinner touched the surface and dissolved the paint. Refer to Chapter 14 to see how it was repaired.

The trick for the lips is getting the stencil cut precisely. It might take a few tries to get it right. That's what's so great about having all the extra paper copies of the drawing. If you cut out something that isn't right, simply try again. The lips can't be too big or too thin. This was the second lip stencil I cut out. The first one was too big, and the lips looked fake. For the red color, red was poured into a mixing cup, and a little burnt sienna and a drop of white and black were mixed in. There's not much time put into the lips at this step because they will be worked on later.

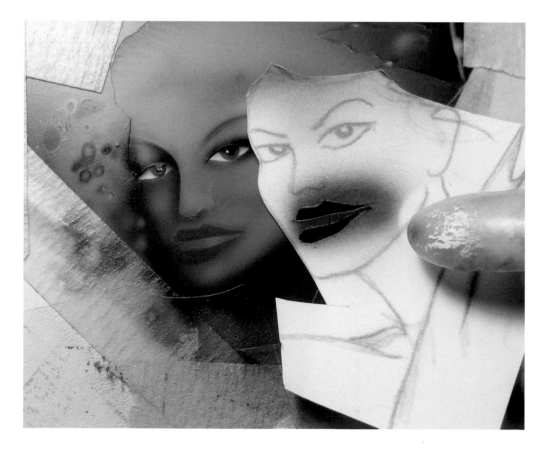

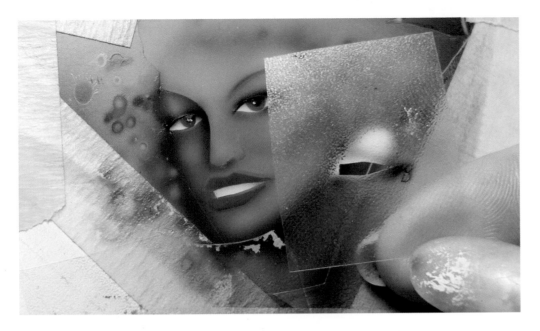

For the teeth, either frisket or clear transfer tape is placed over the mouth. Here I'm using transfer tape. Then, very carefully, the teeth area is cut out, and white is lightly sprayed. A very thin mix of black is airbrushed just under the top lip and along the bottom lip. It is sprayed so light that it looks like a light gray.

Do not overdo it when spraying white! Nothing in real life is ever pure white—not even snow—and surely not teeth or eyes. When airbrushing white, there are several ways to approach it. A light wash of white may be airbrushed, and other colors can be shaded in, or an off-white color can be mixed up. The teeth and eyes in the pin-up seen here are stylized airbrushing, not a realistic mural. The white will add a needed surreal mood. If this were a realistic painting, there's no way any pure white would be used.

Now the lip stencil is placed over the lips again, and the final shading on them is done. A thin wash of burnt sienna and black is airbrushed around the edges. Concentrate it just a bit on the undersides of the lips. For the highlight, a thin wash of white is mixed up. I'll be drawing a narrow, horizontal line across each lip. First I'll go over to the side on the stencil and airbrush a few practice lines to make sure the white is coming out soft and even. It should not be grainy and gritty. After the white is spraying correctly, I quickly draw the two highlight lines I need: one line across the top lip and one across the bottom.

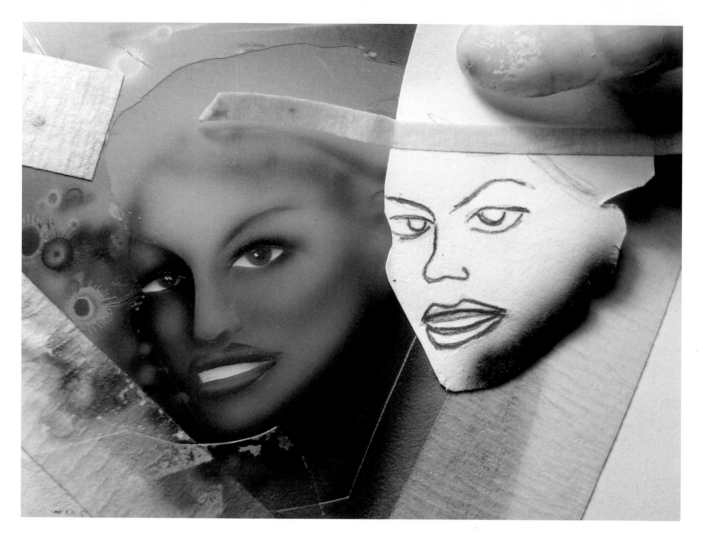

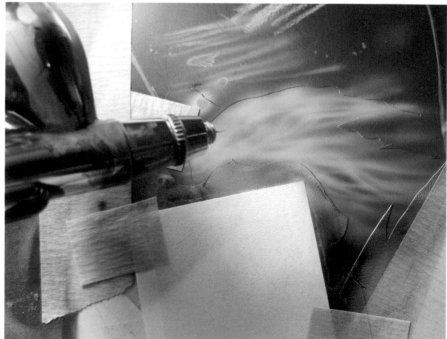

Above: *The face is just about done, but the shadow under the jaw needs to be airbrushed again because overspray has muted it. The jaw stencil is taped on again and a little black is sprayed.* **Right:** *To airbrush the base of the hair, I'll need to tape off the face. I don't want to disturb the face because adhesive may mess with the pencil material that was used. A piece of paper is put over the face to leave the top and side edges of the face uncovered. A piece of clear, transfer tape is put over the paper and the rest of the face. Then the hairline is trimmed off with a #4 stencil knife. Next, black is sprayed over the hair. For the blonde color, yellow is put into a mixing cup with a squirt of white and a drop or two of burnt sienna added. Then the lines of blonde hair are airbrushed. Look at photos of blondes and see how the light reflects off the surface and gives the hair its form.*

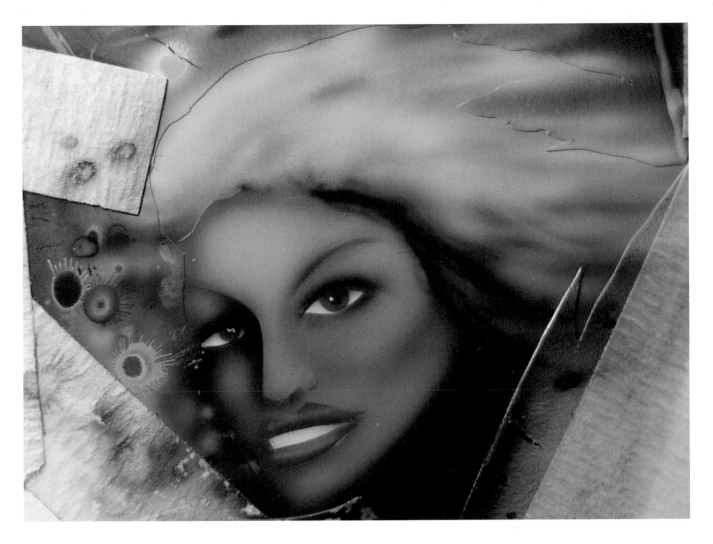

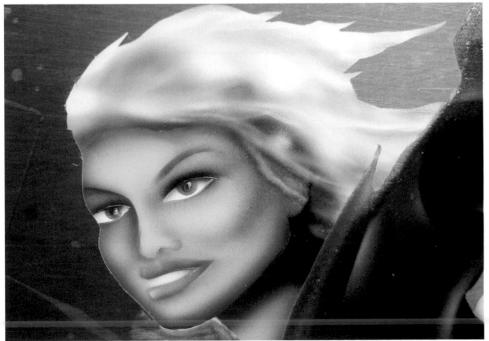

Above: *The mask material is removed. Burnt sienna is airbrushed in the dark spaces to add depth. A few strands need to come over the face. Black or brown/black is used.* **Left:** *Here is a shot of the other side. I have reversed the picture so it can be compared to the following one. More blonde has been airbrushed over the dark strands, and then soft, white highlights are very lightly airbrushed. But now I see a problem—one face looks a lot better than the other. It is hard enough getting them to match perfectly, so I don't even try. Since I am using automotive paint, I can clear coat over the faces and then do rework. If the rework is not satisfactory, it can be sanded off and redone.*

179

The first thing I do is print out a photo of each face, only I'll use a graphics program like PhotoShop to reverse one of them so that they are both facing the same direction. Compare this photo with the preceding one. It will help take out some of the guesswork by having the images look as similar as possible. They don't have to be exactly identical, but they should be a little closer to twins than they are now. I'll pick easy changes to make.

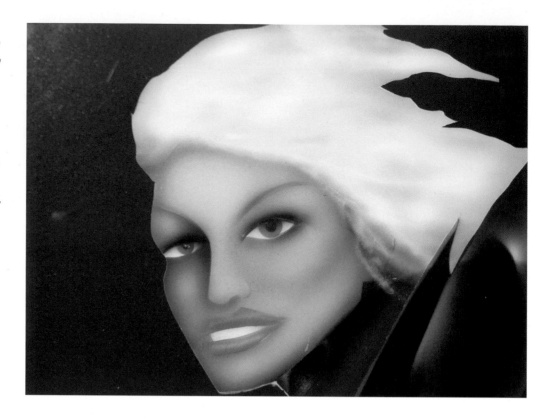

Left: The cleared and sanded second face is masked off with frisket. The first thing I need to do is lighten up the face and warm up the tone a little by adding a tiny bit of yellow to the lighter skin tone. Next, reworking the eyebrows is another easy change I can make. I'll brown them up and slightly change the shape of the right one. Using the other side as a reference, an eyebrow shield can be made by tracing the eyebrow on the first or right side of the tank and then cutting along the traced line. That way, the new eyebrow I spray will be an exact match. Here you can see where lighter tones have been airbrushed onto the face and the eyebrows have been reworked. **Right:** Next, the eyes need to be opened up a little. Using the first face, I lay a piece of frisket paper over the eyes, trace them, and cut them out on the cutting mat. Now I take the stencil I first used for the whites of the eyes and compare it to the other side of the tank. Has it changed? Did paint build up on the edge and make the openings smaller? Or are the irises too big in the second face? I measure to make sure. Keep in mind that this face is about the size of a quarter. The eyes are repainted as I refer closely to the original.

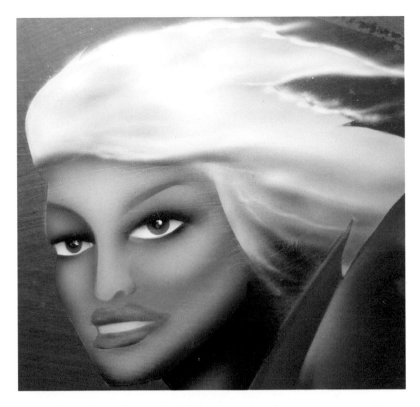

Left: *Next the hair is redone. Actually, I do a bit to the hair on each side of the tank and just airbrush a few strands past the hard stencil line. It gives the hair a more natural effect. Now the shapes of the cheek and nose are a little different. It would take major reworking to change them and I don't have time. I do add a tiny bit more shadow on the nostril. The dark shadows around the eyes are reduced and just a bit more shadow is added to the teeth, under the top lip. A little more brown is brought down under the cheekbone too. Lastly, the lips are masked off with a paper shield and a very light wash of light skin tone is sprayed to the left of the lips. This gives them form. OK, the girl's face is done. Now compare them to the way they looked before rework. Big difference.* **Below:** *Here she is, flying along. I have added a metal-effect circle behind. It helps balance her in the space on the side of the tank, and it adds a sense of symmetry. She has to have flames coming out from her jetpack. But I find that flames may appear to burn her bottom, so only a soft smoke trail is airbrushed. I keep it light. I can always go back and add more later.*

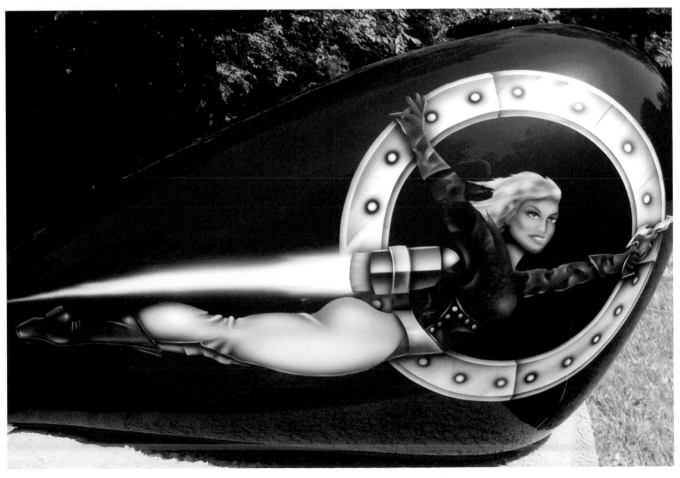

Right: *This mural was painted in 1993. It was my first time airbrushing a leather effect. Lines of thinned-down white are airbrushed across the black surfaces of the legs and arms. Very slight, light highlights are spotted in to give the leather a more worn effect.* Far right: *Almost 10 years later, a new version is airbrushed. The highlights are brighter and sharper, and they give the leather a newer, shinier look.*

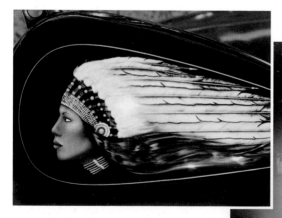

Above: *The Native American princess is another good example of effective skin tones combining to create a good airbrushed mural. The shading is soft, yet it brings form to the face. The hair is airbrushed by spraying black and airbrushing in areas of highlights rather than airbrushing long strands of hair.* Right: *Another mural where accurately painting surface textures combined to create a dimensional image.*

CHAPTER 14
TROUBLESHOOTING AND CARE OF YOUR AIRBRUSH

Bad things are going to happen when you airbrush. There is no escaping it. Weird, irrational problems will crop up, and, most of the time, there's no obvious reason for the problem. It can make the calmest person ready to trash all of their airbrushes and never touch an airbrush again. It even happened to me several times, so it is rather odd that I'm still airbrushing after quitting twenty years ago.

Much of the psychological cure to airbrush hell can be found in Chapter 3. This chapter deals with the mechanical end of problem solving.

TAKE PROPER CARE OF YOUR AIRBRUSH

Yes, many of the problems experienced will be due to poor airbrush maintenance. Airbrush days are long, and the last thing any artist wants to do at the end of a brutal, frustrating day of attempting perfection is to sit at the airbrush bench and thoroughly clean the airbrushes. It's easier to fool yourself into thinking, "I'll just take a little break and come back later to clean the brushes." Then you wake up the next morning and sit down to airbrushes that are still full of paint. It happens to everyone once in a while, so take the extra five to ten minutes and clean those babies.

Each brand of airbrush is different and will be slightly different in the way the inner workings are designed. Don't lose or discard the little pamphlet that came with your airbrush. It will have a diagram that shows how the pieces inside your airbrush fit together. Most airbrushes also come with a little wrench for removing the head or tip. Don't lose these and then try to use regular wrenches because you'll damage the airbrush. Only use the tools that come with the airbrush.

One of the factors that plays a big role in how important cleaning will be is what kind of material you are spraying through your airbrush. Inks and thin watercolors do not contain much pigment or material, so they rinse rather easily from your airbrush. Automotive paint, textile paints, and heavily pigmented watercolors will leave residue in the airbrush's paint passages, even after reducer is blown through them. The airbrush must be partially disassembled and cleaned. Check it out! It's amazing to see the amount of stuff that gets left behind, even though the airbrush appears to be clean.

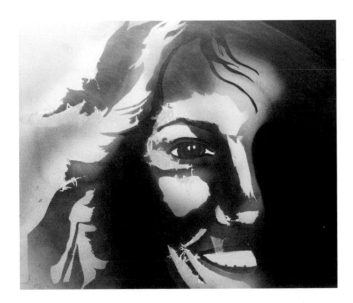

Don't let airbrush problems get you down. Thinking through the problem and factoring out causes can fix any kind of problem. Worst-case scenario: You may have to start over, but that is very rare.

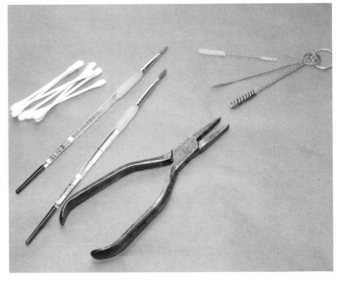

Here are the tools I use to keep my airbrushes happy and healthy: cotton swabs, narrow paintbrushes, small-diameter soft round brushes, and a set of pliers with flat-toothed jaws.

How to Truly Clean Your Airbrush

Left: *Here I'm tearing down and cleaning an Iwata HP-C Plus, which is a dual-action airbrush. Twist off the handle. A knurled nut holds the needle in place. Loosen the nut and slide out the needle. If the needle doesn't pull out easily, firmly grasp it with the pliers and pull it straight back. Make sure to pull it straight back because if you pull it at any kind of angle, it will bend the needle. Be careful, or else you will be replacing the needle.* **Right:** *Wow, look at all that crud on the needle! Now wipe it with thinner and clean it until it's all smooth. I use a cotton swab to wipe down the needle. Also inspect the tip of the needle to see if it is bent or damaged. If it is, replace it.*

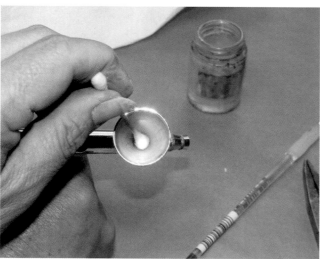

Above: *Use a cotton swab dipped in thinner to wipe down the inside of the color cup. A small, round paintbrush can also be used. I use both; the brush is used to reach in the small space that leads to the tip, and I use a swab to remove the debris. Also, stuff can get stuck in the paint passage from the color cup to the tip. If the paint flow seems obstructed and the needle and tip are not the cause, remove the tip and needle. Look into the tip and use a small, round brush or pipe cleaner to remove anything that is blocking the passage.* **Above right:** *While the needle is removed, also remove the spray regulator or crown cap to clean any paint from the tip opening on the head. Paint tends to build up there and will disturb the paint pattern.*

It is very handy to keep extra parts around for your airbrushes, especially for dual-action airbrushes. Try to have a few extra needles and a tip on hand. Some airbrushes, like the Badger 150, use a Teflon washer that seals the head assembly onto the body. The washer will need to be replaced each time the head is removed, so have a few extra washers on hand. Know your airbrush and the parts that you will need to keep it functioning.

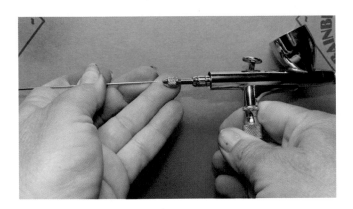

Now simply insert the needle back into the airbrush. This is the tricky part because it takes a little experience to know when the needle is seated properly in the tip. Push the needle in too far, and it will damage the tip. If the needle is not inserted far enough, there will be space between the needle and the tip. The paint will go through that opening, even if the trigger is not pulled back. Gently slide the needle and feel it settling up into the tip. It will stop when it is properly in place, so don't force it. Next, tighten the nut. Pull back on the trigger and make sure it has nice, smooth travel. If not, then repeat the needle-cleaning procedure.

Many times, even with proper cleaning, you'll go into the studio to airbrush, pick up the airbrush, and the trigger won't move or it does not move smoothly. No biggie. It happens all the time. Just pull out the needle and clean it. Many times, stuff forms on the inner diameters that surround the needle. Then, after a night of sitting, that material gets on the needle and causes it to stick. It happens very frequently if you are using automotive paints. In fact, I clean my airbrushes each morning before I start working and then clean them at the end of the day.

VARIOUS AIRBRUSH PROBLEMS

Finding the best remedy for an airbrush problem depends on the airbrush being used. Here are just a few problems, their causes, and remedies. Use common sense when troubleshooting airbrush problems. Stay calm and investigate the problem. Be sure to think it through. Always protect the business end of the airbrush. Keep protective caps in place when brushes are not being used at that moment.

Problem 1

The paint is spitting out of the airbrush and is very grainy—it doesn't have an even, smooth flow.

Cause: The paint is either too thick or the pressure is too low.

Remedy: Look at your paint. Is it already very thin? Then turn up the air pressure a few pounds. Also, make sure the spots or "split" are coming from the tip of the airbrush. Sometimes paint can build up on the crown cap or spray regulator, which will also cause spitting. Unscrew the crown cap/regulator and clean it with a cotton swab dipped in thinner. While you have the crown cap off, carefully clean the area around the tip.

Problem 2

The paint comes out of the airbrush, even when the trigger is not pulled back.

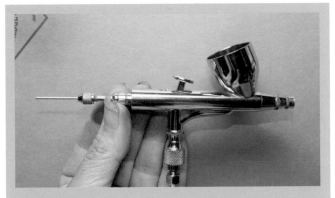

Many times, the airbrush just seems to be working incorrectly. Maybe paint comes out when it should not, or the trigger feels strange.

If you're using a dual-action airbrush and you find yourself dealing with a problem that is hard to pin down, try this: Remove the airbrush handle. Grab onto the needle chucking assembly. Is it loose? If so, simply tighten it up. This assembly has a habit of coming loose occasionally. I have no idea why, but it happens.

Cause 1: Something, maybe dried paint, a hair, a fiber, whatever, is caught in the tip and causes the needle to not close into the tip properly.

Cause 2: Wear and tear on the needle and/or the tip is causing paint to escape through those gaps. It also is caused by paint leaking into the air passages. See paragraph below.

Remedy 1: Remove the needle and tip. Clean both thoroughly. Very carefully, use an old airbrush needle to poke into the tip and see if there's anything caught in the passage.

Remedy 2: Replace worn parts. Replace the needle first. If the problem is still present, replace the tip.

Some tips are held in place by threads, and a little wrench that comes with the airbrush must be used to unscrew the tip. Other tips are simply pushed in place and held there by friction. Be careful with those tips because they can fall out very easily when you are working on the airbrush. Work over a towel so that the tip won't roll away and be lost forever.

Problem 3

No paint comes out of the airbrush, or the trigger must be pulled back farther than normal to get paint flow.

Cause: Something is caught in the paint passages.
Remedy: Remove the needle and tip. Clean them and the paint passages in the airbrush body thoroughly.

Problem 4

Air flow is not consistent.

Cause: The spray regulator or airbrush head is not sealing properly, which causes the outside air to affect airflow. It could be loose or, with some airbrushes, the head washer could be worn.
Remedy: Remove the spray regulator or head. Look to see if the sealing surfaces are clean and free of debris. Replace the head washer, if applicable.

Problem 5

No paint comes out when using a bottle-feed airbrush.

Cause: Either the tube or the siphon cap is clogged, or the air hole in top of the cap is clogged.
Remedy: Check and clean the paint passage up from the bottle and clear out the air hole.

Problem 6

The needle does not move smoothly when pulled back.

Cause: Paint may have leaked back past the needle seal and is sticking in the "machinery" that pulls the needle back.
Remedy: Remove the needle, needle chuck, and spring assembly. Take apart the assembly and thoroughly clean it. Remove the trigger. Clean out the airbrush inner body with cotton swabs. Use a small, round brush to clean out the needle chucking guide. Reassemble.

If paint has been leaking into these areas, the seal or packing that seals the head from the body is worn. In some airbrushes, it is not too hard to replace. In others, it is a total pain. I usually buy a new airbrush or try not to let very reduced paint sit in the airbrush. Very reduced solvent-based paint will leak out faster than thick paint. Paint leaking into the airbrush body can also leak into the air passages. Clean out the body and, if possible, take apart the air inlet and clean it. Remove the head assembly, reinstall the trigger, and blow air through the brush until it comes out clean.

Problem 7

Paint is piling up on the tip of the airbrush.

Cause: This happens for several reasons. Lower air pressures are needed for fine work, but the lower the pressure is, the slower the paint flows through the airbrush. The paint doesn't have enough velocity to keep bits of paint from sticking to the end of the needle. It tends to be a pesky problem when working with water-based airbrush colors because they dry so quickly.
Remedy: No easy answer here, but there is a simple solution—although, it's not the one you want to hear. Always pay attention to the airbrush. When using auto paints, I have gotten into the habit of "clearing out" the airbrush before getting started on a new area of the painting. In fact, I'm not even aware of doing it anymore. It has become an automatic move when I airbrush. For example, I'm spraying yellow for a woman's hair. Then I need to add white highlights. After I'm done with my yellow, I pick up the airbrush with the white. I point the airbrush toward my ventilation inlet and away from my painting surface. I pull back all the way on the trigger and give a good blast of paint out of the airbrush.

This does two things: It takes away most of the paint that is built up on the tip and it also clears away any wet paint that may have settled on the inside surface of the spray regulator or crown cap. This method only works with solvent-based paints because the solvent in the paint is so strong that it can soften the paint on the tip until it blows away.

Now, ***this does not work with water-based paint*** because it is already dry and does not react like a solvent-based paint. Once the paint is dry, it must be picked off the tip. If you are using water-based paint, get in the habit of picking the paint off the tip each time you pick up the airbrush, and every few minutes while airbrushing. It seems frustrating at first, but after a while it will become something you automatically do without even thinking about it.

Problem 8

Air bubbles appear in the color cup or bottle when pressing the trigger and/or a pulsating spray of paint is coming out of the airbrush.

Cause: Air is leaking into the paint passages and interrupting the flow of paint. The head of the airbrush is not tight, or if there is a Teflon washer, it is worn.
Remedy: Remove the head assembly of the airbrush. Look for any debris on the sealing surface and clean it. If there is a washer, replace it. Do not overtighten the head and do not use a tool to tighten it. Just tighten it down with your fingers.

A somewhat clean and organized studio can help the artist's attitude considerably. Before starting a new project, always take an hour or so to go through your studio. Clear away the clutter that seems to accumulate on every available surface. Keep folders for each paint and project. Put any paperwork related to that job in its folder. Even when the pressure is on to get the next project started, take that time to clean the studio or shop. It feels much better and less stressful to work in a neat studio where you can find things rather than feeling under the gun in a place where you're surrounded by clutter.

HOW TO REPAIR A PROBLEM

So what do you do when a part of the painting gets messed up? Don't freak out. Allow the paint to dry and think the problem through. If you are working on illustration board, maybe you can spray some white, cover up the area, and repaint the artwork in that area. But above all, think! Sit back, relax, and think the problem through.

I was finishing up this face when I picked up a paper stencil to use on the eye. Somehow thinner had gotten onto the stencil. When I touched it to the paint in that area, the thinner got onto the surface, softened the artwork, and messed up the face. First, I allowed the area to completely dry out.

Next, I spray some skin tone on the brow area using a shield that I masked off the left eye before I sprayed the skin color. Wow, it looks pretty dark against all those soft layers of various skin tone! Now I'll start to blend in the repair starting with under the brow. The stencil for the brow line is placed on the surface to mask off that area. Then the shield for the eye is held over the eye, and the darker tones are sprayed, which will fade and blend the repair.

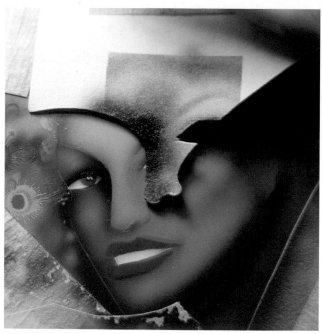

Left: *Next, the procedure is repeated with the stencil for the upper brow, and the lighter skin tones are airbrushed on to blend that darker skin tone. I started out with the dark because the damaged area had areas of light and dark. The surface tone had to be evened up. If I had simply sprayed the light tone, the dark areas would have still been visible. The dark color covered everything up and gave me a solid base for working. Also, overspray from lighter colors tends to be very noticeable. Note in this picture that the overspray from the lighter color is getting onto the right eye. I'll have to do a bit of rework there also by going over the dark colors of the eye and surrounding area.* **Right:** *By going back and forth between the two stencils and fading in a little color each time, I slowly get the repaired area to blend in. It's about done. Now, if you look closely, you can see the little raised areas of the disturbed paint surface below the repair. This is automotive paint, so I can clear coat over it, sand it, and the surface will be level. Just a small bit of airbrushing will cover any last bits of any inconsistencies in that area.*

Here is the finished version and there's no sign at all that there ever was any damage. Making repairs to artwork that was created with automotive paints is much easier than when working over paper surfaces. You have to be very careful because the paper surface is easily bothered when too much wet paint is layered on at one time. When working on those surfaces, build up your repair slowly. Do not saturate the surface and watch that overspray. The areas around the repair area can tend to get bumpy if small bits of paint land there, and it will build up a rough textured surface. After each application of color, allow it to dry and run your clean hand over the surface to sweep away any loose overspray. You can also use a gentle tack cloth like Gerson's Blend Prep Cloths.

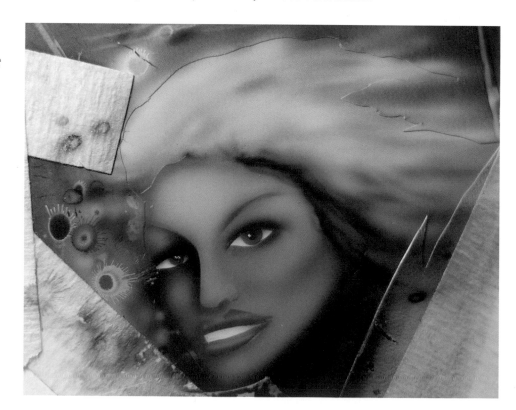

APPENDIX
AIRBRUSH RESOURCES

The following places may come in handy for finding products or answering questions as well as finding the times and locations of airbrush lessons and seminars. The forums on these sites are a great place to network with other artists, especially when you need the answer to a problem. You can also help out other artists who have a problem for which you have a solution. Many well-known artists post on these forums, so take advantage of these sites because their resources are so complete.

www.airbrush.com: This is a website that features forums, galleries, news about events and classes, and a store. It is a great resource for networking with other artists to help with problems, find the latest news about new products, look at the work of other artists, and get opinions of your work. It is easy to post photos on this site, and it also has a search feature. Simply type in a few keywords of a problem or technique, and get a list of all the posts that deal with those subjects. It one of my favorite resources to find out what is going on in the airbrush world.

Airbrush Action magazine: This is a monthly publication that is available by subscription or at the newsstand. I recommend getting a subscription because it tends to sell out fast at the newsstand. It also has a great companion website, **www.airbrushaction.com**, that features a forum, galleries, store, information about events and classes, and other resources for the artist. *Airbrush Action* also puts on Airbrush Getaway weekend several times a year. Many well-known airbrush artists teach at these getaways.

www.learnairbrush.com: Mike Learn's Airbrush Resource site. This is a very comprehensive site for the artist who wants to learn about every aspect of the craft. Its main focus is on automotive airbrushing. It contains quite a few different forums, how-to projects, a store, galleries, and much more. There's even a live airbrush cam where you can actually watch Mike working. Mike and Diana Learn cover all the bases with this site.

www.drublair.com: Dru Blair is famous for his incredible photorealistic painting. He gives specialized classes in these techniques. Find out the times and reserve a space in one of his classes. I highly recommend it.

www.bearair.com: A very comprehensive online airbrush store. Great selection of airbrushes, compressors, and more.

www.coastairbrush.com: This is a great site for products, classes, and much more.

www.dickblick.com: Great online store for artist supplies like cutting mats, illustration boards, fine art paints, stencil knives, and much more.

INDEX

3M adhesive, 28, 29, 112, 132, 136, 143

Adobe Illustrator, 33, 101

Air compressors

airbrush and custom paint shop, 21, 22

buying, what to look for, 20

diaphragm, 19, 20

piston-driven, 20, 21

overheating, preventing, 21

Air regulators, 18

Air sources

canned propellants, 18

CO_2 tanks, 18, 19

compressed air, 18, 19

Airbrushes

deciding which type to purchase, 11

external-mix, description, 10, 11

internal-mix, dual-action, description, 12, 13

internal-mix, single-action, description, 11

maintenance, 15

problems, 170, 185, 186

proper care, 183–185

Artograph Super Prism projector, 25

Artool Shields, 30, 31, 85, 157, 175

Auto Air paint, 14, 17, 37, 61, 146

hints for using, 39

Badger

150 airbrush, 14, 184

air compressors, 21

Air Opaque White, 35

Propel, 18

Bic 0.9 mechanical pencil, 33

Binks regulator, 17, 18

Blair, Dru, 27, 189

Brushes, 27, 28

Charette Art Store, 7

Chick's Harley-Davidson, 131

Chick-fil-A Company, 101

Coast Airbrush

Automask, 28

paint storage bottles, 38, 65, 87, 112, 143, 148, 153

Computers, and airbrushing, 32, 33

CorelDraw, 33, 71, 101–109

tools, 102

Creative Cycle Works Custom Paint, 101

CutStudio, 109

Dagger strokes, about, 52

DeBerardiis, Olivia, 44

Dr. Ph. Martin's, 7, 34, 35, 48

Eagle, airbrushing, 143–151

material and equipment, 143

Edwards, Allan, 101

E-Z Mix disposable mixing cups, 38, 87, 90, 112, 118, 143, 152

Faber-Castell Perfection eraser, 33

Filtering equipment

hoses, 23

lighting, 23

Fitto, 40

Fraser, Craig, 30

Frazetta, Frank, 44

Frisket film, using, 58–64

working from drawings, 64

Gerber vinyl mask, 28, 29, 65, 115, 152, 167

Gerson's Blend Prep Cloths, 188

Golden Artist Colors, 36

Goodeve, Vince, 40

Gorski, Robert, 143, 144

Grafix frisket paper, 28, 29, 58, 80, 87, 152

Grandma's Music and Sound, 113, 114, 131

Gripster knife, 27

Grumbacher Miskit Liquid Frisket 559, 29, 132

Harris, Mickey, 28, 37

Holbein Aeroflash Colors, 35

Holders, airbrush, 32

House of Kolor

KC-20, 29, 112

paint, 37, 132, 135, 141, 143, 148, 168

SG-100 Intercoat Clear, 135

Human figures, airbrushing, 152–182

material and equipment, 152

painting faces and skin tone, 168–182

Iwata

airbrush, 12, 13, 65, 80, 87, 113, 132, 140, 143, 152, 184

Eclipse dual-action airbrush, 11, 80

Eclipse HP-BS airbrush, 13

Great White Shark air compressor, 21

PowerJet air compressor, 20

Revolution Series, 14

Smart Jet air compressor, 20, 43

Sprint Jet air compressor, 43

Jerry's Artarama, 39

Koh-I-Nor Rapidograph pen, 33

Kyle Petty Charity Ride, 101

Lavallee, Mike, 31

Learn, Diana, 189

Learn, Mike, 32, 33, 40, 189

Liquid frisket, using, 132–142

for hard surfaces, 134–142

liquid mask, 132, 133

material and equipment, 132

rubber cement, 133

Location, airbrushing on, 43

Luma ink, 34

Mack Pinstriping brushes, 27

Masking supplies

adhesive-backed films, 28, 29

liquid masking, 29–32

reusable plastic shield and templates, 29

Masquepen liquid frisket, 29, 31, 133

McCully, Blake, 37

Metal surface and texture effects, 65–79

material and equipment, 65

taping, 66, 67

using CorelDraw, 71

Metalflake Company Spray Mask, 29, 31, 132, 134, 143

Movements, airbrushing

fades and gradations, 53–55

hints, 56

holding the airbrush, 48, 49

practicing, 49–52

single-action vs. dual-action airbrush, 49

Paasche airbrush, 7, 10, 14

Paint feed styles, 13, 14

Paint job, repairing, 187, 188

Paints,

acrylics, 35, 36

automotive, solvent-based, 36–38

gouche, 35

inks, 34

oil paints, 36

safety rules for solvent-based, 43

watercolors, 34

Parson's School of Design, 7

Pearl Paint, 39

Pentel Techniclick mechanical pencil, 33

Photographs, airbrushing from, 45–47

Pigma Micron permanent marker, 33

Pink Pearl eraser, 33, 55

Polar Bear air compressors, 21

PPG Envirobase paint, 38, 168

Prismacolor Pencils, 33

Research and reference materials for airbrushing, 44, 45

Resources for products and information, airbrushing, 189

Richpen

013G single-action airbrush, 11

213C dual-action airbrush, 11, 65, 132

GP-2 airbrush, 14

Roland

GX-24 Camm 1 plotter, 65, 100, 109, 112, 129

Stika plotter, 100

Sandia Classic Motorcycle Race, Third Annual, 113, 131

Saral Transfer Paper, 33

SATA

0/444 filters, 23

dekor artbrush, 15, 16, 132, 140

Minijet 4 spray gun, 16, 17

SATAgraph 1 airbrush, 14, 87, 152

SATAgraph 2 airbrush, 132

SATAgraph 3 airbrush, 11, 12, 14, 15, 58, 65, 80, 87, 98, 112, 143, 152, 157

SATAjet 2000 HVLP spray gun, 17

Sears Craftsman air compressor, 22

Sharpie Fine Line permanent marker, 33, 152

Shivas Liquid Masque, 29

Silentaire air compressors, 21

Sorayama, Hajime, 44

Spray guns, 15–17

Springsteen, Jay, 113, 131

Stabilo pencil, 33, 87, 97, 143, 148, 152, 165, 175

Stencil layers, 80–86

materials and equipment, 80

Stencils, complex, using on a guitar, 112–131

material and equipment, 112

Sticky Mickey transfer tape, 28, 29

Studio setup, 43

Surfaces

bristol boards, 34

canvas, 34

hard-surfaced paper boards, 34

Theory, airbrushing

equipment frustrations, 40

learning process, 40

paint subjects, 41, 42

painting obstacles, 42

painting references, 42

testing materials, 40

working for pay, 42, 43

Tools and supplies, finding, 38, 39

Tools, airbrush, basic, 24–27

TransferRite transfer tape, 28, 29, 152

Uncle Bill's Sliver Gripper tweezers, 26, 65, 112, 132, 143

Valejo, Boris, 44

Vaughan, Stevie Ray, 8

Vector drawing, creating, 100–109

examples of artwork, 110, 111

with Bezier tool, 103–109

Ventilation, 43, 44

Walnut Hollow stencil burner, 28

Whetstone blade sharpener, 26

Windsor Newton easel, 24

Wolf, airbrushing, 87–99

material and equipment, 87

X-Acto knives, 26, 27, 58, 60, 65, 70, 80–82, 85, 87, 89, 112, 117, 132, 135, 143, 145, 152, 154, 160

Young, Ryan, 44